PHOTOGRAPHY YEARBOOK 1999

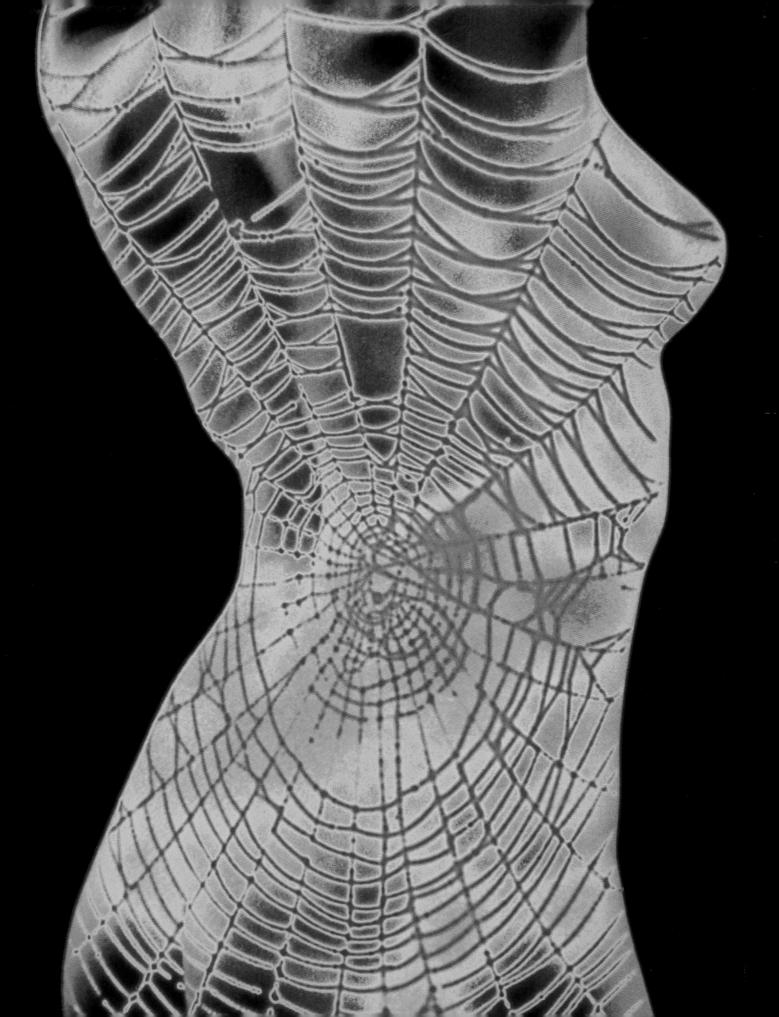

PHOTOGRAPHY YEARBOOK 1999

EDITOR
Chris Hinterobermaier

CONTRIBUTING EDITOR
Joseph Meehan

DESIGNER
Grant Bradford

FOUNTAIN PRESS

PHOTOGRAPHY YEARBOOK 1999

Published by
FOUNTAIN PRESS LIMITED
Fountain House
2 Gladstone Road
Kingston-upon-Thames
Surrey KT1 3HD

Editor
CHRIS HINTEROBERMAIER

Contributing Editor
JOSEPH MEEHAN

Designed by
GRANT BRADFORD
DESIGN CONSULTANTS
Tunbridge Wells, Kent

Reproduction
SETRITE DIGITAL GRAPHICS
Hong Kong

Printed by
SUPREME PUBLISHING SERVICES

© Fountain Press 1998
ISBN 0 86343 377 4

Title page photograph 'Spiderwoman' by Peter Jeffery

CONTENTS

EDITOR'S MESSAGE

This is my first issue as editor of the PHOTOGRAPHY YEARBOOK, having been the International Editor since 1996. Together with Joseph Meehan, the US Editor, Grant Bradford, the Designer and Harry Ricketts the Publisher, we have formed a team that sees its aim as producing a book showing the development of photography and maintaining the prestige that has been built up over the past 64 years. It has been and will always be the aim of the Photography Yearbook to present the world's most outstanding pictorial photography and I am pleased to be able to continue this tradition.

In 1996 it was decided to embark on a major layout change and the Photography Yearbook is now divided into two parts: a portfolio section enabling the Editor to feature the work of well-known photographers like Lord Snowdon, Robert Farber, Jerry Uelsmann and Pedro Luis Raota and a gallery section offering the opportunity for photographers from all over the world to have their work published.

For the portfolio section we are continuing the presentation of major photographers and in this edition I am pleased to present the work of Bob Elsdale, one of UK's most influential photographers, who has specialised in the field of digital imaging and combines a strong sense of humour with an excellent knowledge of digital manipulation. His computer generated work never seems to be sterile or impersonal. His prints tell a story and can be very humourous. Elsdale is not only a very successful professional photographer for clients in the UK, but more than this he sees the possibilities of digital photography as a key to communication, especially with children. This he intends to develop in a series of books for children.

Constantinos Petrinos from Greece loves and records the wonderful underwater world with his camera. His exotic shots taken mainly in the sea around Indonesia show the beauty of nature as well as reminding us to preserve this paradise environment.

The Belgian photographer, Roger de Groof, works in the tradition of surrealism and is strongly influenced by the famous painter Rene Magritte, but despite his classic education at the Academy of Arts in Belgium, his prints are very imaginative.

Theresa Airey from the USA is not a typical experimental photographer and in some respects the complete opposite to Roger de Groof. She is able to combine creativity in the form of light and colour with a warm, undoubtedly feminine touch. She is interested in bringing her experimental abilities to the creative world, full of secrets and mysteries.

Tony Worobiec is a master in the technique of hand toning and air brushing, which gives his monochrome prints a very individual character. Tony shows us his latest works taken in the arid deserts of Nebraska and Montana, a journey to the "Ghosts in the Wilderness".

Up till now the successful concept of the Photography Yearbook has not changed. What is really new in this year's edition is the first regional portfolio. The plan is to present a region, a country or a group, reflecting as many individual ideas as possible to illustrate the work of a number of people. In a portfolio of 16 pages we are presenting South Africa, a country of change, by showing through the lenses of its photographers something of what is going on in photography in that country. What one sees from South African photographers is the beauty of the scenery and its fabulous wildlife. There are new creative aspects to their photography now that they have been given the opportunity to show all facets of the country.

In the future we will feature special occasions, themes, or events and to that end we are already planning the edition for the year 2000. Our theme will be "time" in all its aspects, so readers please think about this and let us have your pictures.

The second part of the book, the gallery section, still is the forum for the best imaginative and creative photography in the world. It is the place for people, who have chosen the camera to record and interpret their view of the world to submit new ideas with perfect pictures. In other words, a refuge for inspiration for photo enthusiasts. This gallery is open to everyone who wants to send messages to other people by means of photography.

The Photography Yearbook has a very close relationship with the Austrian Super Circuit, the world's largest salon of photography and has become a wonderful source of material for the gallery section of the book, but contributions are not confined to this, everyone can take part.

Photography is truly a language for all of us fortunate enough to be able to see and if your thoughts and feelings are influenced by pictures in this edition of the Photography Yearbook then we have made a small contribution to what we all love so much: photography!

Dr. Chris. Hinterobermaier

EDITOR

VORWORT

Dies ist die erste Ausgabe des Jahrbuches der Fotografie, der ich als Chefredakteur vorstehen darf, nachdem ich bereits seit 1996 an dieser jährlichen Publikation mitarbeite. Gemeinsam mit unserem USA-Korrespondenten Joseph Meehan, dem Designer Grant Bradford und dem Herausgeber Harry Ricketts besteht ein Team, dessen Ziel es ist, alljährlich ein Buch aufzulegen, das die neuesten Entwicklungen in der Fotografie reflektiert und den Prestige der vorhergehenden 64 Jahresausgaben gerecht wird.

Im Jahrbuch der Fotografie werden die besten Fotokunstwerke eines Jahres präsentiert und ich fühle mich geehrt, diese Tradition fortzusetzen.

1996 wurde eine völlige Neukonzeptionierung des Jahrbuches der Fotografie vorgenommen, das sich seither als zweigeteilter Bildband präsentiert. Der Portfolio-Teil ermöglicht es uns, die Arbeiten von so berühmten Meistern wie Lord Snowdon, Robert Farber, Jerry Uelsmann oder Pedro Luis Raota, umfangreich und retrospektiv vorzustellen. Im zweiten Teil des Buches, der sogenannten Galerie, haben Fotografen aus aller Welt die Chance, ihre Werke darin auszustellen.

Auch ich bleibe gerne diesem Konzept treu und freue mich, die Arbeiten von Bob Elsdale, dem einflußreichsten britischen Digitalfotografen vorzustellen, der sich ganz auf computergenerierte Fotografie konzentriert und es schafft, seine großartige Meisterschaft in der digitalen Manipulation mit einer gehörigen Portion Humor zu würzen. Seine "Computerfotografie" wirkt niemals steril oder unpersönlich. Elsdale ist nicht nur ein höchst erfolgreicher Berufsfotograf, sondern sieht die digitale Fotografie als einen Schlüssel zur Kommunikation, ganz besonders mit Kindern. Derzeit arbeitet er an einer Serie von Kinderbüchern.

Constantinos Petrinos aus Griechenland ist Unterwasserfotograf und zeigt uns in seinem Portfolio die wunderbare Welt der Meere. Die Arbeiten entstanden auf einer seiner Expeditionen in die Gewässer Indonesiens. Er erinnert uns mit seinen Bildern stets auch an die Verletzbarkeit des komplizierten Unterwasserökosystems.

Der belgische Fotograf Roger de Groof arbeitet in der Tradition des Surrealismus und ist stark von berühmten Malern wie Renè Magritte beeinflußt, aber im Gegensatz zu seiner klassischen Ausbildung an der Akademie der Künste in Belgien sind seine Arbeiten sehr imaginativ.

Die Amerikanerin Theresa Airey ist keine typische Experimentalfotografin und steht in gewisser Weise zu Roger de Groof in Opposition. Sie kombiniert Kreativität in Form, Licht und Farbe mit einem warmen, zweifellos weiblichen Touch. Sie ist daran interessiert, ihre experimentellen Fähigkeiten in Bilder voller Geheimnisse und Mysterien zu packen.

Tony Worobiec aus England schließlich gilt als Meister der handcolorierten Abzüge, die er zusätzlich noch mit der Airbrushtechnik bearbeitet. Er entführt uns in die weiten Steppen Nebraskas und Montanas und läßt uns in seinen Arbeiten den "Geist der Wildnis" verspüren.

Insoweit habe ich das erfolgreiche Konzept des Jahrbuches der Fotografie nicht verändert. Neu hingegen ist das erstmals in dieser Ausgabe gezeigte regionale Portfolio. Es ist mein Ziel, in jedem Jahr eine Region, ein Land oder eine Gruppe zu präsentieren, in der ich so viele individuelle Ideen wie nur möglich mit Fotos verschiedenster Fotografen illustrieren möchte.

Auf 16 Seiten zeigen wir Südafrika, ein Land im Umbruch. Wir versuchen im Umweg über die Linse der dort tätigen Fotografen die Veränderungen des Landes aufzuzeigen. ‹blicherweise kennt man aus Südafrika nur die Schönheit der Landschaft und die faszinierende Tierwelt. Es gibt aber auch neue kreative Aspekte in der südafrikanischen Fotografie, denen wir nun eine Möglichkeit zur Präsentation einräumen.

Für die weitere Zukunft sind wir offen für spezielle Gelegenheiten, aktuelle Themen oder Ereignisse und schon jetzt planen wir für die Ausgabe des Jahres 2000 vor. Dort wird anläßlich des Milleniums "Zeit" unser Thema sein und gerne rufe ich die Leser des Jahrbuches der Fotografie auf, sich schon jetzt mit dieser Thematik auseinanderzusetzen.

Der zweite Teil des Buches, die Galerie, ist weiterhin ein Forum für die besten und kreativsten Fotografen der Welt. Es ist hier der Raum für jene Leute geschaffen, welche die Kamera als Werkzeug für ihre Sicht der Welt verwenden, um neue Ideen in perfekte Bilder zu integrieren. Mit anderen Worten: hier besteht eine internationale Ideenbank allererster Güte für Fotofreunde. Diese Galerie ist rund um die Uhr für jeden geöffnet, der seine Botschaften mit den Mitteln der Fotografie anderen mitteilen möchte.

Das Jahrbuch der Fotografie steht in einer engen Beziehung zum Austrian Super Circuit, dem weltgrößten Salon der Fotokunst, der sich als eine sprudelnde Quelle für Material, das in der Galerie Verwendung finden kann, herausgestellt hat. Abgesehen davon können interessierte Fotografen aber auch direkt an den Herausgeber ihre Werke für eine mögliche Berücksichtigung einreichen.

Fotografie ist eine Sprache, die alle Menschen verstehen können, die in der Lage sind, zu sehen. Und wenn ihre Gedanken und Gefühle von den Bildern dieser Ausgabe des Jahrbuches der Fotografie berührt werden, dann hat diese Publikation einen kleinen Beitrag zu dem geleistet, was wir alle am meisten lieben: Die Fotografie!

Dr. Chris. Hinterobermaier

EDITOR

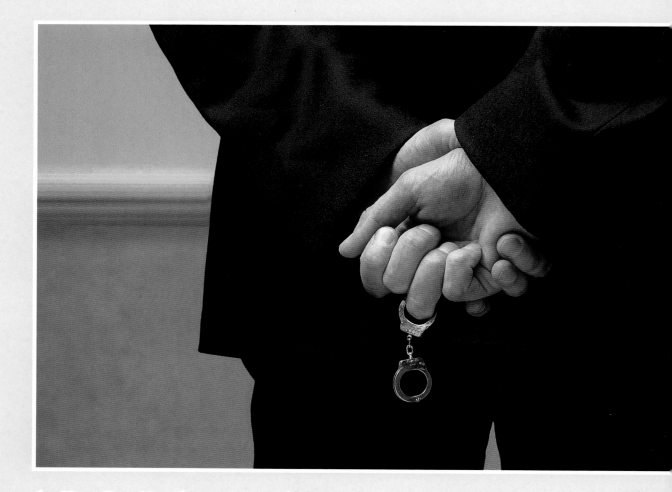

BOB
Elsdale

Bob Elsdale was bom in Bristol in 1947, he studied industrial chemistry at Loughborough University of Technology where he became interested in photography and attended the London College of Printing as a postgraduate student. "I managed to last 3 months before deciding that college was not for me. Instead of learning the theory of photography, I decided to assist various professional photographers gradually working my way up the ladder. I learned more in one day watching professionals at work than I did in my whole time at the college."

It was not long before Bob opened his first studio. He has always been interested in conceptual photography and achieved this through 'in camera' effects. Front projection was experimented with in the early days as were a number of darkroom techniques like Dye Transfer. Computers were a natural extension. Bob bought his first Mac and today runs a very successful studio and digital company, RGB Limited, in London. Bob has had to expand the operation and employ staff to help him with the additional amount of business. However,

Bob has one basic rule: "I would never work on other people's photography!" What is unique is that he has kept a sense of humour in all the digital work he undertakes and his prints tell a story which often need a second look to be fully understood.

Bob Elsdale loves to work with animals. "All the animals I use are supplied and handled by professionals. Digital imaging allows me to place an animal in a special situation and together with other animals, or even humans, you can create a personality. This is impossible in conventional photography!"

Bob Elsdale recently started working on children's books, "I thought that I had potential in that my kids loved my bedtime stories". In this type of personal work, which is financed by his commercial photography, he uses all his creative flair to entertain children and to invent characters. Bob does not see himself as an artist but he says, "I would be very happy if other people considered me to be one. I just do what I do, the way I want to do it".

Bob's website for further information is http://www.bobelsdale.com

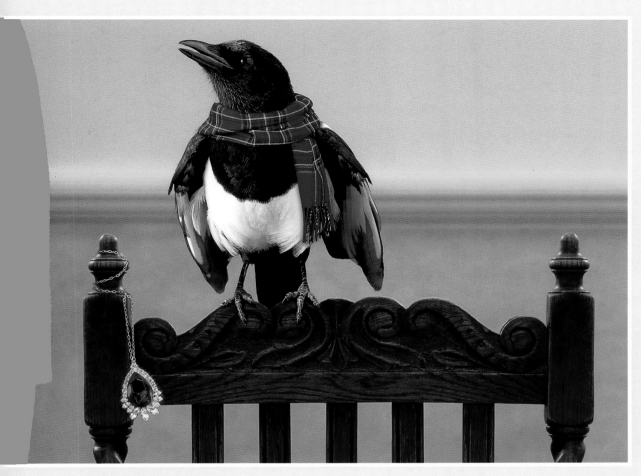

MAGPIE AND POLICEMAN
The front cover of Marvin The Magpie –
a proposed children's book.
The magpie was photographed in
the studio, a live bird and exceedingly
difficult to photograph. The back of
a real policeman, handcuffs reduced
in size on system.

BOB ELSDALE

Der britische Berufsfotograf Bob Elsdale, wurde 1947 in Bristol geboren, studierte Chemie an der Loughborough Universität und interessierte sich schon während seiner Studienzeit für Fotografie. Er belegte Kurse an einer Londoner Fotofachhochschule, "aber es hat nur 3 Monate gedauert, bis ich wußte, daß dies für mich nicht der richtige Weg zur Fotografie war", stellt Elsdale rückblickend fest. Statt grauer Theorie am College, ging Elsdale in der Folge den harten Weg eines Assistenten bei verschiedenen Berufsfotografen und arbeitete sich rasch die Karriereleiter hoch. "Manchmal lernte ich an einem Tag als Assistent mehr, als in der ganzen Zeit am College". Nicht lang danach eröffnete Elsdale sein eigenes Studio. Schon damals befaßte er sich mit konzeptioneller Fotografie und Spezialeffekten. In diesen Tagen arbeitete er gerne mit der Technik des "Dye Transfer" und der Einsatz des Computers in der Bildbearbeitung war die logische Fortsetzung des eingeschlagenen Weges. Elsdale hat sich mit aller Energie in diese neue Technologie gestürzt und gehört heute zu den wichtigsten Digitalspezialisten. Seine Firma RGB Limited in London beschäftigt eine Reihe von kreativen Köpfen in dieser innovativen Technologie. Trotz aller Bildmanipulationen befolgt Elsdale eine eiserne Regel: "Arbeite nie mit den Bildern anderer". Die computerbearbeiteten Werke von Bob Elsdale zeigen, daß die scheinbar so kühle, steril wirkende digitale Arbeit sehr wohl Platz für Humor bietet und viele seiner Fotos erzählen uns Geschichten oder brauchen einen zweiten Blick, um sie voll und ganz zu verstehen.

Vor kurzem hat Bob Elsdale aus einem inneren Bedürfnis heraus mit der Arbeit an Kinderbüchern begonnen. "Ich dachte, wenn meine eigenen Kinder meine frei erfundenen Gute-Nacht-Geschichten lieben, dann könnten diese auch anderen Kindern gefallen". Diese Art von freier Arbeit zeugt von seiner Liebe zur Fotografie abseits des Berufsalltages und Bob setzt all sein kreatives Flair in dieses neue Projekt, um Kinder zu unterhalten.

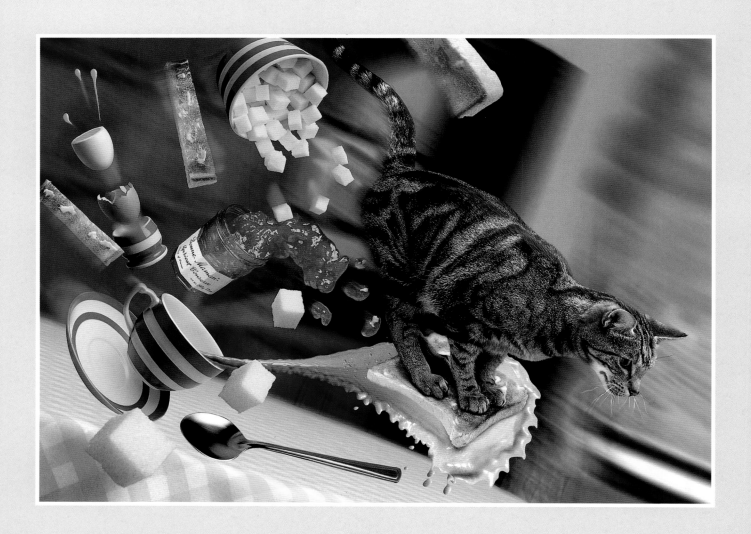

CAT SURFING ON TEA

The front cover of Mac's Triumph, a children's book. The cat was photographed in the studio on a 6x7cm. A high speed flash with a duration of approximately one ten thousand of a second was used to expose the tea. I thought that this image was one of the most difficult to produce so I did it first. If you have to make a cat surf on a wave of tea, things can only get easier.

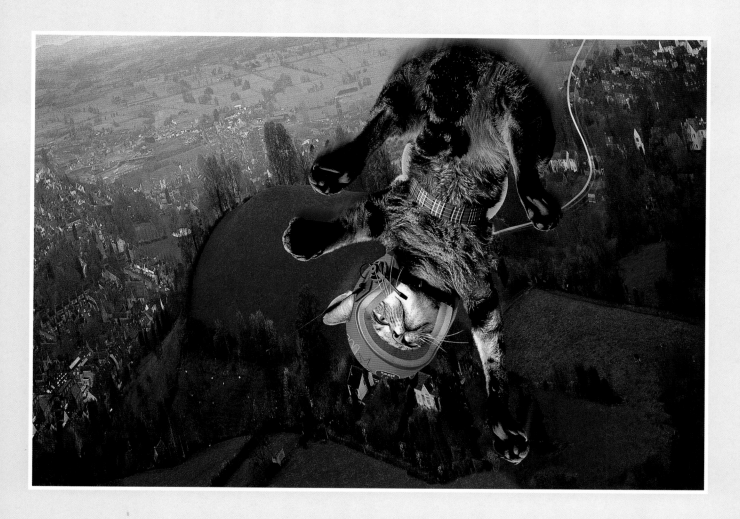

FALLING CAT

Another image from the same book.
The cat was held by the handler and
assembled from around six parts.
He was photographed against a blue
screen and masked out using Ultimatte
software. The background was shot
from Glastonbury Tor in the UK and
stretched on system to create
the 'overhead' angle.

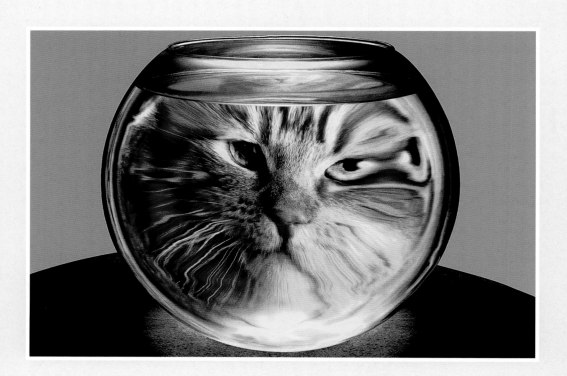

CAT IN GOLDFISH BOWL

Created for Benson & Hedges press and
billboard advertising. The cat was
photographed in the studio on 6x7cm
and originated on 25ASA negative film.
High quality colour prints were then
positioned behind a large goldfish bowl
and the required distortions created
in-camera. The colourising I did
on the system.

GOLDFISH BOWL ON BEACH

Shot at Barton on Sea on the South coast of England. The image was shot for real with no digital help other than balancing the final transparency. It was early evening in August and we ended up with quite an audience. Still one of my favourite images and created relatively easily.

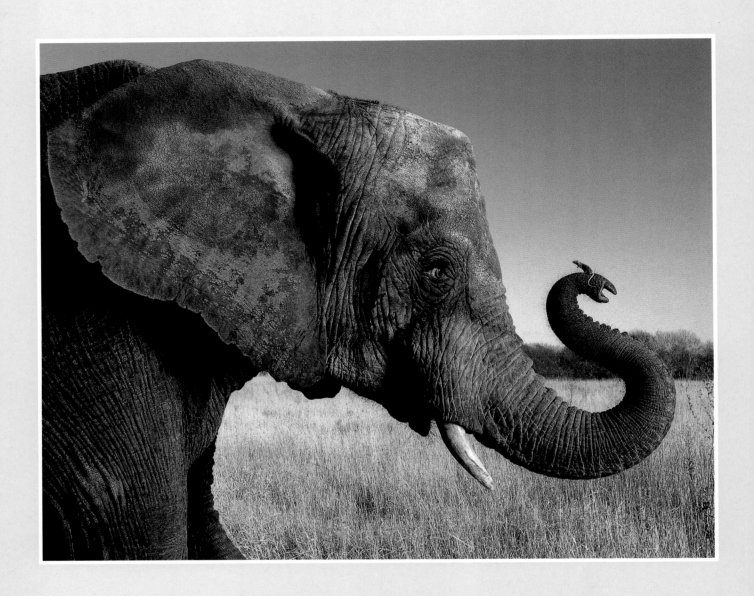

ELEPHANT AND MOUSE

The elephant was shot on location against a blue screen and two frames were used to get the best body and trunk. The background was shot just off the North Circular Road, London and the mouse in the studio. All images were originated on 6x7cm.

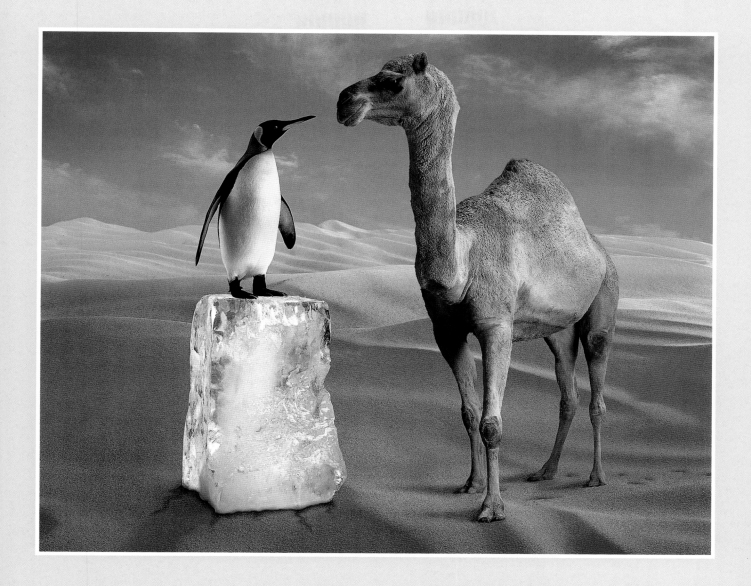

PENGUIN AND CAMEL

Sometimes animals are a privilege to
photograph and sometimes they are a pain.
The penguin was a real charmer and absolutely
immaculate. Being hand-reared and imprinted
on his handler the shoot was easy. The camel
was a different story and totally unhelpful.
A studio desert and a sky I shot in China were
composited on system to create the final result.

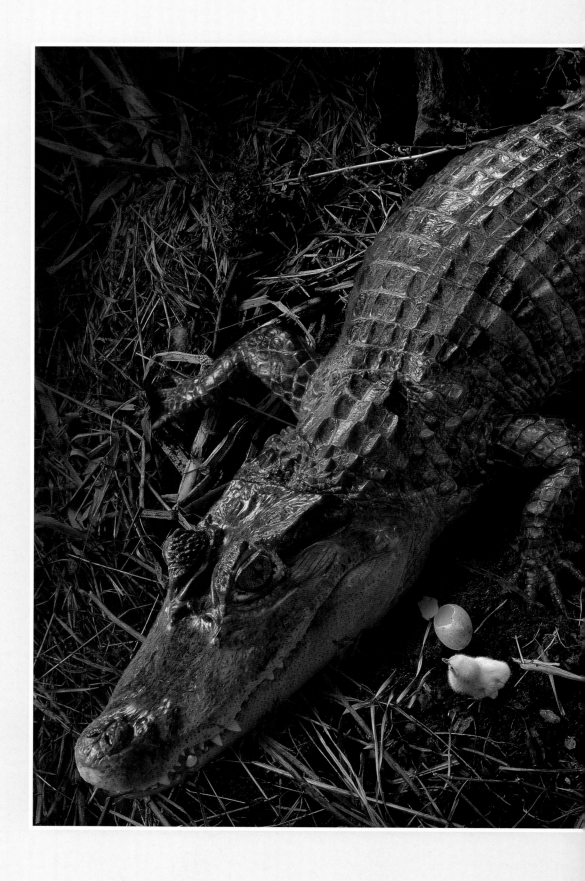

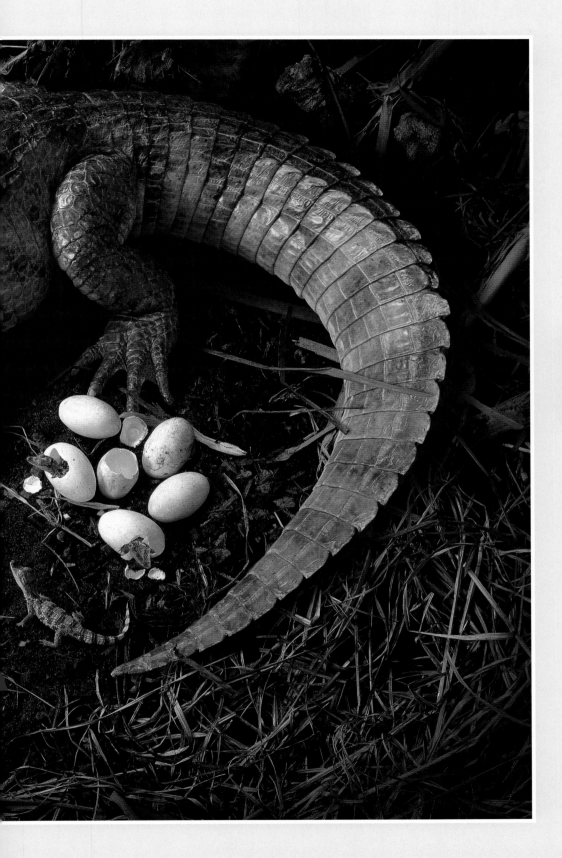

CROCODILE

The crocodile was actually
a Caiman and shot
independently from the nest.
The chick was stuffed and
size 1 chicken eggs were
slightly enlarged and
distorted on system to give
them the required irregular
look. All the parts were
shot on 6x7cm apart from
the nest which was
originated on 5x4.

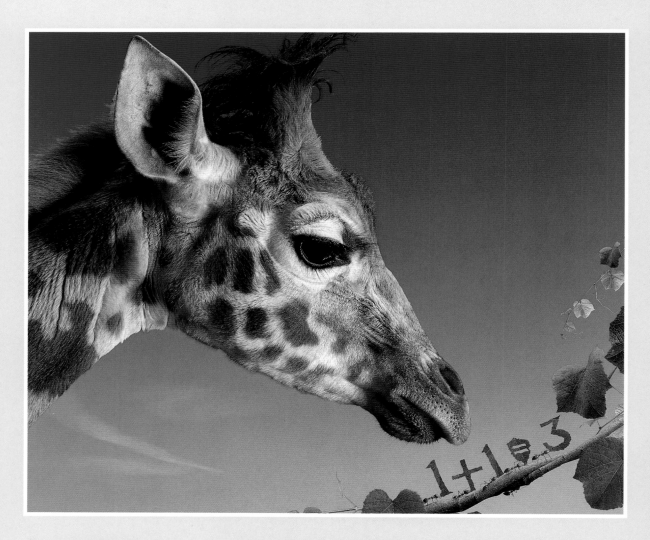

GIRAFFE

This giraffe was shot on location against a blue background. This allowed me to matte the very hairy outline relatively easily. It was a baby giraffe, only about eighteen months old and in beautiful condition. The soldier ants were made by a model maker and everything composited together on system.

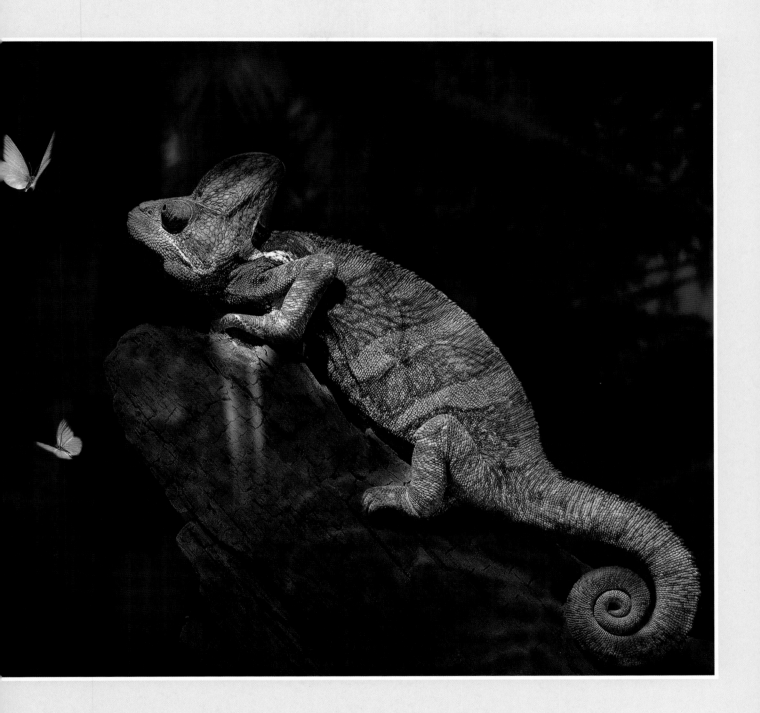

CHAMELEON

The chameleon was quite large, probably sixteen inches in length. I placed him on a suitably aged piece of wood and photographed him in the studio on a 5x4. The butterflys were sadly deceased, but resurrected with some movement on system. A hothouse environment provided the background.

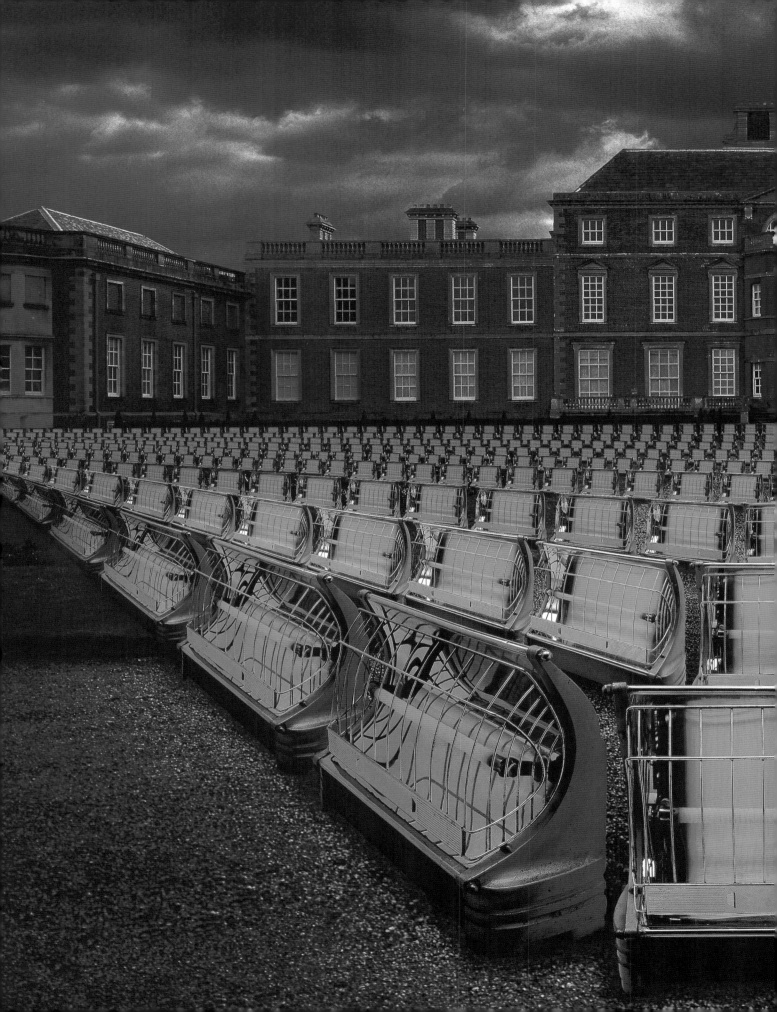

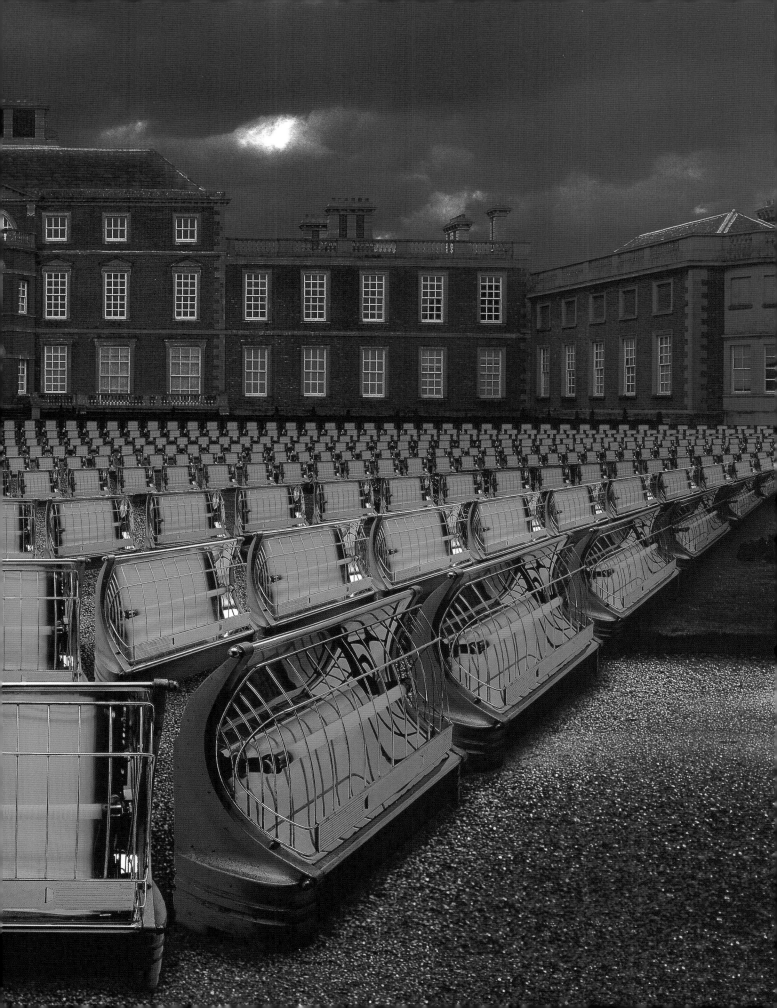

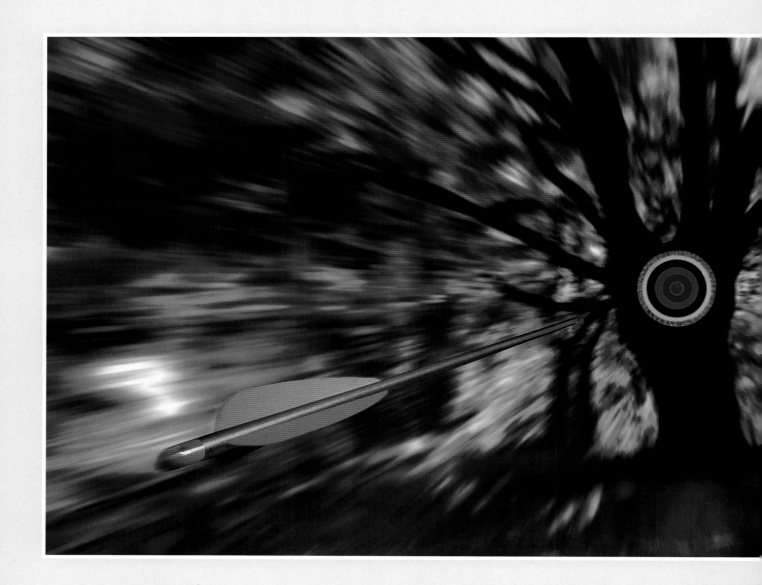

ARROW
The background was photographed on Hampstead Heath in North London. Both the arrow and target were shot in the studio and the zoom effect created on system.

Previous spread
ELECTRIC FIRES
One fire was photographed from a number of angles and the left side of the assembly created on system. The image was duplicated and flopped on system to create the full picture and composited with the background. Much of the system work on both this image and on the 'Arrow' above, was done by David Mack, a London art director.

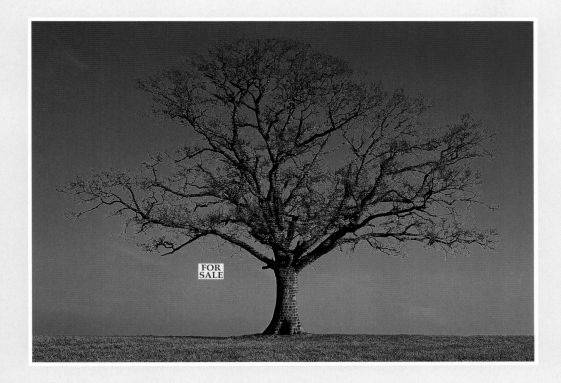

TREE IN BRICK

Created as personal image from a tree
which was originally photographed on
a half-plate field camera. Quite a tricky
image to create and time consuming
in system time. Still, hopefully it
imparts a message.

EQUIPMENT

CAMERAS

Nikon F90 with dedicated flash, 28-70mm and
70-210 zoom D Nikkors.

Mamiya RB 6x7cm x2 with Polaroid back, 45 prism
and 50, 65, 90, 127, 180 and 250mm lenses.

Horseman and Ebony 5x4s, with 65, 90, 115, 150,
180, 210 and 300mm lenses.

Arca 6x9cm with Polaroid, viewer and rollfilm
backs, 6x9 and 6x7cm.

FILMS

Fujichrome Provia 100ASA and Agfa 100 and
400ASA black and whit camera stocks.

COMPUTERS

Kodak Premier scanning and film writer, x2
Sunsparc 20 workstations with Kodak Premier
software, x2 Sunsparc 470 workstations.

Daystar 800 x4 180mhz 604E processors, x3 Raid
drives total 15Gb., 800Mb RAM.

Macintosh 604E 180mhz with SCSI 3 and 14 Gb
disc drives, 512Mb RAM.

Macintosh 7100, Kodak 225 CD writer and ISDN 2.

LIGHTING

Mainly Bowens 3000 packs with an assortment
of heads, reflectors and softboxes. In quartz 500,
1000 and 2000W fresnels and a number of
300/500W mizars.

T O N Y
WOROBIEC

GHOSTS IN THE WILDERNESS

I first travelled to an area of America between eastern Montana and western Nebraska in the summer of 1996. Whilst this area had previously been called The North Western Desert, because of its unpredictable rainfall, I was nevertheless surprised to see how neglected farms, homesteads and some communities had become. I frequently came upon buildings which had been bowed under the tonnage of the winter snows, but as a photographer, I was initially drawn to the old abandoned cars, preserved by the arid climate, which seemed to litter the fields. But once I appreciated that the buildings were completely abandoned, I began to investigate those as well. It was a sobering experience; the fact that these homes were still filled with furniture, books, clothing and toys prompted me to question why anybody should wish to desert their home and leave so much behind.

After talking to various farmers, I began to understand why abandoned cars were littering the fields; it was a form of self-sufficiency. If a vehicle broke down, these farmers lived too far from town to call for assistance, and would remove workable parts from discarded vehicles in order to keep others on the road. But why were the farms abandoned? Shortly after my return to England, I stumbled upon a publication by the travel writer Jonathon Raban called "Bad Land"; in it, he graphically describes the plight of many of these homesteaders, especially those from south-east Montana. Prior to homesteading, the land had been used for ranching; however throughout the early l900's, various railroad companies decided that they wanted to extend lines through the area, and therefore made the decision to establish communities along the railroad. As land was being offered at minimal cost, they had no difficulties in attracting potential homesteaders, especially from the large cities in the east, and from Europe, whose farmers were experiencing fierce competition from Mid-West America.

Whilst the summers are very hot, and the winters are breathtakingly cold, most of the newcomers set about establishing their farms with admirable zeal, and in the main they deserved to succeed. Initially many enjoyed successful harvests and were encouraged to borrow money in order to mechanise. What they had not bargained on was the unpredictability of the rainfall which can be as little as 15 inches per annum. After a succession of poor harvests and mortgaged beyond their limit, many were declared bankrupt, and so they abandoned their homes and moved west. As this cycle of good years and bad seems to go decade by decade, the farming population gradually thinned out as the century progressed.

One would be mistaken to assume that events such as these affected only a small part of America; in fact similar tragedies seem to have occurred throughout the west, and over the border into Canada. When I enter the wreck that was once someone's home, to peruse books which had formed the bedrock of their culture, examine farming financial sheets, read discarded essays on English literature and touch aged garments as delicate as a spiders web, I still have a passion to travel to and photograph this harsh, yet beautiful, forgotten pocket of America, in order to record as much as I can before the evidence disappears forever.

"Mich fasziniert die North Western Desert, jenes Steppengebiet in Nebraska und Montana, das wegen des trockenen Klimas alte Autowracks und verlassene Farmhäuser geradezu ideal konserviert. Wegen der riesigen Entfernungen zum nächsten Abschleppdienst ließen Farmer, deren Autos unterwegs defekt wurden, diese früher einfach in den Feldern stehen. Noch funktionierende Teile wurden weiterverwendet, der Rest rostet seit Jahrzehnten langsam vor sich hin. Auch die alleinstehenden Farmhäuser, deren Dächer längst durch die tonnenschwere Schneelast des Winters eingedrückt wurden, haben ihre Geschichte. In den Jahren des Eisenbahnbooms haben sich viele Farmer in den billigen Landstrichen angesiedelt, dann eine Reihe guter Ernten eingefahren und sind danach mit viel Kredit weiter expandiert. Doch der Regen kann in diesen Landstrichen oftmals lange ausbleiben, Mißernten führten zum Bankrott vieler Farmer, die anschließend die Gegend extrem heißer Sommer und bitterkalter Winter für immer verließen. Zurück blieb oft nicht nur die Häuser, sondern auch die halbe Einrichtung, ja sogar Kleidungsstücke der ehemaligen Bewohner, die diesen "Geist der Wildnis" ausstrahlen und mich fotografisch begeistern".

Opposite:
ABANDONED FORD, MONTANA
What initially caught my eye were the beautiful tones of the car, set in this dour, and slightly intimidating landscape. Discarded vehicles are an ideal subject for a photographer because of their simple forms and rich textures.
Location, near Red Lodge, Montana. Camera Pentax 67. Lens 45mm. Film; T Max 400.

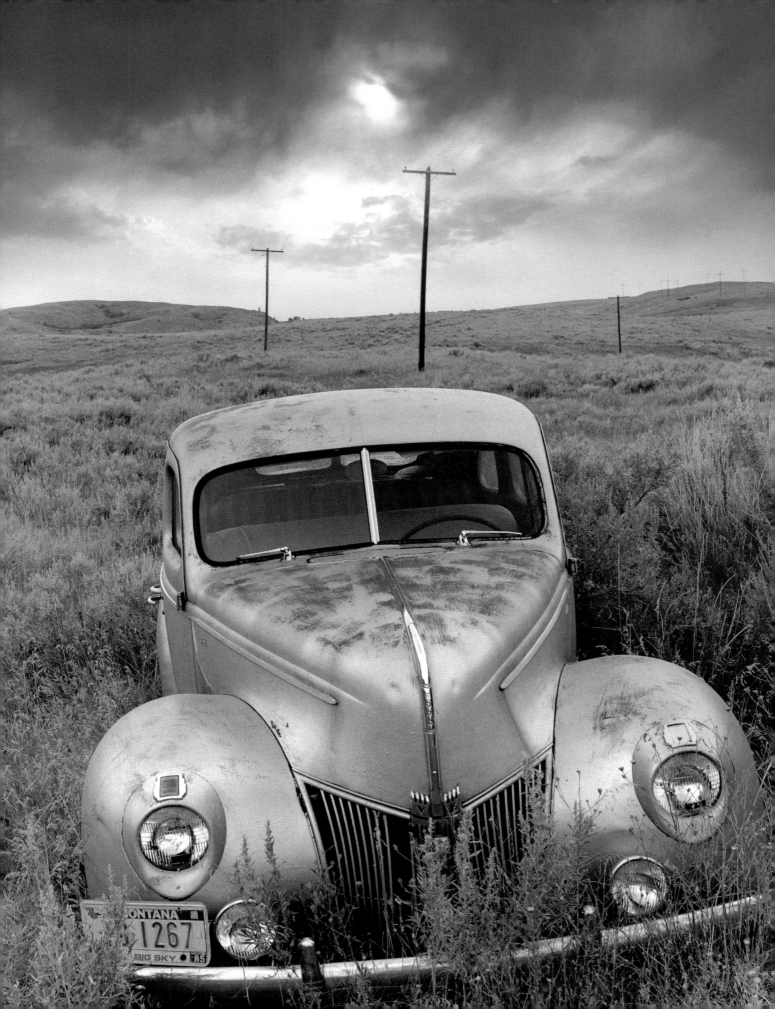

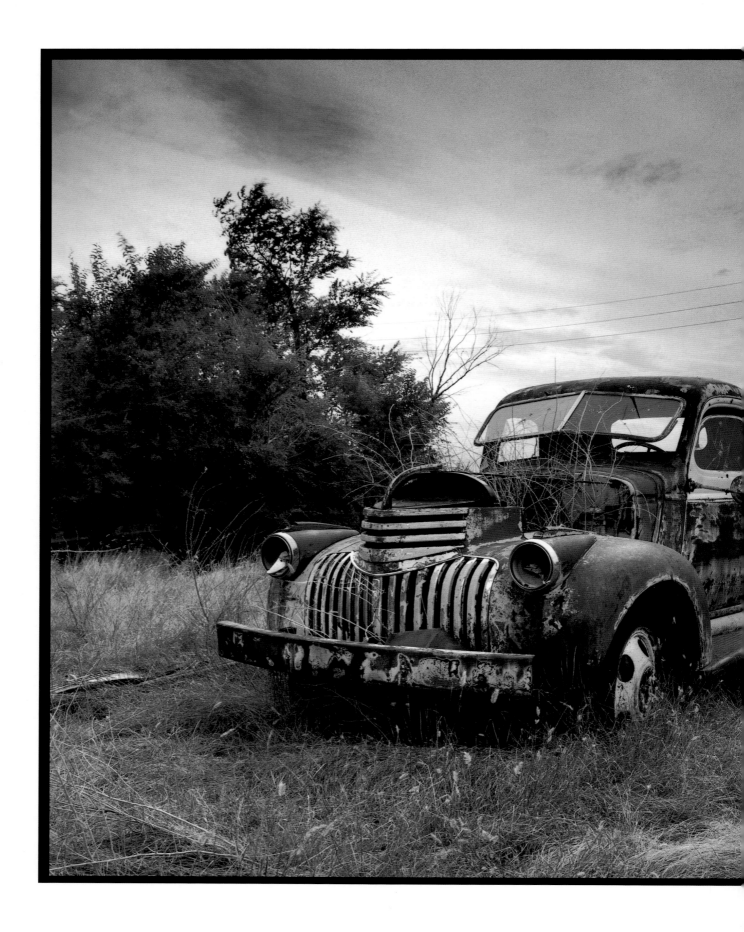

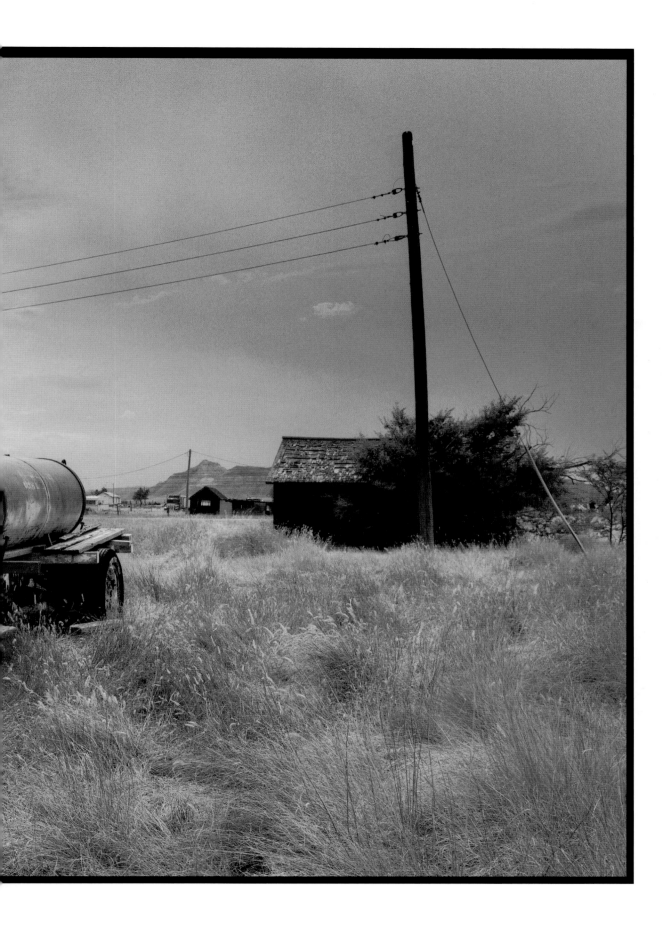

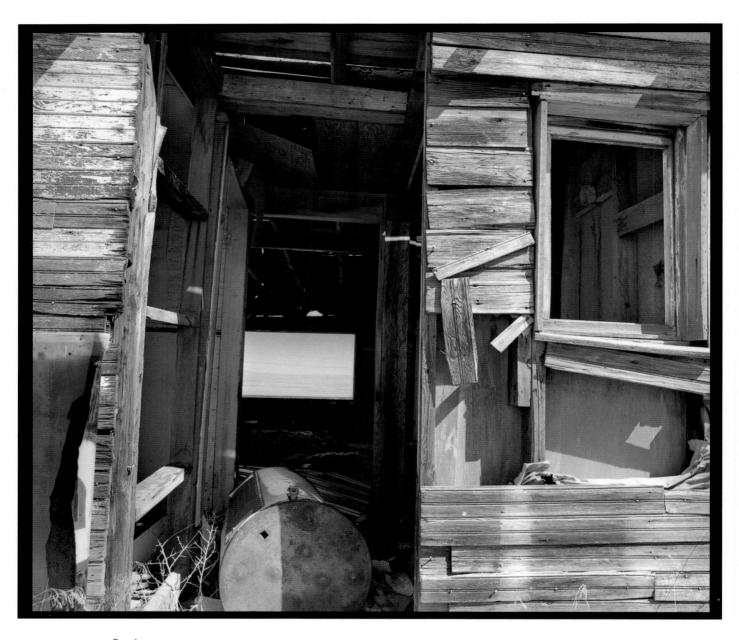

Previous page:

DISCARDED TRUCK, BADLANDS.

I originally photographed this vehicle two years earlier, and was amazed to see that in that time, nothing had changed, which served to emphasise the extent to which this area has been abandoned.

This photograph has been sepia toned and hand-tinted using Kodak E6 dyes, and Marshall photo-oils. Location; Interior, South Dakota. Camera ; Fuji GSW 690, Film Agfapan 25.

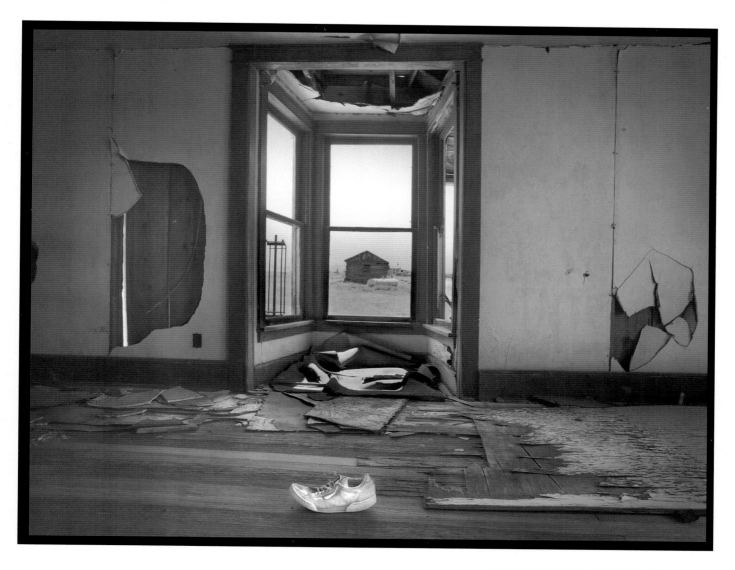

ABANDONED SHOE, CISCO

Wandering through this interior, I looked through the empty window and felt that another element was required to complete the composition. I saw the single shoe to my left, so I moved it into a more central position and took the photograph. By chance, I was passing near Cisco the following year, and decided to visit once more; I located this building, walked in and was astonished to see that the shoe had not been moved in the 12 months that I had been away.

This photograph has been sepia toned and hand-tinted. Location; Cisco, Utah. Camera; Pentax 67, Lens 45mm, Film Agfapan 25.

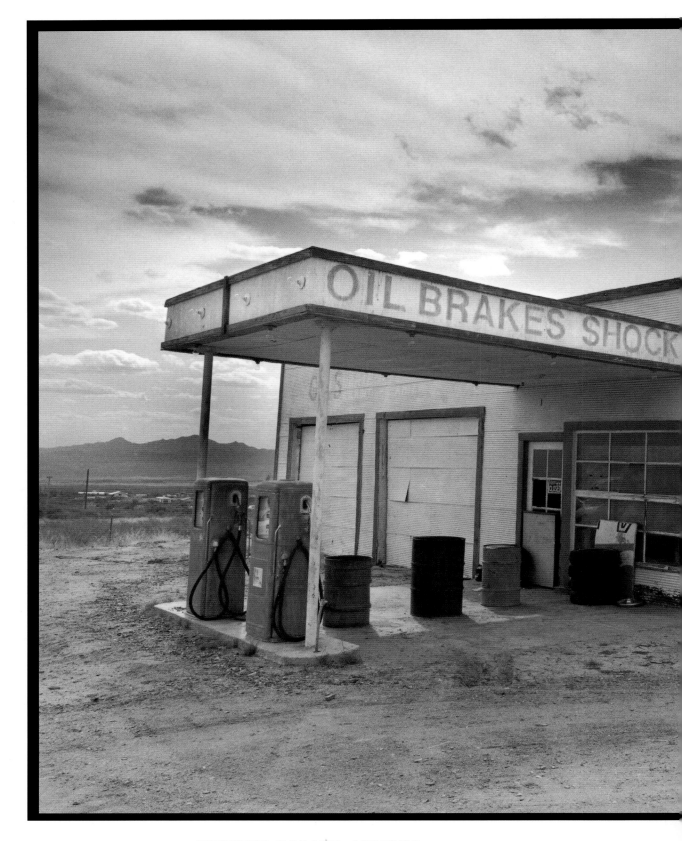

DESERTED GARAGE, ARIZONA

This is a garage I stopped at with the serious intention of filling up; it was 20 seconds or more before I realised that it had been abandoned. It made me appreciate that America, is an extremely mobile society. Communities are not as established as we are used to seeing in Europe, and if there are economic reasons for going, populations up and leave, to establish new lives elsewhere.

Location, near Wickenburg, Arizona. Camera; Pentax 67. Lens 45mm. Film T. Max 400.

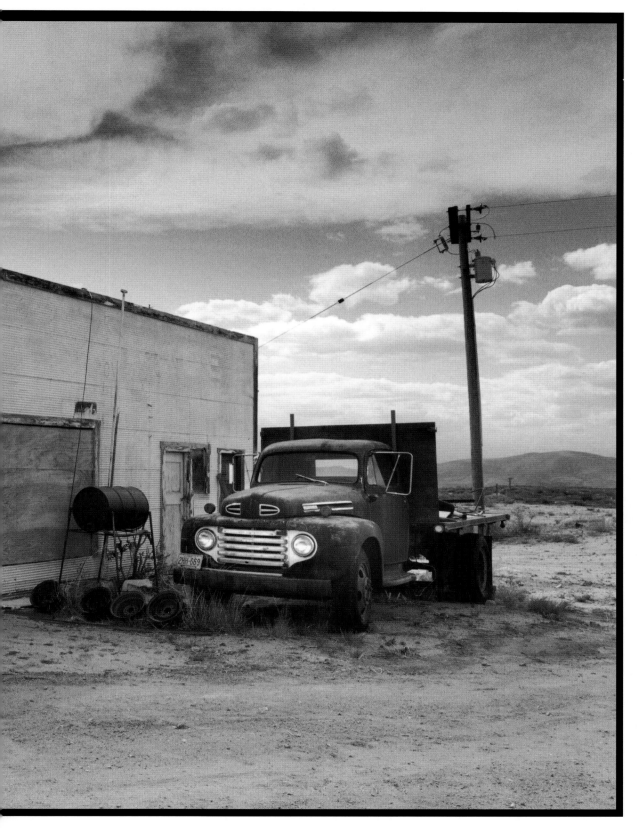

Next page:

ABANDONED CHEVVY, NORTH DAKOTA

This is a typical scene in so many of the hard-core homesteading areas of this part of America. Farmers would keep old vehicles in their fields, so if they experienced a breakdown, they were able to salvage the workable parts. When they finally deserted their farms, their old cars remained as a visual legacy of the past.

This photograph has been sepia toned and hand tinted.
Location; Belfield, North Dakota. Camera; Pentax 67, Lens, 45mm, Film, T Max 400.

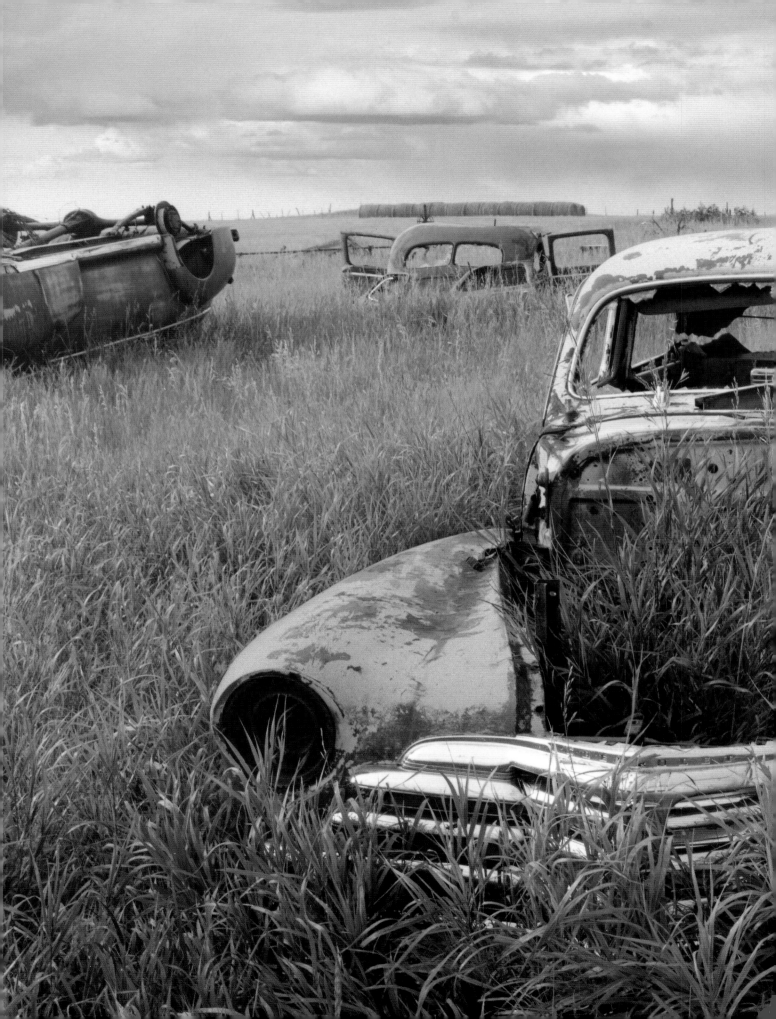

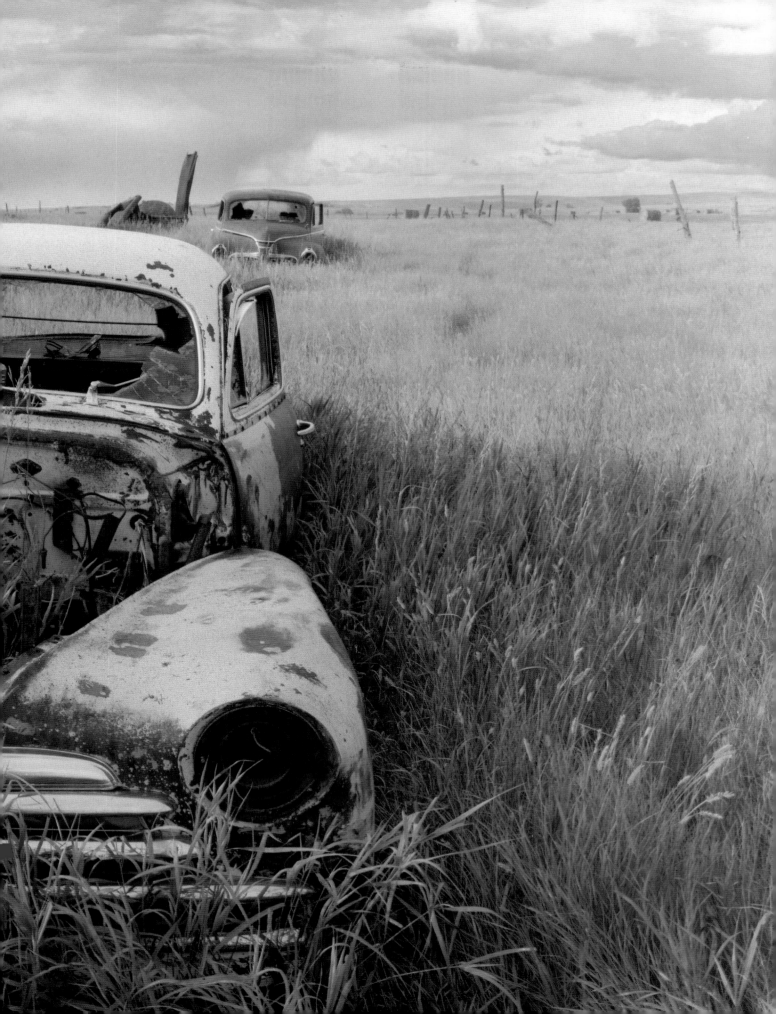

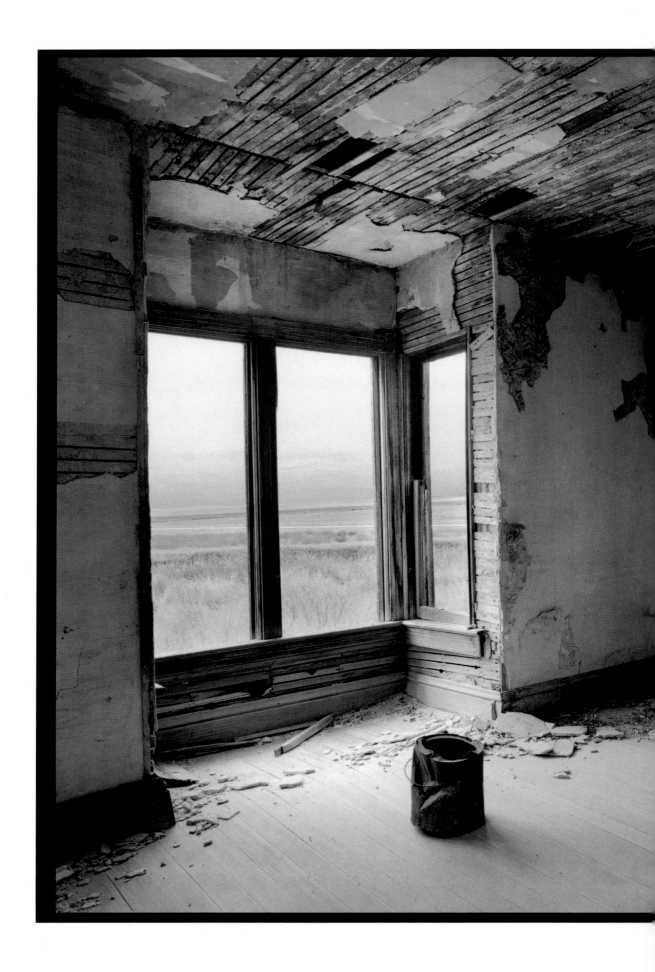

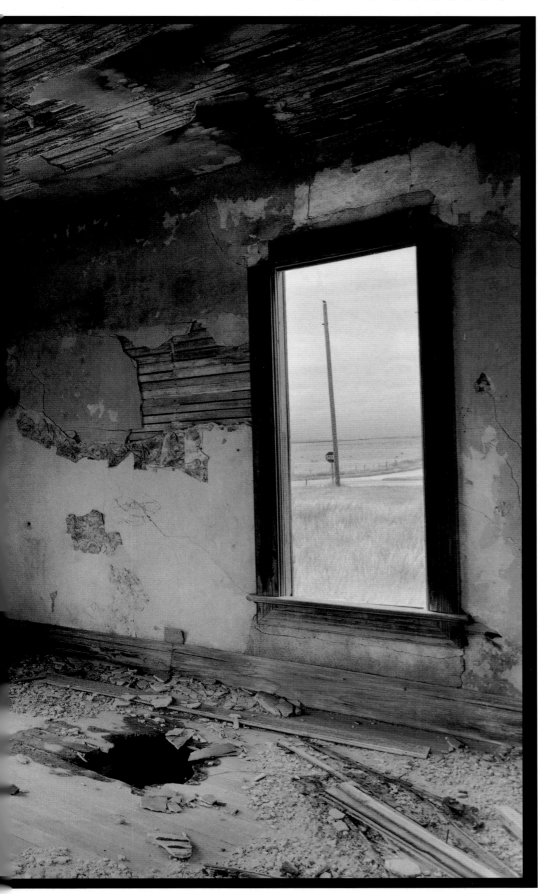

ABANDONED FARM WITH HOLE IN THE FLOOR

It was quite a sobering experience entering some of these abandoned farms, as evidence of the past, books, photographs, financial records were often strewn across the floor. It was easy to imagine the kind of lives the inhabitants had led. What was particularly eerie was the featureless landscape outside.

Location; Western Nebraska. Camera; Pentax 67. Lens 45mm, Film, T Max 400.

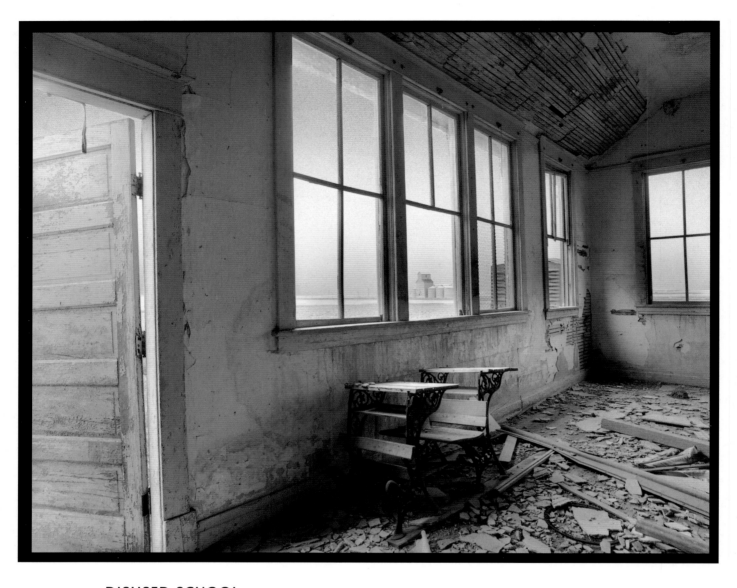

DISUSED SCHOOL

The school played an important part of the homesteaders lives; it was not just a place where their children were educated, but it also served as a focal point for the community. As the population drifted away, countless schools, especially on the short grass prairies were abandoned.

Location, near Marmarth, North Dakota. Camera, Pentax 67. Lens 45mm, Film T Max 400.

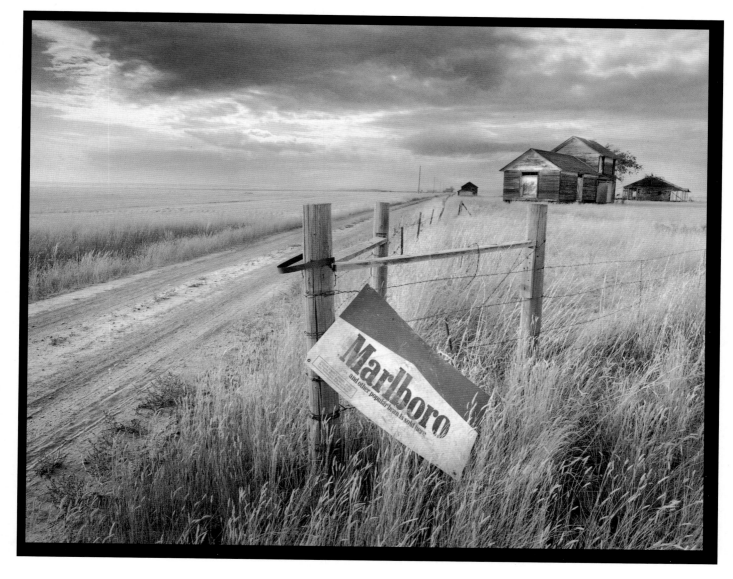

MARLBORO COUNTRY

We are all no doubt aware of an extended advertising campaign on behalf of Marlboro cigarettes which celebrates the American good life. This image serves as a parody, reminding us that where there is success, there is also likely to be failure.

Location, Box Elder, Montana. Camera Pentax 67, Lens 45mm, Film T Max 400.

Next page:

ABANDONED FARM, NORTH DAKOTA

This image precisely encapsulates "Ghosts in the Wilderness"; the car is preserved by the dry and arid climate, but in the background, the farm buildings are rapidly falling into disrepair. However in the distance there are bales of hay indicating that, as each farm is deserted, it is subsumed into the land of the successful farmers, who benefit from someone else's failure.

Location, Belfield, North Dakota. Camera, Pentax 67, Lens 45mm, Film T Max 400.

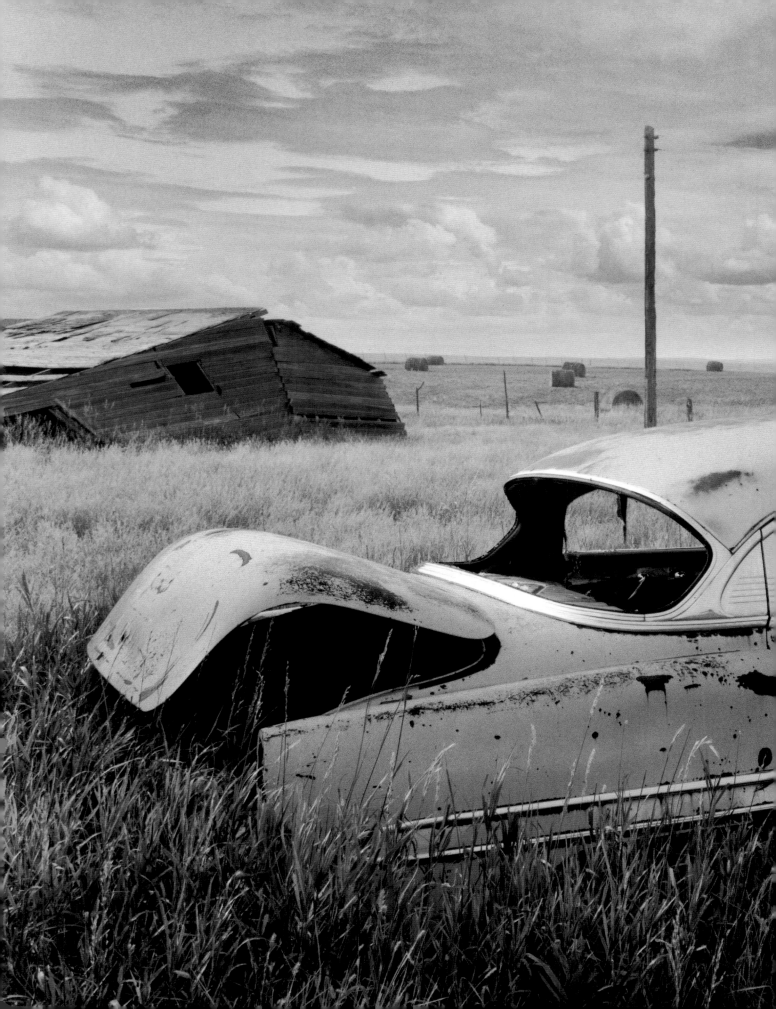

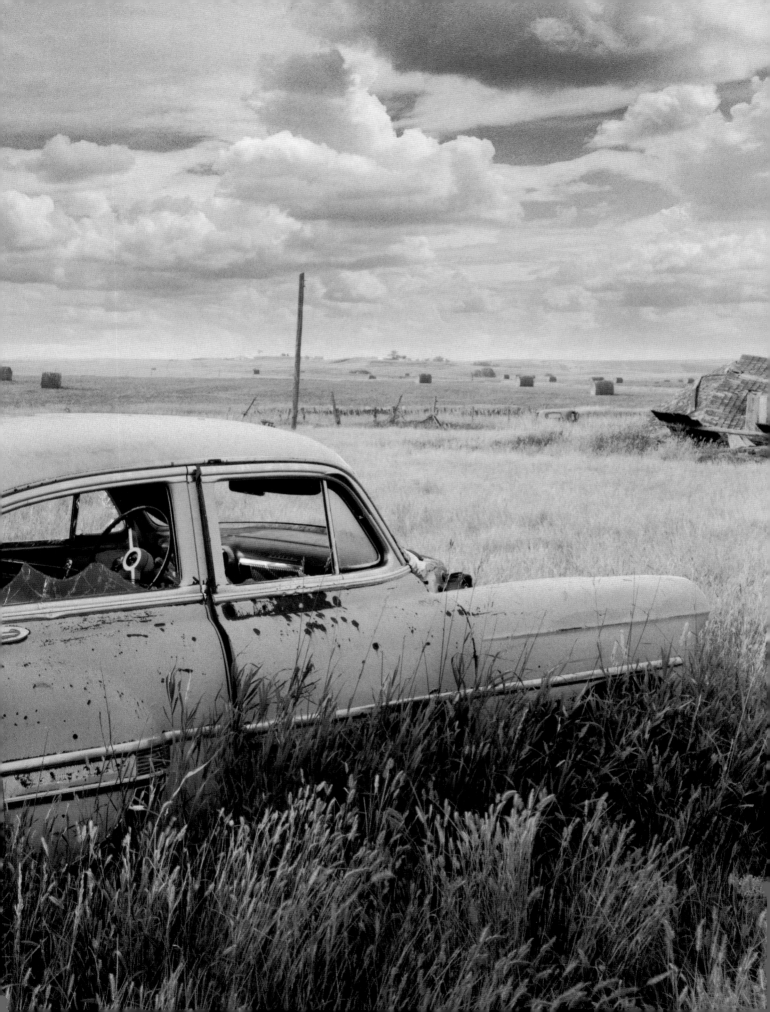

CONSTANTINOS
Petrinos
JEWELS OF THE SEA

Constantinos is a 37 year old professional underwater photographer who lives in Athens. While growing up he aspired to become a marine biologist but more practical considerations led him to an MBA degree in the US. Ten years ago, he started scuba diving eventually becoming a PADI Master Instructor and an avid underwater photographer. However, it was a course with his good friend Cathy Church that really made the difference for Constantinos. Cathy helped him sharpen his skills and move ahead in underwater photography.

Constantinos is currently the leading Greek underwater photographer and his photos and articles have been widely published. In 1996, following the opportunities that emerged as a result of his highly commended award in the BBC Wildlife Photographer of the Year Competition, he decided to make the "big step" and become a full-time professional. In 1997, his pygmy seahorse picture won the second prize in the World Festival of Underwater Pictures at Antibes. Various other distinctions followed, such as the Martin Withers Award from the Royal Photographic Society and the third prize in the PADI competition The Living Reef 1998.

Constantinos has dived in many parts of the world. Most of the pictures in this portfolio are from the Lembeh Straits which are located in North Sulawesi, Indonesia. All pictures were taken using a Nikon F4 camera in a Subal Pro Housing with two Nikon SB-105 strobes. While on the field, Constantinos relies on the invaluable support of Colin Doeg and Steve Warren from Ocean Optics, London. Constantinos plans his trips at least six months in advance. He studies the behaviour of his subjects and makes a "hit list" of what he would like to shoot. This does not mean that "everything goes" once the fish is found. Constantinos will not take a prized shot if this will involve disruption of the environment or of the creature in question. On location he works closely with the local dive guides and of course with Alkistis, his dive buddy and spotter.

He frequently conducts slide shows in Greek schools and museums to generate among children a strong awareness regarding the underwater world and nature. Three children's books are planned for the near future.

Constantinos is a frequent guest speaker at the Visions in the Sea Underwater Photography Conference in London and an Associate of the Royal Photographic Society.

Der 37-jährige Grieche Constantinos Petrinos lebt in Athen und hat sein Leben der Unterwasserfotografie gewidmet. Seiner Freundin Cathy Church verdankt er seine ausgefeilte Technik und sein Können im Unterwasserbereich. Zahlreiche Erfolge beim BBC Wildlife Wettbewerb oder beim Unterwasserfestival in Antibes ließen ihn den großen Schritt zum Vollprofi wagen. Heute taucht Petrinos in allen 7 Weltmeeren, die Bilder dieses Portfolios entstanden hauptsächlich in den Gewässern vor Indonesien. Er plant seine Trips exakt und versucht dann die ihm vorschwebenden Motivbereiche zu realisieren. Gerne nimmt er die Unterstützung lokaler Tauchspezialisten in Anspruch, immer mit dabei ist sein Assistent Alkistis. "Nie würde ich für ein gutes Bild die Unterwasserumwelt oder das Verhalten einer Art gefährden" sagt Petrinos, der in griechischen Schulen und Museen mit Diavorträgen eine Lanze für den Schutz der einmaligen Unterwasserwelt bricht.

Orange Anthias

This shoal of orange female anthias (Pseudanthias squammipinnis) with two larger purplish males was photographed in the Somo-Somo Straits, Fiji. Anthias live in harems with a dominant male. When the male dies, the largest female changes her sex and replaces the deceased as a fully functioning male. 'Highly Commended', BBC Wildlife Photographer of the Year 1996.

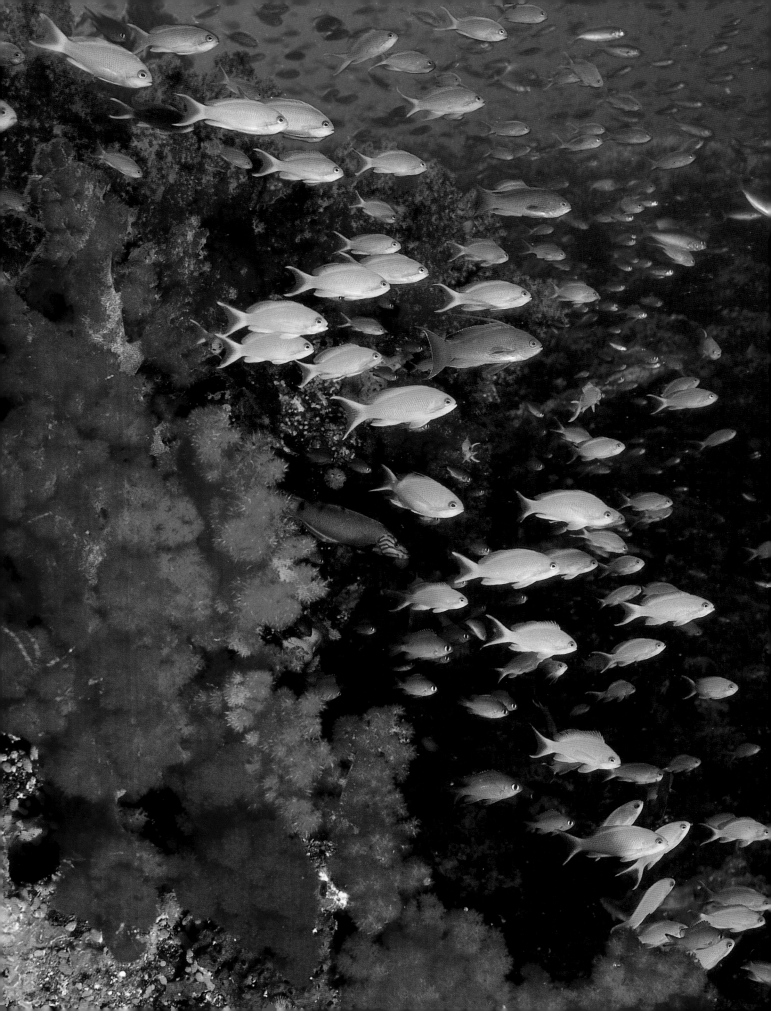

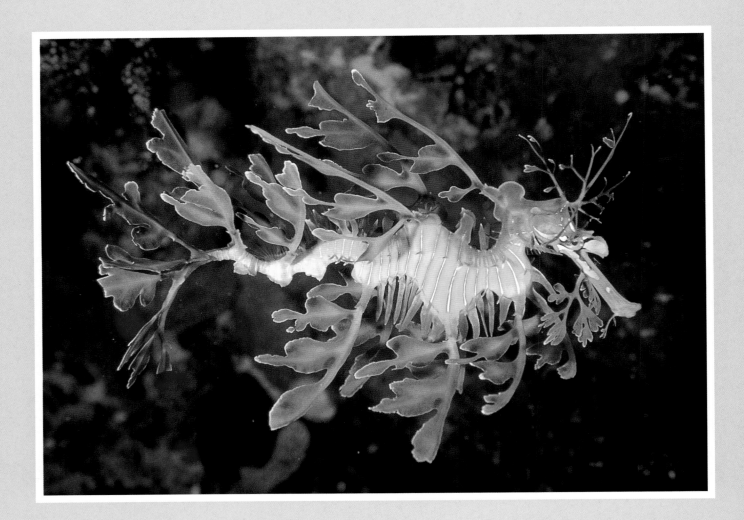

As far as camera equipment is concerned, I use a Subal Pro Housing with a Nikon F4 camera. The macro pictures in this portfolio were taken using Nikon's AF 105mm f/2.8 D Micro lens. When photographing particularly small subjects, I sometimes use a +1 or even a +2 diopter close-up lens. For the 1cm long! pygmy seahorse I had to use a +3 diopter. Occasionally, I use the bulkier and heavier 200mm f/4 D Micro lens when I need to photograph a particularly shy subject that will not allow me to get within the 105's range. The 200mm lens doubles the working distance and so allows me to get a similar picture to that with a 105mm while being positioned twice as far from the subject. For wide angle I work between the 18mm and the 35mm lens and I use a Sekonic Marine Meter to measure ambient light. Although I use Nikon SB-105 strobes, I would gladly switch to land guns (Nikon SB-25 or 26) in Subal strobe cases (SC or SN26) to take advantage of true matrix metering. I always use two strobes which are mounted on Ultralight modular arms. This enables me to reposition my strobes and light a subject from different angles. As far as focusing is concerned I always work in auto focus.

Leafy Sea Dragon

The Leafy Sea Dragon (Phycodurus eques) is unique to the south coast of Australia and is undoubtedly spectacular. Despite its relatively big size (approx. 25 cm), its resemblance to the kelp amongst which it lives is such that it is practically impossible to distinguish from its surroundings. Males lack the typical seahorse brood pouch. Instead, they carry the eggs on the underside of their tail. Locals at Kangaroo island, where these pictures were taken, estimate that a Leafy Sea Dragon sells for US $10.000 in the illegal aquarium trade despite the fact that leafy sea dragons do not survive in aquarium conditions. In general, seahorses are in decline due to their popularity in aquariums, souvenirs and especially in traditional Chinese medicine as aphrodisiacs. According to biologist Amanda Vincent, Thailand, Vietnam, the Philippines and other countries now export more than 20 million seahorses per year.

Location: Kangaroo island, South Australia

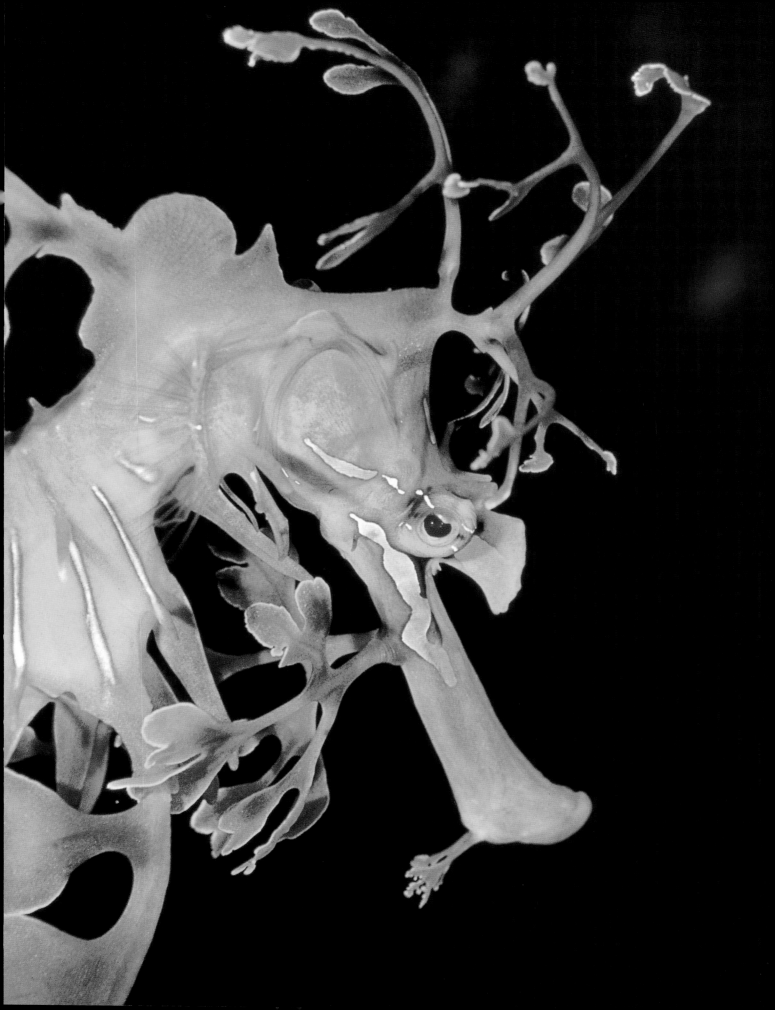

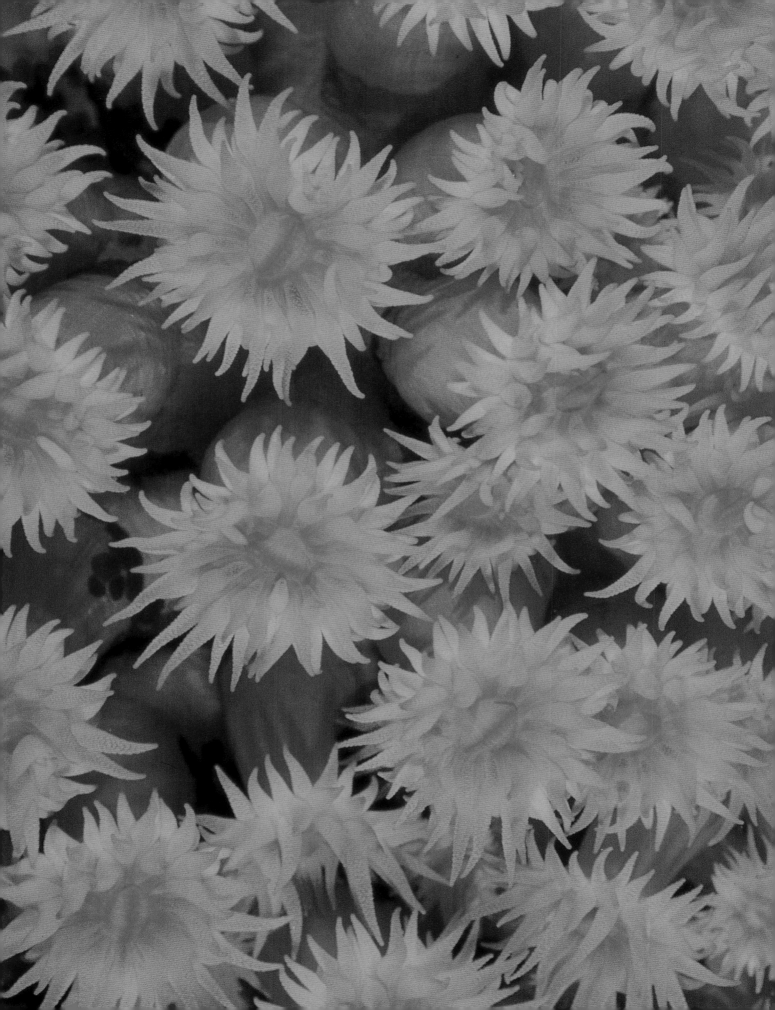

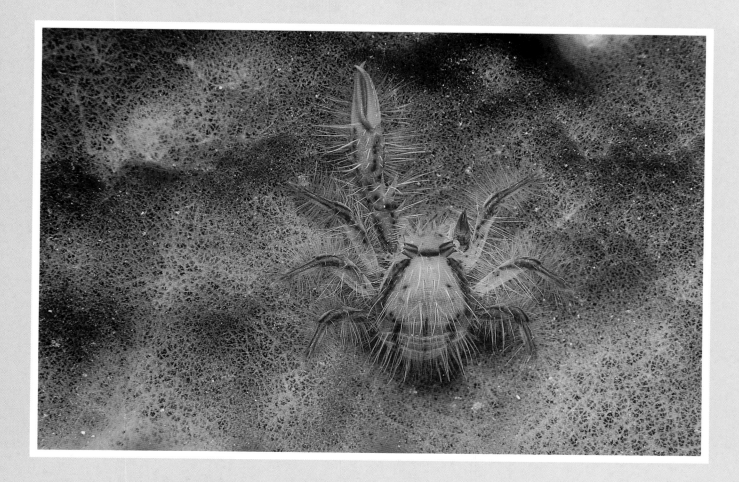

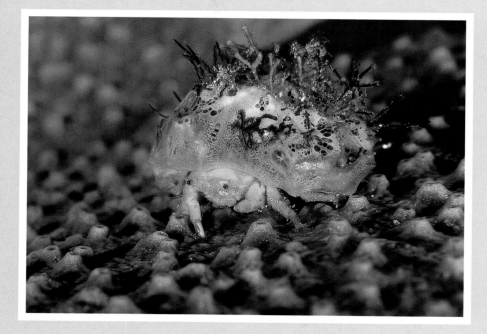

Above:

Squat Lobster

Barrel sponges (Xestospongia testudinaria) can attain over a meter in height. Divers are impressed by the size of these sponges and usually pass them as if they were dead rock. However, the cavities of barrel sponges are a safe haven for a number of creatures, including the squat lobster (Lauriea siagiani). With his hair, he is able to detect changes in water movement and thus disappear into a sponge cavity at the approach of a predator, whether it is a fish or a photographer.

Location: Sulawesi, Indonesia.

Left:

Decorator Crab

Decorator crabs are simply fun to watch. They come out in the open at night and are very skittish when confronted with powerful dive lights. I use relatively weak dive lights so as not to scare them away.

Location: Sulawesi, Indonesia.

Opposite:

Orange Cup Corals

A common sight of the coral reef, orange cup corals (Tubastrea sp.) are commonly seen under ledges.

Location: Sulawesi, Indonesia

45

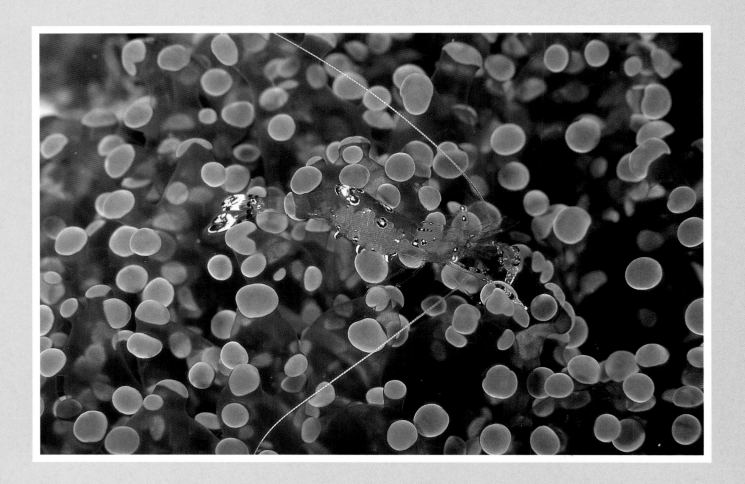

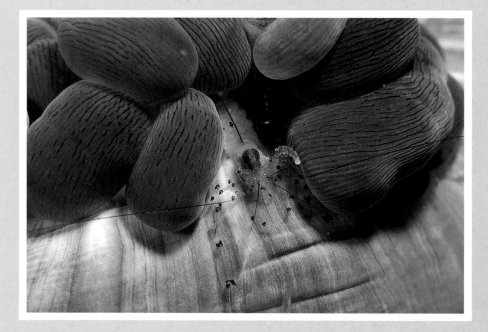

Above and left:

Anemone and shrimp

Divers usually associate anemones with clownfish. Without them an anemone seems devoid of life. A closer look however, often reveals a commensal shrimp living in the protection of the anemone´s stinging tentacles.

**Location: Sulawesi, Indonesia (above)
Solomon Islands (left)**

Right:

Imperial Shrimp & Tiny Crab on sea cucumber

The imperial shrimp (Periclimenes imperator) is found on several hosts, including the nudibranch Hexabranchus, the sea cucumbers Stichopus, Bohadschia and Synapta, and the sea star Gomophia. I liked the composition with the tiny crab and the skin of the sea cucumber.

Location: Sulawesi, Indonesia

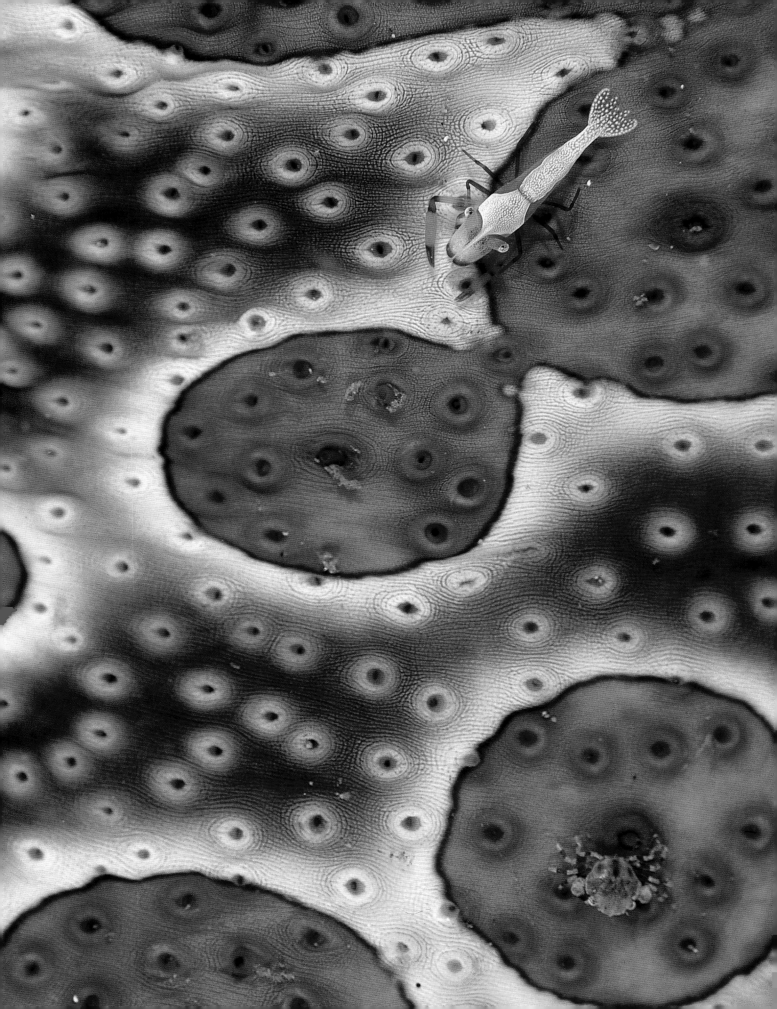

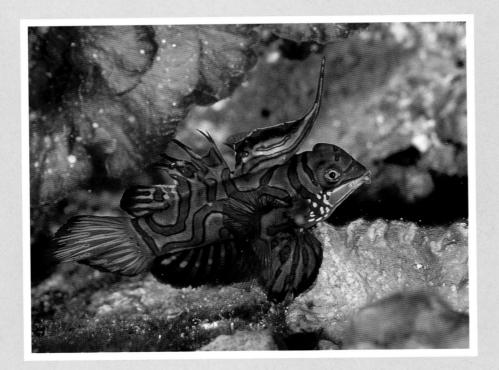

Mandarin Fish Fighting (right)

Mandarin Fish in Threat display
(left)

On land it is 'common' to watch animal aggression. In comparison, aggression in the underwater world takes place very fast and divers hardly notice it. Given its secretive lifestyle, divers rarely see, if ever, a mandarin fish (Synchiropus splendidus). I was observing mandarin fish for several days when I saw a male mandarin fish in full display. Notice the spine on the front of the operculum which is fully extended to intimidate its opponent. Seconds later he attacked another male nearby biting at the neck. Such fights can result in death. However, a split second after I could position myself for a shot, the loser managed to escape and fled. This is probably the first photograph to document this behaviour.

Location: Sulawesi, Indonesia

Right:

Ribbon Eel

The ribbon eel (Rhinomuraena quaesita) is a fascinating species of moray eel that may change sex and colour three times in its lifetime. There is a black, a blue and a yellow phase which correspond to a juvenile, a male and a female ribbon eel respectively. The ribbon eel in the picture has lost the bright blue colour of the male phase and the transformation to the female phase is still in process. Although I have pictures of them in all three phases, I like this photograph best because it was taken between two phases.

Location: Sulawesi, Indonesia

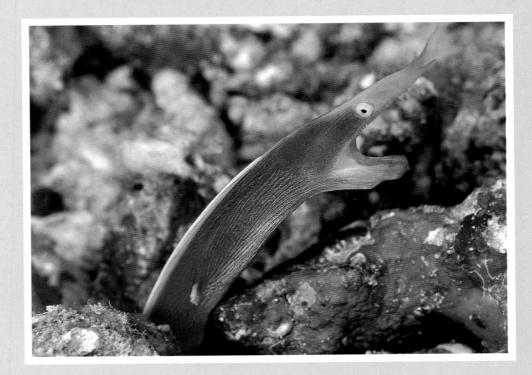

48

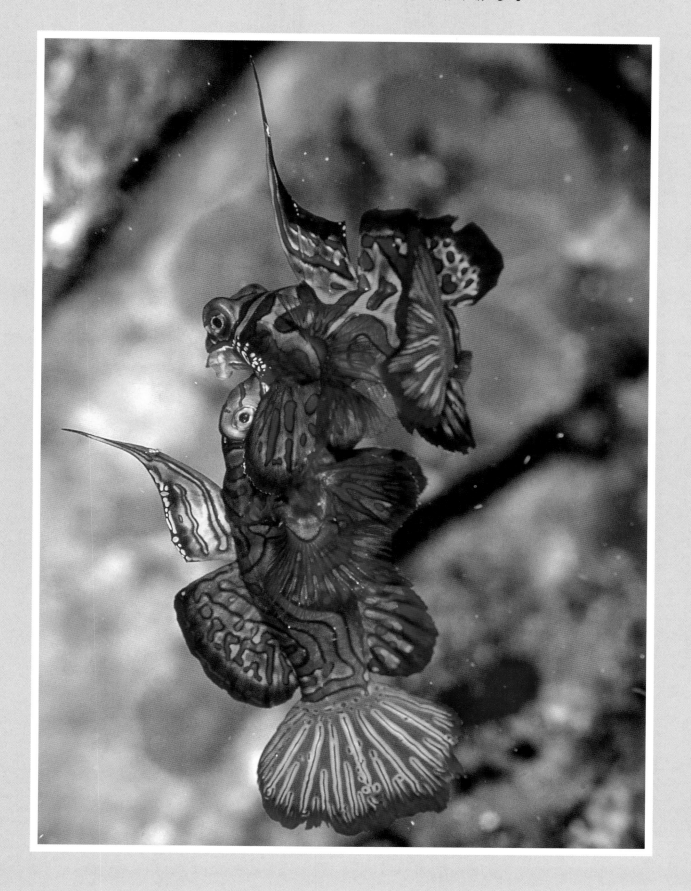

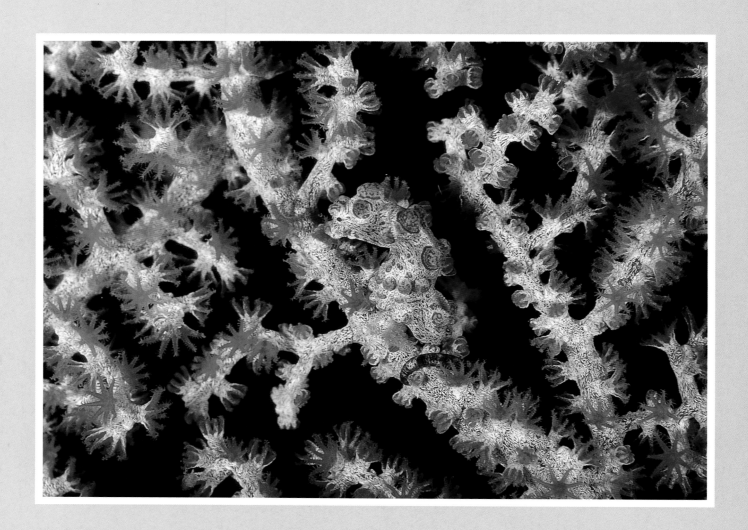

Pygmy Seahorse

The tiny 1cm-long Pygmy Seahorse (Hippocampus bargibanti) is probably among nature's best examples of camouflage. It lives on a particular species of Gorgonian sea fan, Muricella sp. Its skin matches completely the colour of the sea fan it even has pink tubercles to match the sea fan's polyps. Second prize, World Festival of Underwater Pictures, Antibes.

Location: Sulawesi, Indonesia

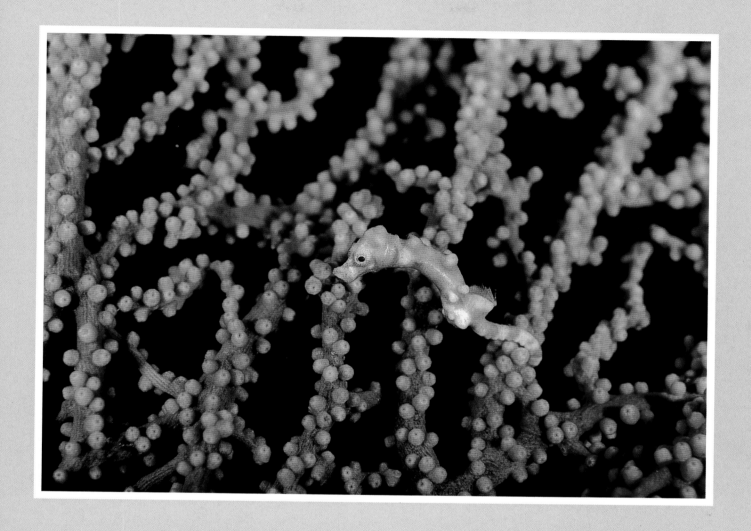

A Tiny Seahorse

If camouflage makes the sizeable Leafy Sea Dragon invisible, try distinguishing this extremely small (approx. 1cm) yellow seahorse, possibly Hippocampus minotaur. Larry Smith, the dive manager of Kungkungan Bay Resort in Indonesia, showed it to me and I had to arrange several dives to photograph it using the 105 mm lens and a +3 diopter.

Location: Sulawesi, Indonesia

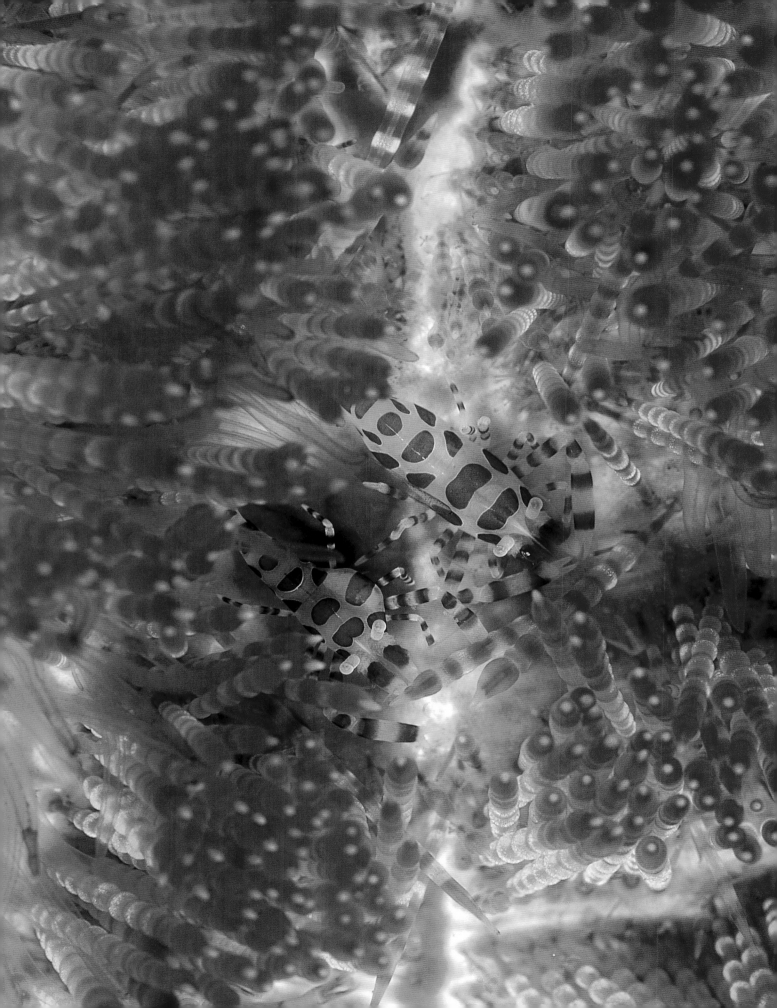

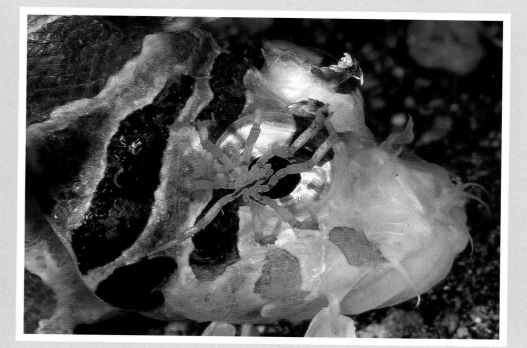

Right:

Lionfish and Sea spider

During a night dive I noticed a Zebra dwarflionfish (Dendrochirus zebra). When I moved closer to take its portrait, I noticed a sea spider walking on its body. I had never seen a sea spider on a fish before. Eventually, the sea spider moved over the lionfish eye and thus gave me the opportunity for an unusual lionfish portrait. Patience is a virtue in underwater photography but you also need a little bit of luck.

Location: Sulawesi, Indonesia

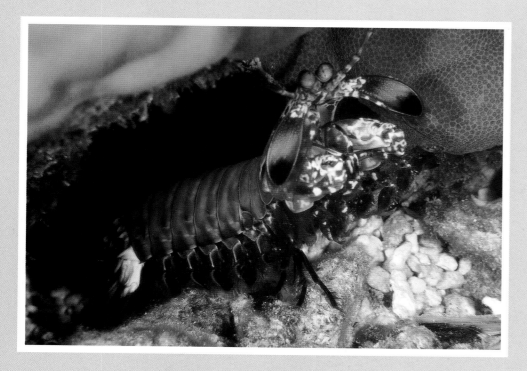

Left:

Mantis Shrimp

The mantis shrimp (Odontodactylus scyllarus) ressembles a preying mantis. Its large spiked raptorial claws can strike with formidable power, enough to pierce two centimeters of wood or break your camera housing or smash your fingers.

Location: Solomon Islands

Opposite:

Coleman´s Shrimp Pair on Toxic Sea Urchin

The underwater world has numerous examples of symbiotic relationships. The Coleman's Shrimp (Periclimenes colemani) is found exclusively on the venomous sea urchin (Asthenosoma varium), also known as Fire Urchin or Toxic Sea Urchin. The sea urchin's toxin is dangerous to humans. However, the shrimp seems perfectly happy in this poisonous world. It occupies a patch which it has cleared of tube feet and spines. Moreover, it is able to move amongst the spines and pedicellariae without being harmed.
The female Coleman´s shrimp is significantly larger than the male.

Location: Sulawesi, Indonesia

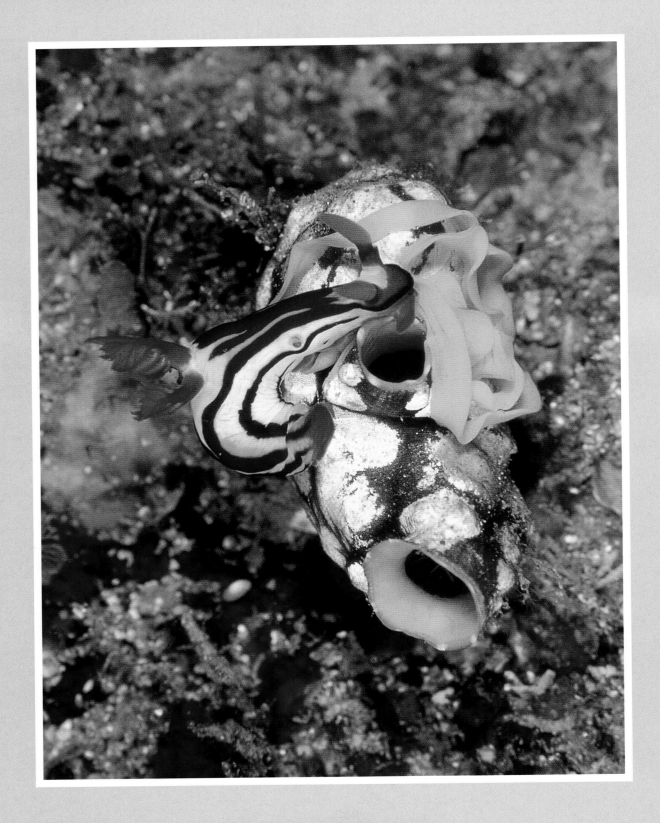

Nudibranch laying eggs on ascidian (above)
Mating Nudibranchs (right)

With my dive buddy, we arranged a special dive in the Lembeh Straits, Indonesia hoping to see the uncommon nudibranch Nembrotha purpureolineata. However, when we started the dive, our hopes disappeared when we saw the tremendous current. Fortunately, the dive manager of Kungkungan Bay Resort, Larry Smith, led us expertly in one of the strongest currents I ever dove. We were rewarded since next to a mating pair we found another nudibranch laying its eggs on an ascidian.

Location: Sulawesi, Indonesia

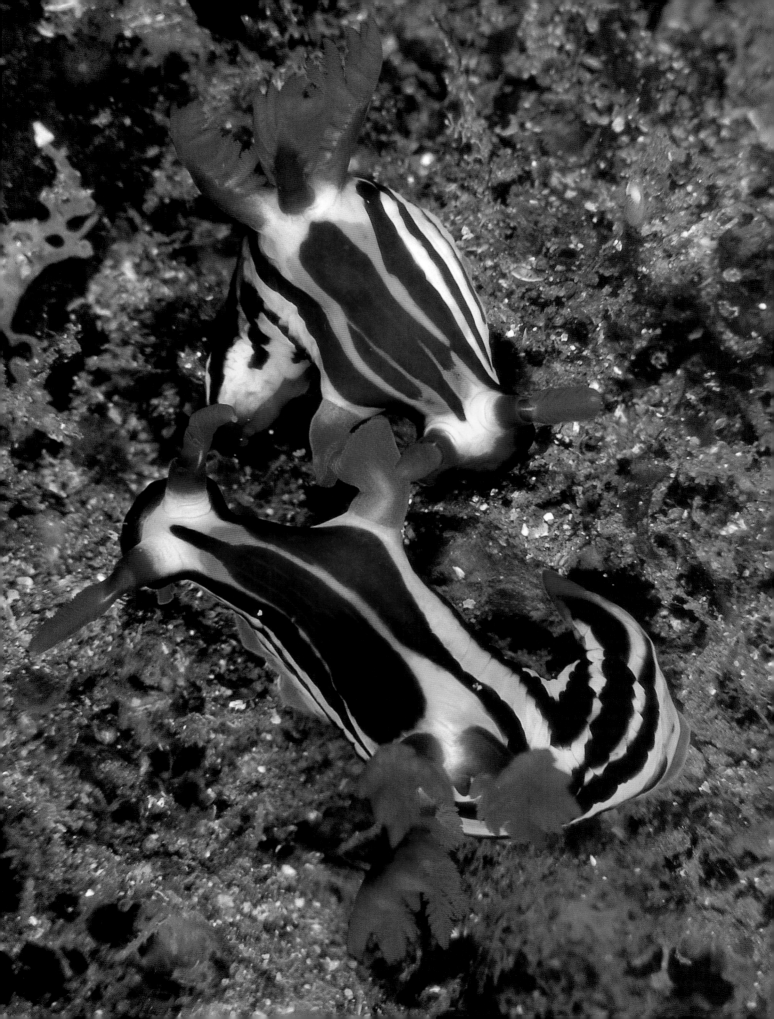

Theresa
Airey
IMPRESSIONS

The photographic images of Theresa Airey combine the traditional visual elements of the photograph with the creative power of methods and materials associated with painting and drawing as well as the conventional photographic darkroom. Thus, for Airey, the click of the camera's shutter is just the beginning of a creative process that may include one or more of the following; application of liquid emulsions on various surfaces, pre- and post-manipulation of Polaroid materials, selective bleaching and toning, hand colouring, the transfer of images to different surfaces and the use of Infrared film. The result is an image that extends the ability of photography to capture a moment of light and time into something that also speaks strongly of mood, atmosphere, and emotion.

Theresa Airey's works are in permanent collections as the Pretenkabinet of the Rijkuniversiteit in Leiden, Holland, the Polaroid Collection in Boston, Massachusetts, and private collections such as that of Hillary Clinton, wife of the President of the United States. Airey holds a Masters Degree in Fine Art and teaches at the Maryland Institute, College of Art. She gives frequent workshops on her techniques at professional photographic shows and institutes including the Ansel Adams Workshop in Yosemite, California. Airey's recent book, 'Creative Photo Printmaking' (Amphoto: New York), describes many of her methods and has been praised widely for its emphasis on creativity. A consultant to the Polaroid Corporation, Theresa Airey's fine art photographs have been used commercially in advertisements, stage productions, posters, and calendars.

Die Fotografien von Theresa Airey kombinieren traditionelle Elemente mit kreativen Methoden und Materialien, die man mit Malerei und Zeichnung ebenso in Verbindung setzen kann, wie mit konventioneller Dunkelkammerarbeit. Folglich ist für Airey das Klicken des Kameraverschlusses nur der Beginn eines Kreativprozesses, der eine oder mehrere der folgenden Methoden beinhaltet: Manipulationen an flüssigen Emulsionen auf verschiedenartigen Oberflächen, Vor- und Nachbehandlung von Polaroid-Materialien, selektives Bleichen und Tonen, Handcolorierung, Transfer von Fotos auf verschiedene Bildträger und die Verwendung von Infrarot-Filmen.

Das Resultat sind Werke, welche die Fähigkeit der Fotografie demonstrieren, einen Moment aus Licht und Zeit einzufangen und auf uns, die Betrachter, als Stimmung, Atmosphäre und Gefühl zu übertragen.

Theresa Airey's Arbeiten werden in öffentlichen Sammlungen, wie dem Pretenkabinet der Rijkuniversiteit in Leiden, Holland, der Polaroid Collection in Boston und privaten Sammlungen, wie jener von Hillary Clinton aufbewahrt. Airey ist Magister der Kunstgeschichte und unterrichtet am Maryland Institute in den Vereinigten Staaten. Sie veranstaltet häufig Seminare über ihre Sondertechniken, so etwa beim Ansel Adams Workshop in Yosemite. Airey's neues Buch "Creative Photo Printmaking" (Amphoto: New York) beschreibt viele ihrer Methoden und wurde für seine Betonung auf dem kreativen Teil der Fotografie mit breiter Zustimmung der Kritiker ausgezeichnet. Als Konsulent für die Firma Polaroid wurden Theresa Airey's Fotokunstwerke bereits in verschiedenen Inseraten, Postern, Kalendern und Werbeproduktionen verwendet.

Opposite:
CONFRONTATION
11" x 14" silver gelatin print. Original printed on Afga Portriga Rapid #117. Copper Split accomplished with Berg Brown/Copper Toner. Taken with Kodak Tri-X film. This is a digital print made from slide of the original. These are one of a kind.

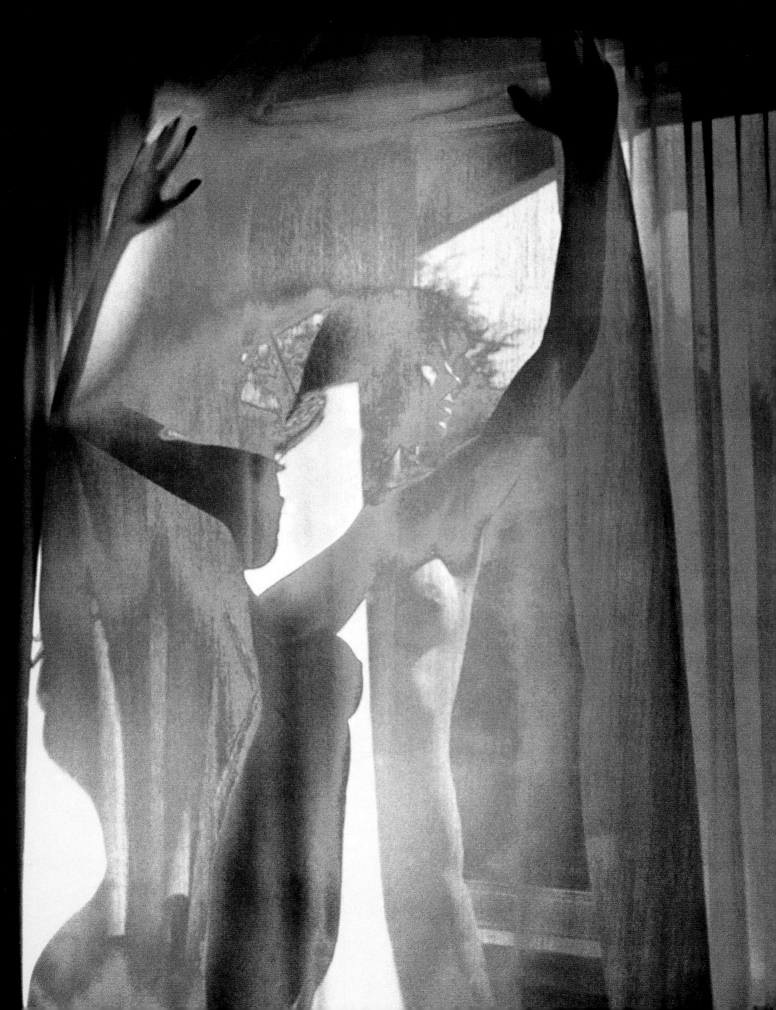

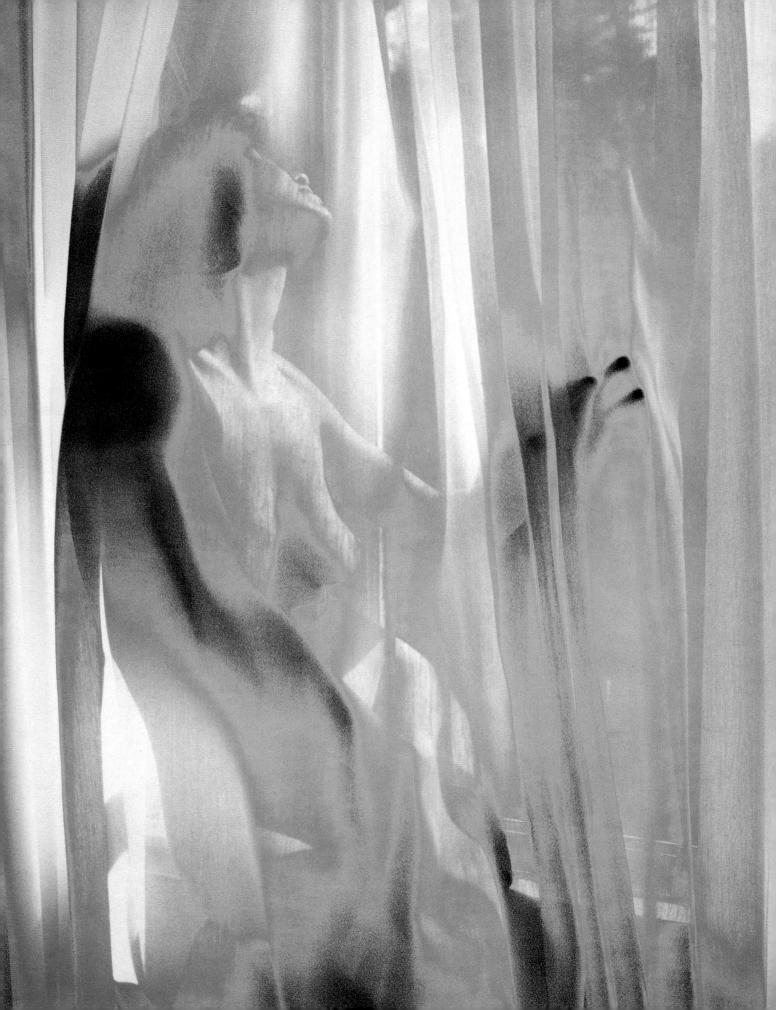

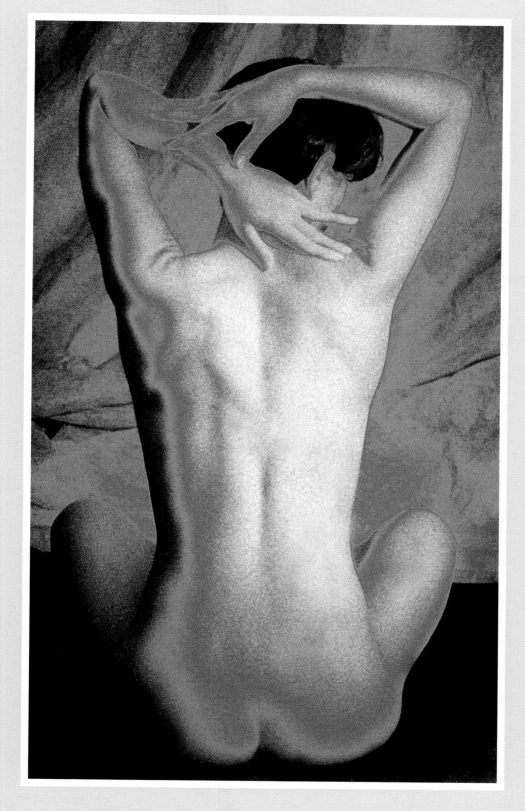

Opposite:
MELANCHOLY
11″ x 14″ silver gelatin print. Printed
on Agfa Portriga Rapid #118. Copper
Split with Berg Brown/Copper toner.
Taken with Kodak Tri-X film.

Above:
FEMININITY #1
8″ x 10″ digital print. Printed on
watercolour paper on an Epson Stylus
Color 600 desktop printer.

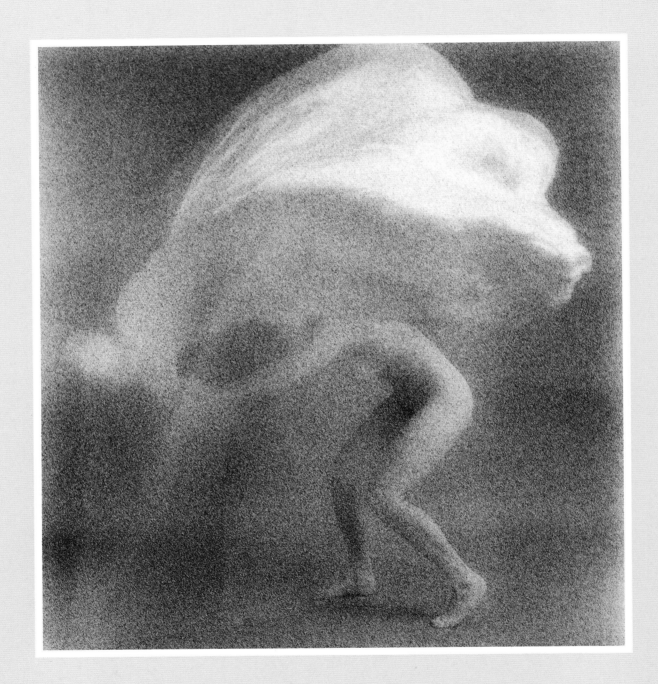

Above:

B.J. DANCING WITH CLOTH #1

11" x 14" silver gelatin print. Printed on Ilford matt surface Multigrade paper. Slightly hand coloured with Conté pastel pencils. Taken with Kodak infrared film.

Opposite:

B.J. DANCING WITH CLOTH #2

11" X 14" silver gelatin print. Printed on Ilford Matt surface Multigrade paper. Slightly hand coloured with Conté pastel pencils. Taken with Kodak infrared film.

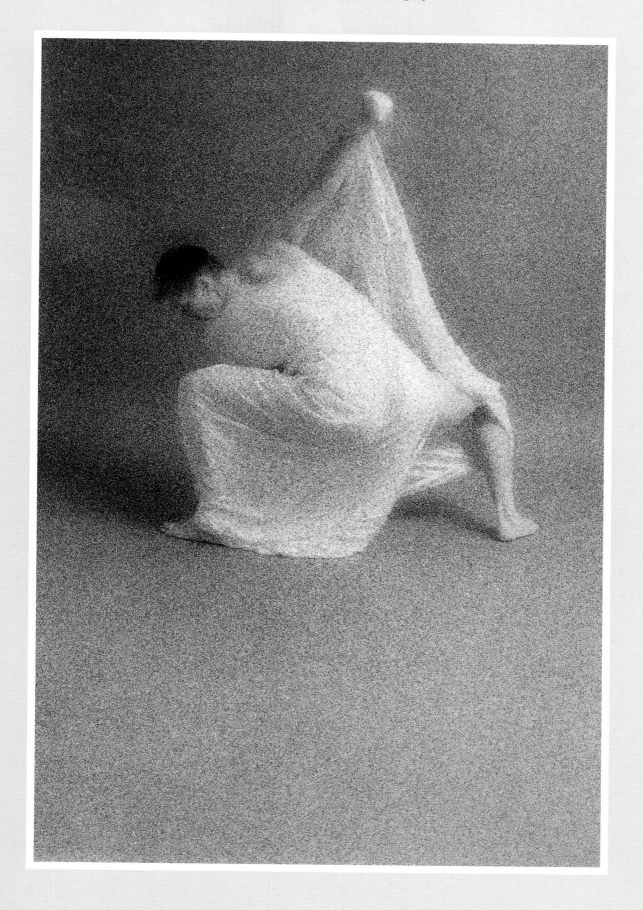

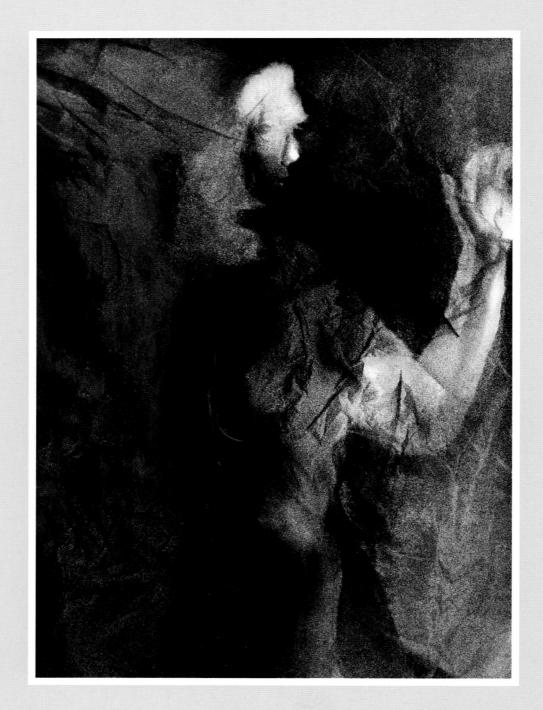

Above:
MASKED NUDE
11" x 14" silver gelatin print.
Printed on Luminos Flexicon Fibre
paper. Hand coloured with Shiva
transparent oils "Permasols".
Taken with Ilford SFX 200 film.

Opposite:
NUDE BEHIND CLOTH
20" x 24" silver gelatin print. Printed
on Luminos RCR paper. Hand coloured
with Shiva Permasol transparent oils.
Taken with Ilford SFX 200.

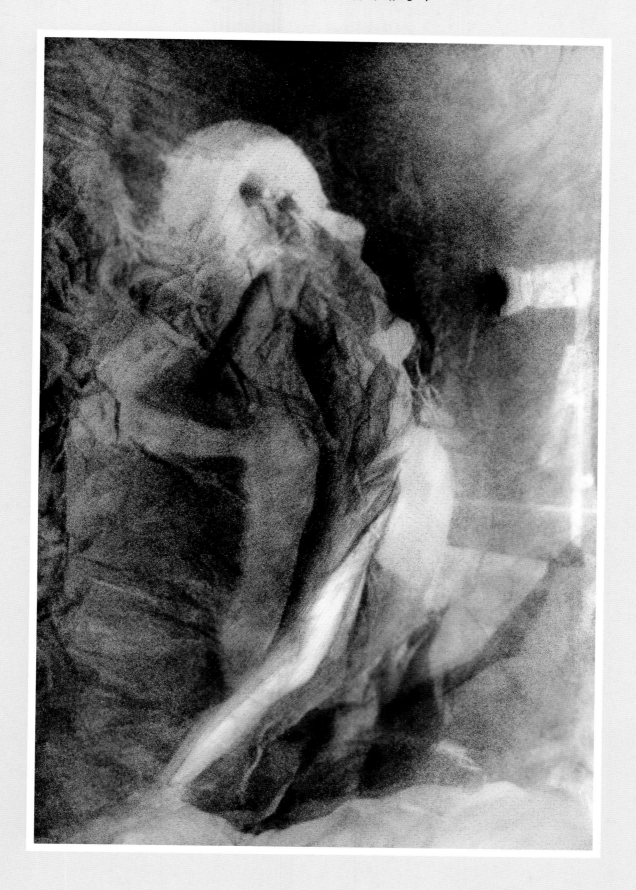

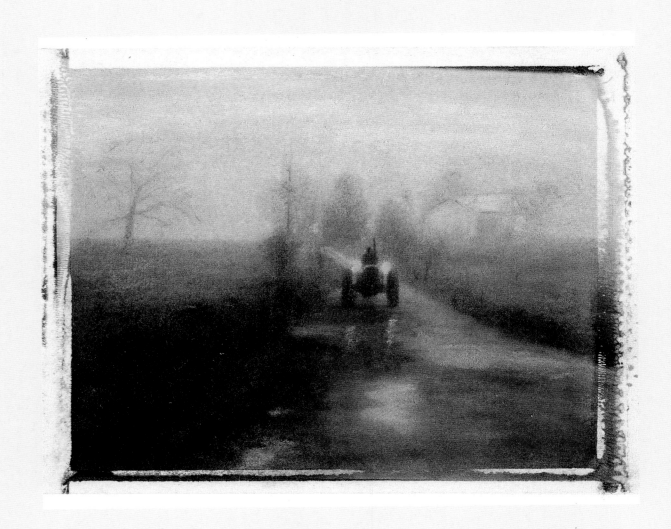

EARLY MORN

8" x 10" Polaroid Image Transfer.
Transferred to Fabriano Artistico
watercolour paper. Hand coloured
with Conté pastel pencils. Taken with
Agfachrome 1000.

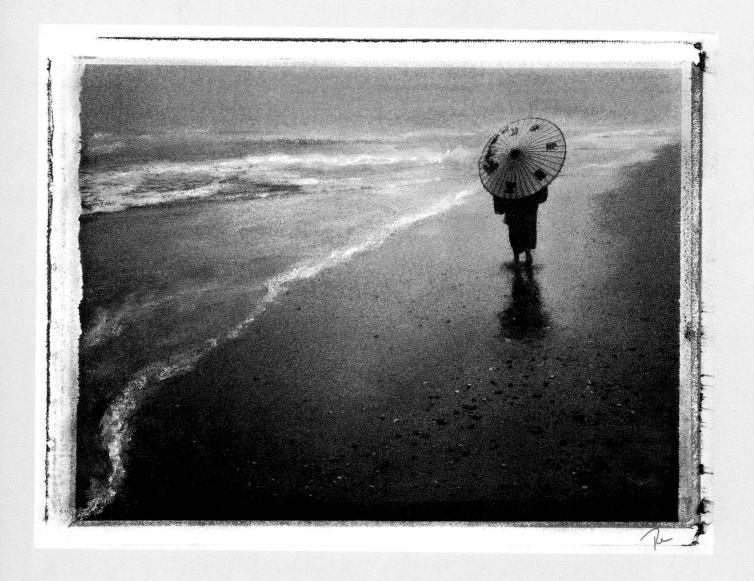

BEACH COMBER
8" x 10" Polaroid transfer. Transferred onto Fabriano Artistico watercolour paper. Hand coloured with Conté pastel pencils. Taken with Agfachrome 1000.

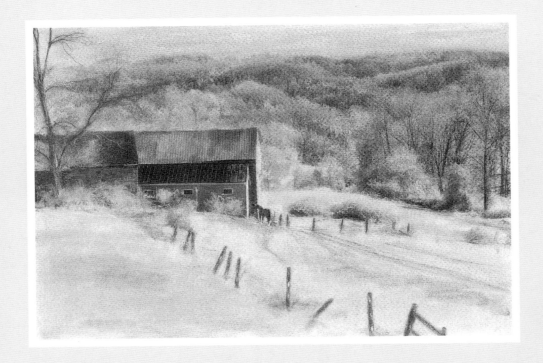

Left:
CHILCOAT FARM
11" x 14" silver gelatin print. Printed on Luminos Tapestry paper. Hand coloured with Conté pastel pencils. Taken with Kodak infrared film.

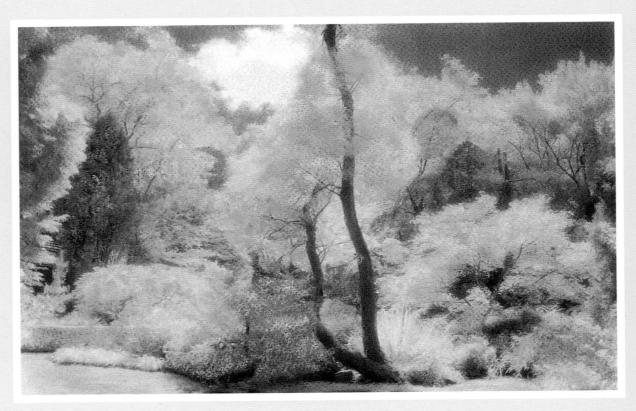

Above:
YELLOW GARDEN AT LADEW
11" x 14" silver gelatin print. Printed on Luminos Tapestry paper. Hand coloured with Conté pastel pencils. Taken with Kodak infrared film.

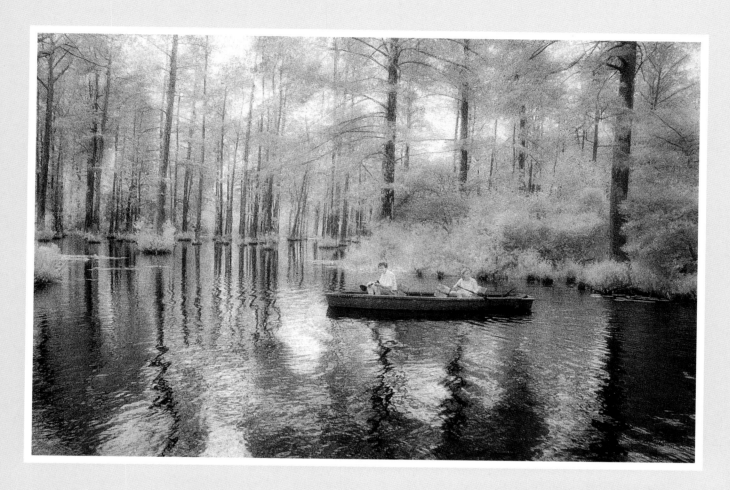

LOOKING FOR GATORS

11" x 14" silver gelatin print. Printed on Luminos RCR paper. Hand coloured with Conté pastel pencils. Taken with Kodak infrared film.

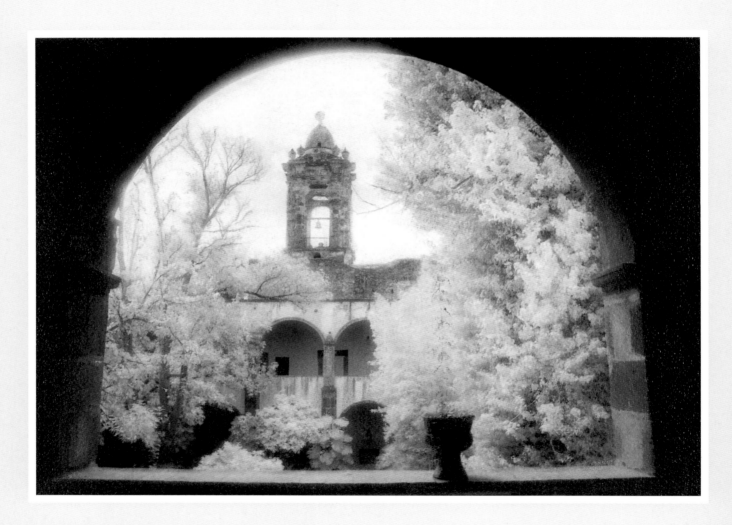

BELLAS ARTES,
MEXICO

11" x 14" silver gelatin print. Printed
on Luminos Tapestry paper. Hand
coloured with Conté pastel pencils.
Taken with Kodak infrared film.

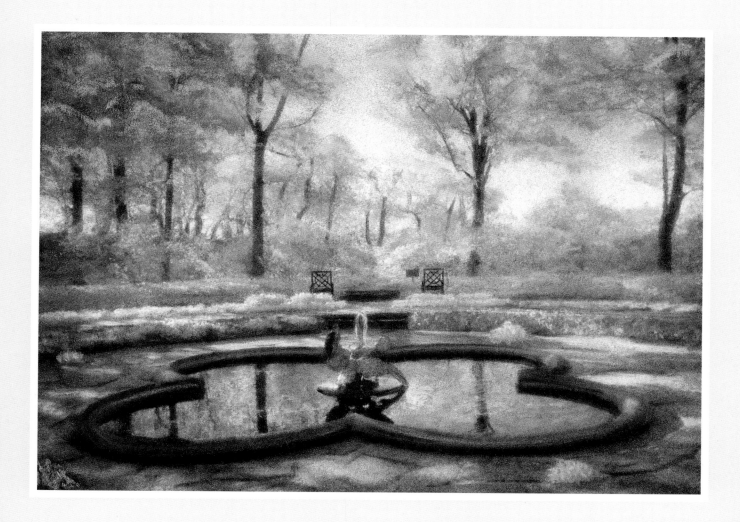

LILLY POND AT LADEW

8" x 10" digital print. Printed on an Epson Stylus 600 printer. Hand coloured with Conté pastel pencils. Taken with Kodak infrared film.

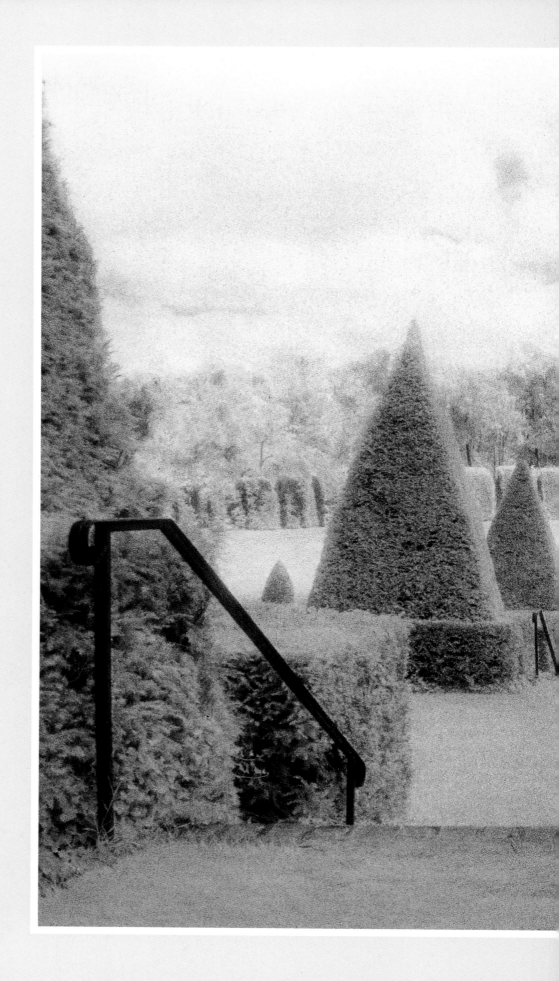

SAM AT LADEW GARDENS

11" x 14" silver gelatin print. Printed on Luminos Flexicon Fibre paper. Hand coloured with Conté pastel pencils. Taken with Kodak infrared film.

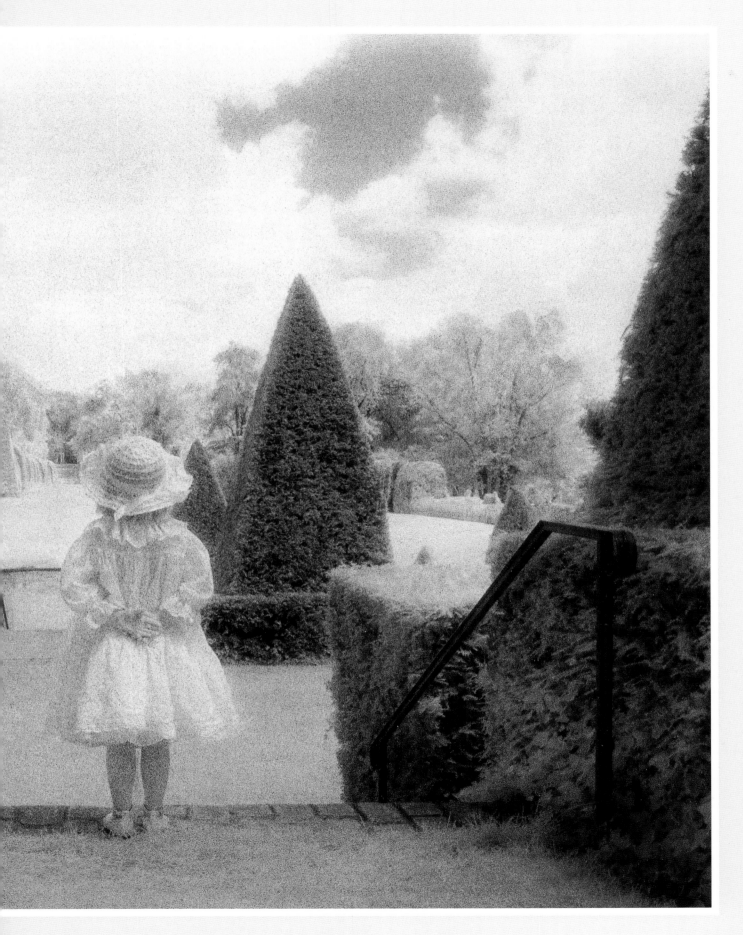

ROGER De GROOF

A SENSE OF ISOLATION

Roger de Groof, born in 1940 in Belgium, worked as a technical designer until his retirement in 1993.

Like thousands of other beginners, Roger was given a simple camera for a birthday and with this he started to record his family life. However, he soon became obsessed with photography, read every available book and magazine on the subject and visited museums and galleries where he took every opportunity of studying the work of well-known photographers. He joined his local club, Duffelse Fotokring, where he developed his knowledge of darkroom techniques.

He decided to specialise in photo montage which as Roger says gives him creative freedom. He starts work by putting his ideas on paper and then goes through his archive of 16,000 negatives and if subjects are missing he takes out his camera to search for the missing elements.

Roger de Groof has won many international awards and still enjoys photography, but most of all passing on his knowledge to younger enthusiasts.

Der 1940 in Belgien geborene Roger de Groof arbeitete bis zu seiner Pensionierung im Jahr 1993 als technischer Designer.

De Groof gilt als die führende Instanz im "fotografischen Surrealismus" und ist ein Meister der Dunkelkammertechnik. Wie tausende andere Anfänger kam Roger de Groof über eine ganz einfache Kamera zur Fotografie. Vorerst wollte er nur familiäre Ereignisse festhalten. Dann aber wurde er vom Virus der Fotografie so heftig infiziert, daß er sich bis heute nicht davon erholt hat. Als Autodidakt bildete er sich selbst weiter, las alle verfügbaren Bücher und Magazine, besuchte Museen und Galerien und beschäftigte sich intensiv mit den Arbeiten bekannter Fotografen. Schließlich wurde er Mitglied im berühmten Duffelse Fotokring, wo er seine meisterhaften Fähigkeiten in der Dunkelkammerarbeit ausbildete.

Roger de Groof entschied sich für eine Spezialisierung im Bereich der Fotomontage, die ihm wie er sagt: "ausreichende kreative Freiheit ermöglicht". Sein Weg ist der eines konzeptionellen Fotografen. Zuerst notiert er seine Ideen, durchforstet dann sein mit 16.000 Negativen bestücktes Archiv und wenn ihm Teile für seine neuen Montagen fehlen sollten, so benutzt er die Kamera, um die notwendigen Bildelemente zu produzieren.

Roger de Groof hat viele internationale Preise gewonnen und ist immer noch der Fotografie mit Haut und Haaren verfallen. Seine größte Freude ist es heute, den jungen Fotoenthusiasten in seinem Land sein großes Know-how weiterzugeben.

Opposite:
LORD CASTELLAN

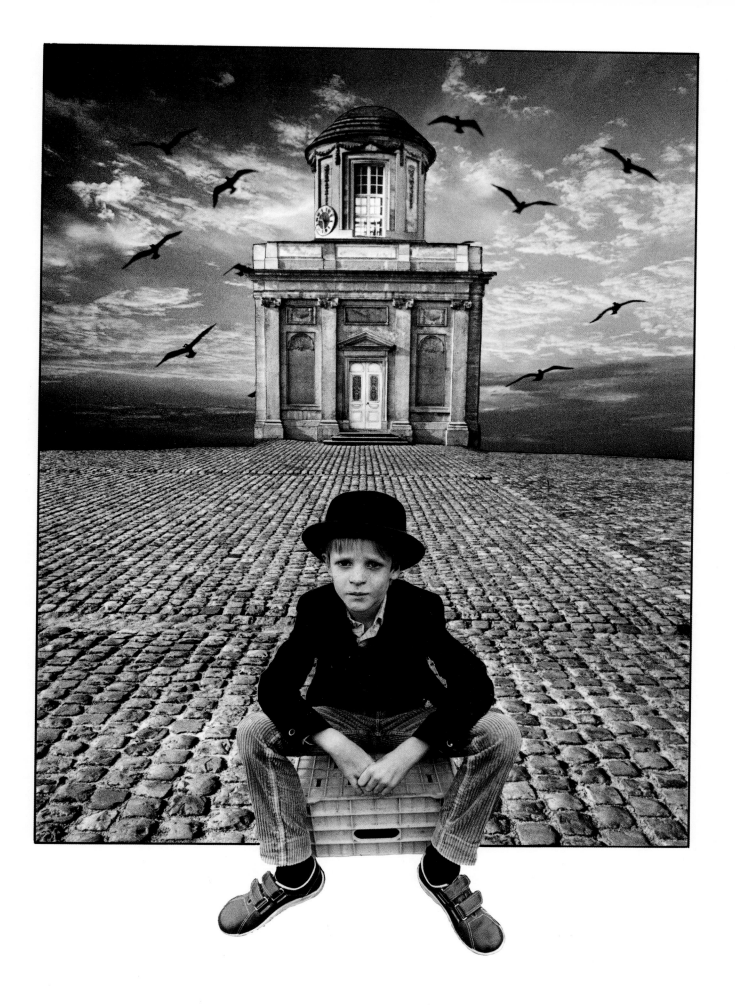

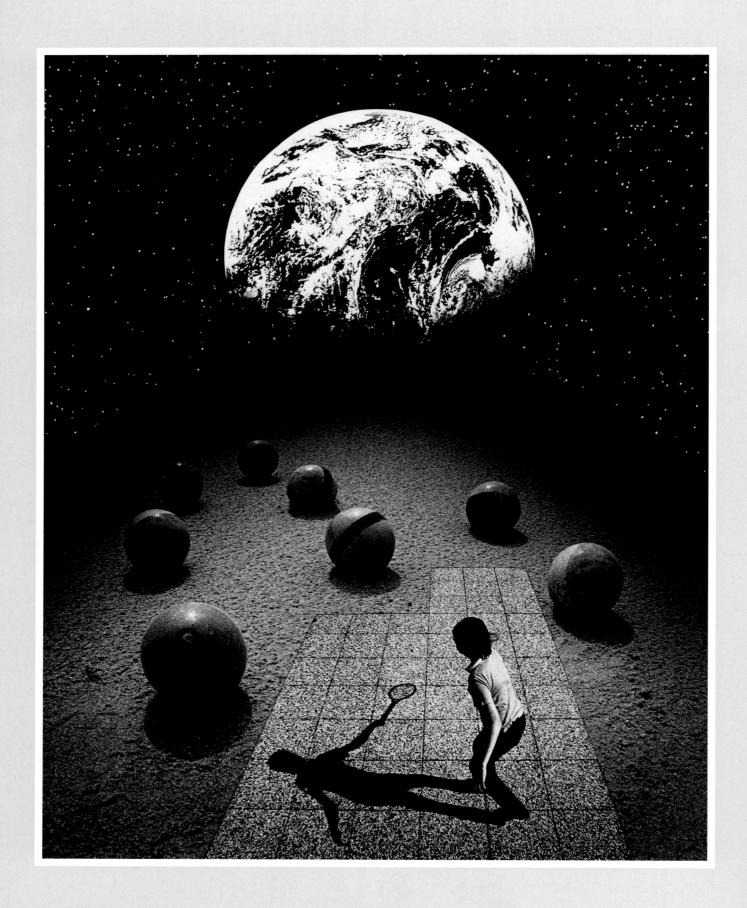

TENNIS PLAYER

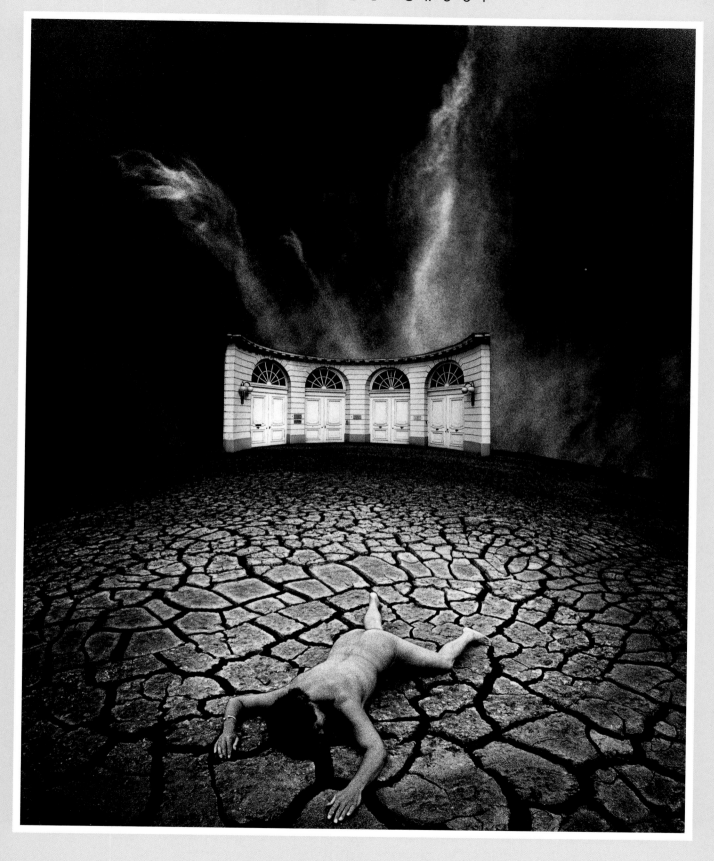

DEGRADING

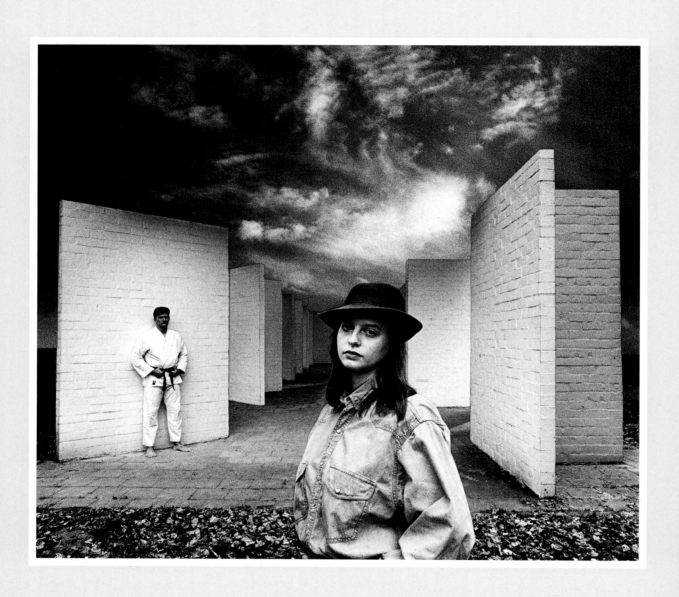

GUARDIAN ANGEL

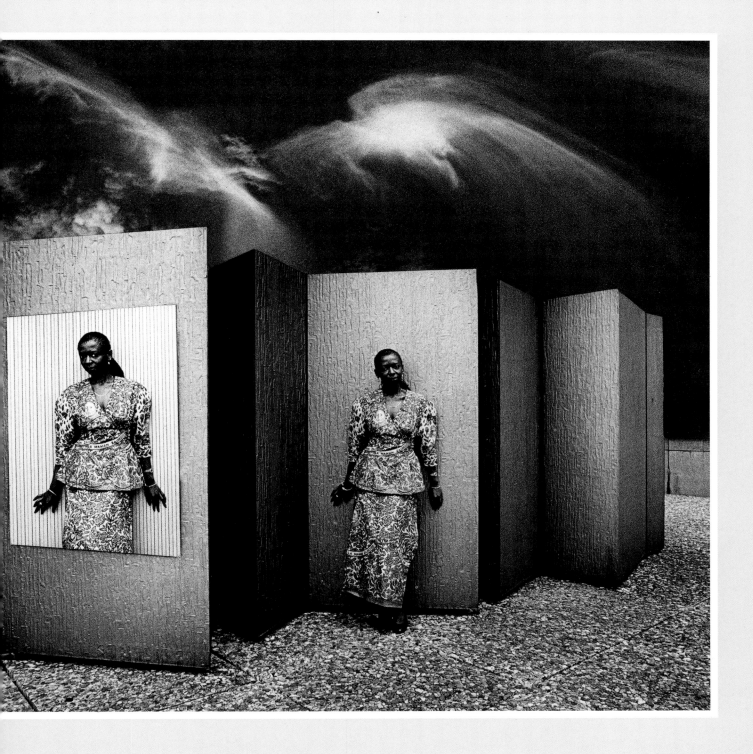

IN DUO

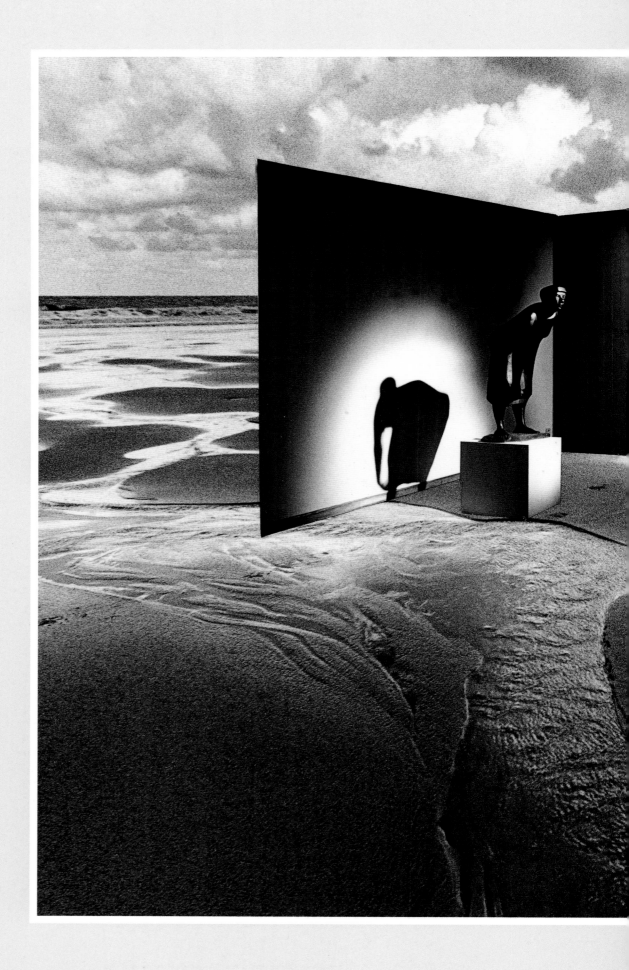

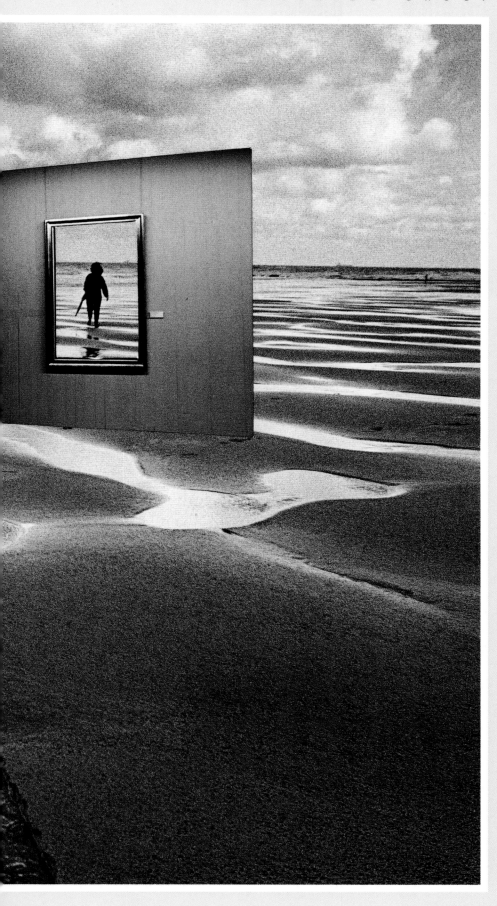

COAST GUARD

Above:

ELS IN THE HARBOUR

Opposite:

IN THE FRAMEWORK

SOUTH AFRICA
PORTFOLIO
A COUNTRY OF CHANGE

South Africa is a "world in one country". It offers beauty and a variety of photographic subject matter. Nature, wildlife, mountains, two oceans and a semi desert can be captured under sunny skies, giving South Africa its enormous photographic appeal.

"We are a country in the throes of change" says Frank J. Reuvers, Vice President of the Photographic Society of Southern Africa and one of the internationally known photographers from his country.

South Africa has made rapid strides since the change in government. It has become a true non racist society with co-operation and communication between the different race groups. Overseas investment has increased substantially. Such changes affect every aspect of life, even photography. Black photographers are still in a minority, but companies like Agfa, Fuji and Kodak have been arranging lectures and workshops and issuing monthly bulletins containing 'how to' articles thus encouraging the black population to take up photography.

For many years, during the apartheid era, the country remained isolated from the rest of the photographic world. As such, international trends in photography never really influenced the South African community.

There are approximately 100 camera clubs in South Africa, the majority of whose members regard photography as a hobby recording nature, wildlife, landscapes and sport. With increasing exposure to the photographic trends developing worldwide, South African photography is showing signs of shifting away from the traditional to the artistic.

Where is South African photography going? "I believe that our photography will gradually change from the conservative to the creative, including a move towards digital imaging, an environmentally friendly tool to creativity", says Frank J. Reuvers.

Südafrika ist ein Land mit vielen Gesichtern. Die Schönheit der Natur, seine Tierwelt, die Berge, zwei Ozeane und eine Halbwüste können unter Südafrika's stets sonnigem Himmel eingefangen werden und geben dem Land enormes fotografisches Potential.

"Wir befinden uns derzeit in einer ganz starken Umbruchsphase" sagt Frank J. Reuvers, Vizepräsident der Photographic Society of Southern Africa und einer der international bekanntesten Fotografen seines Landes.

Viel hat sich in Südafrika geändert, seitdem die schwarze Bevölkerungsmehrheit die Macht im Land übernommen hat. Die Gesellschaft Südafrika's lebt rassenvorurteilsfrei und zwischen den verschiedenen Bevölkerungsgruppen und Hautfarben herrscht Kooperation und eine gute Gesprächsbasis. Wirtschaftlich gesehen hat dies einen gewaltigen Zuwachs an Investment aus Europa und den USA gebracht. Solche Veränderungen haben einen signifikanten Einflufl auf das tägliche Leben, ja sogar auf die Fotografie.

Schwarze Fotografen sind zwar immer noch eine Minderheit, aber Firmen wie Agfa, Fuji und Kodak haben Vorträge und Workshops organisiert und versuchen mit Fachartikeln die schwarze Bevölkerung für die Fotografie zu begeistern.

Das Land war während Apartheid für viele Jahre vom Rest der fotografischen Welt isoliert. Insoweit haben internationale Trends der Fotografie das Fotoschaffen in Südafrika kaum beeinfluflt.

Heute gibt es rund 100 Fotoclubs im Land, die Mehrheit der Mitglieder betrachtet Fotografie als ein Hobby. Die bevorzugten Motivbereiche sind die faszinierende Tierwelt, Landschaft und Sport. Allerdings öffnen sich die in ihrer über viele Jahrzehnte eingeübten Bildsprache gefangenen südafrikanischen Fotografen neuen Trends.

Was ist die Zukunft der südafrikanischen Fotografie? "Ich glaube," sagt Frank J. Reuvers "dafl unsere Fotografie von einer konservativen zu einer kreativen Linie umschwenken wird und dafl etwa die digitale Bildbearbeitung ein umweltfreundlicher Weg zu einer erweiterten Kreativität in den Werken sein wird.

DEREK PEARMAN

The worker – Pretoria

The slide was taken at the railway workshop in Pretoria. It is a hand held shot with available light conditions.
Pentax LX, Pentax 35-105 Zoom, Fujichrome RDP

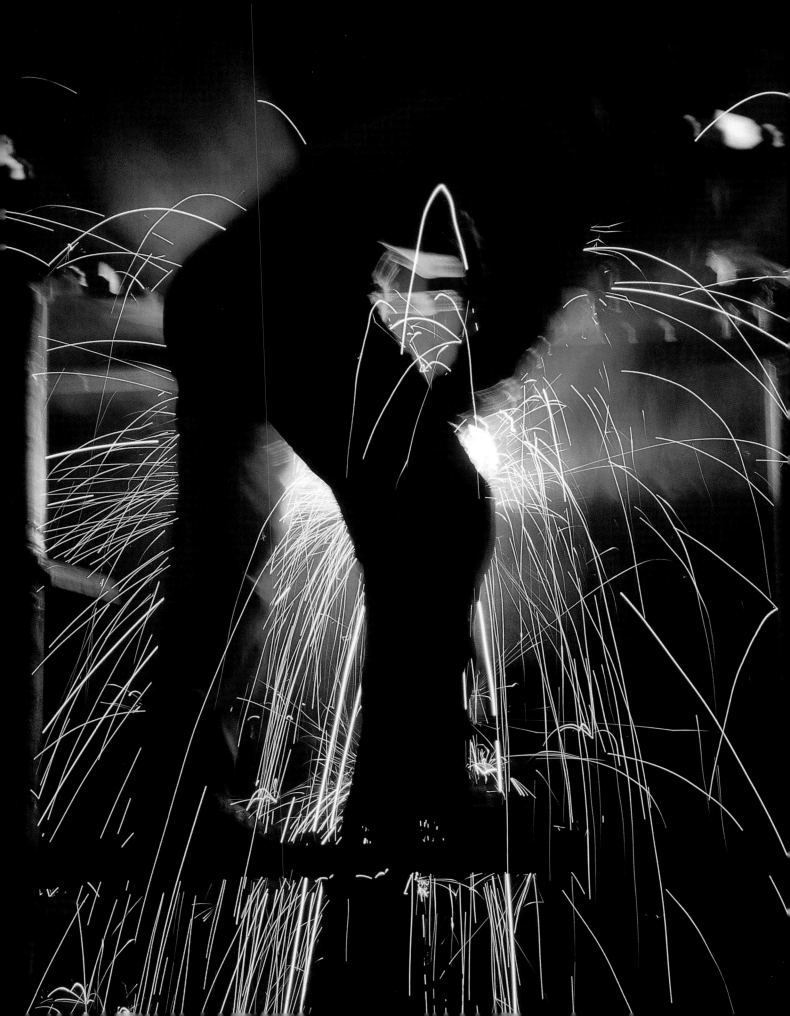

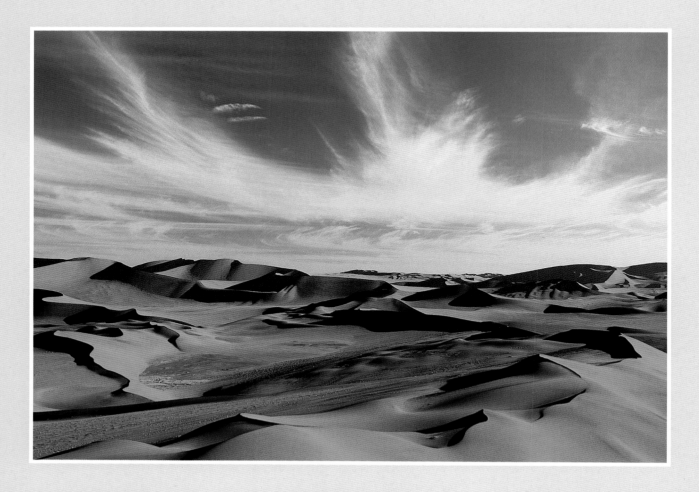

MARIKE BRUWER

Sea of sand and
sky – Sossusvlei

Nikon F801s, Nikkor 24mm,
Fujichrome Velvia

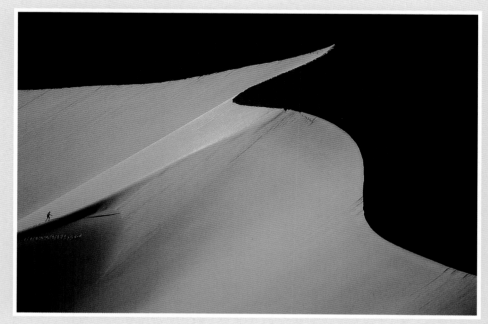

GEOFF ARMSTRONG

Immense and brooding
Namib – Sossusvlei

Minolta 9XI, Rokkor 500mm,
Fujichrome Velvia

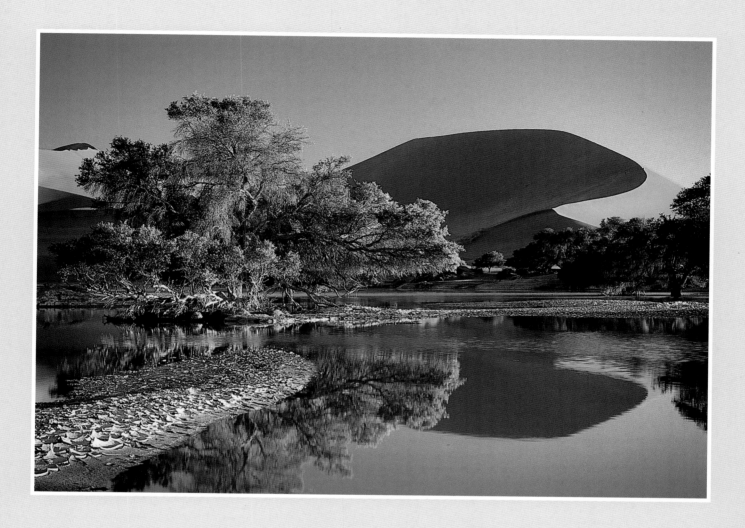

COLIN P. MEAD
Dawn Design – Sossusvlei

This slide was taken just a few
minutes after sunrise and after
floodwaters had reached the
area for the first time in
fourteen years.

**Canon T90, Canon 28-85mm,
Fujichrome Velvia**

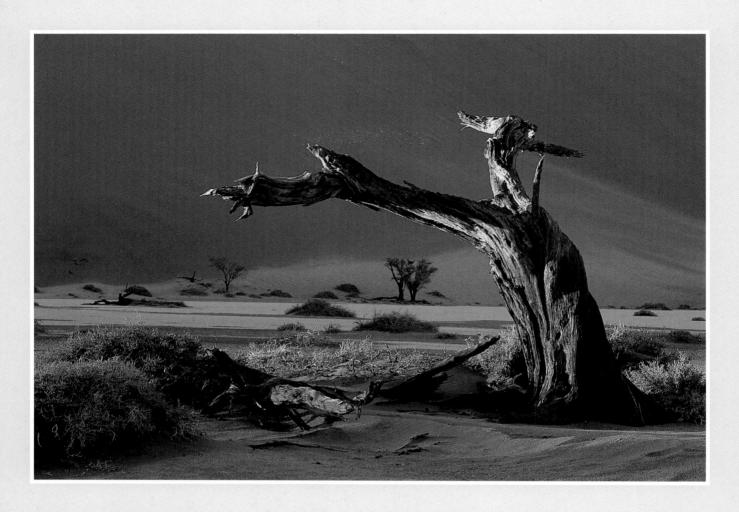

ERNEST PREISS

Hidden Vlei at dawn

It was my aim to capture the stark beauty of the Hidden Vlei in the Namib Desert at dawn.

Nikon F4s, Nikkor 28-70mm, Fujichrome Velvia

SUE WITT

Saltscape – Badwater

My objective was to demonstrate the pictorial element of the patterns in the salt.

Nikon 8008, Nikkor 20mm, Fujichrome Velvia

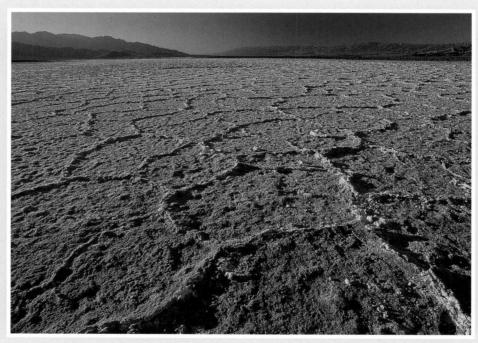

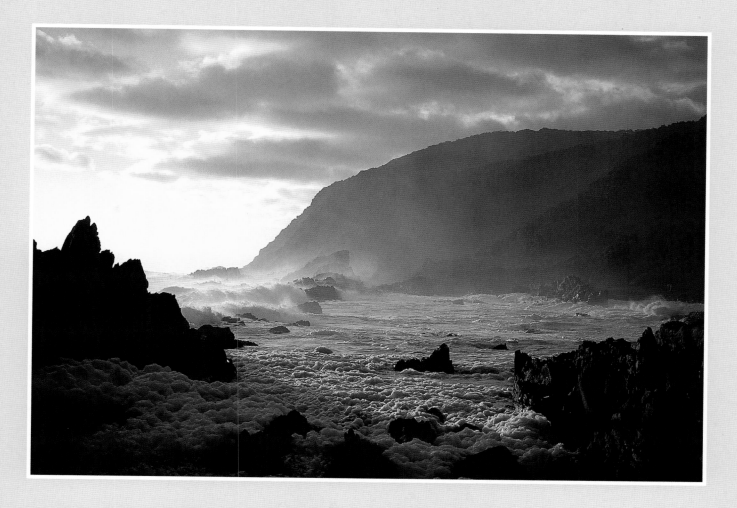

COLIN P. MEAD
**Tsitsikamma Sunset –
Plettenberg Bay**

This slide was taken on a very stormy day a few minutes before sunset on the South Cape Coast in the Tsitsikamma National Park.

**Canon T90, Canon 28-85mm,
Fujichrome Velvia**

RICHARD DANEEL
Kokerboom – Richtersveld

Nikon F50, Sigma 75-300mm,
Fujichrome Sensia

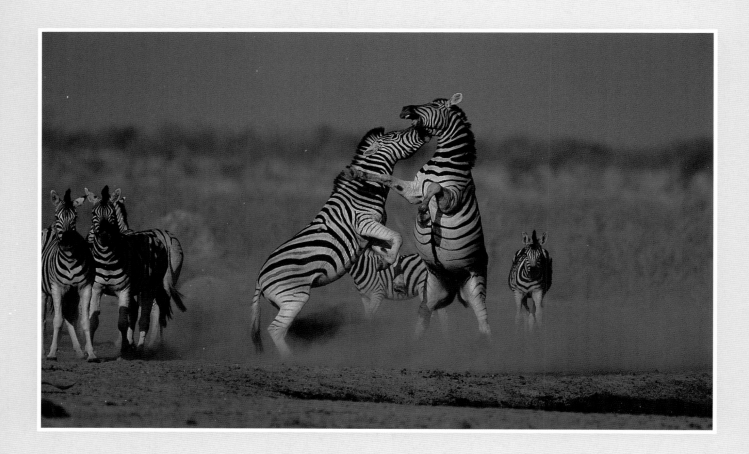

PIET HEYMANS

Mares fighting – Kalahari
Gemsbok Park

Minolta 7XI, Rokkor 600mm,
Fujichrome 100

BARRY WILTON

Heads you lose

Nikon 801s, Tokina 150-500mm,
Fujichrome 100

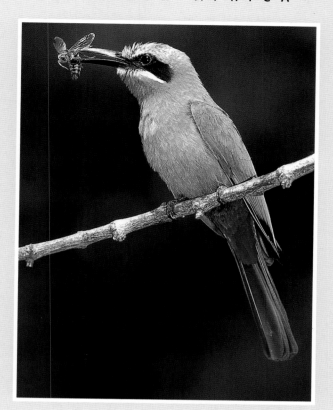

NICKY WILTON

**Bee eater with insect –
Krüger Park**

White fronted bee eaters were
sitting on their nest site waiting
to get into the nest to feed
their chicks.

Nikon N90, Tokina 150-500mm,
Fujichrome Velvia

PIET HEYMANS

**Not a chance – Kalahari
Gemsbok Park**

Minolta 7XI, Rokkor 600mm,
Fujichrome 100

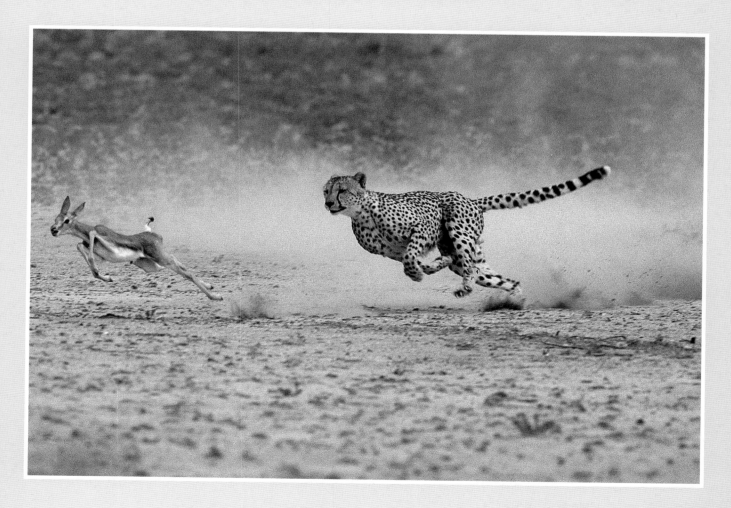

J. J. VILJOEN
Sunset ostrich in the dust

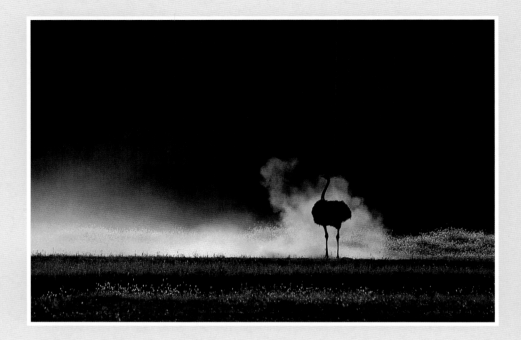

SHANNON &
KAY CLARK
Having a scratch – Krugersdorf
Nikon F4, Tokina 150-500mm,
Fujichrome Provia 100

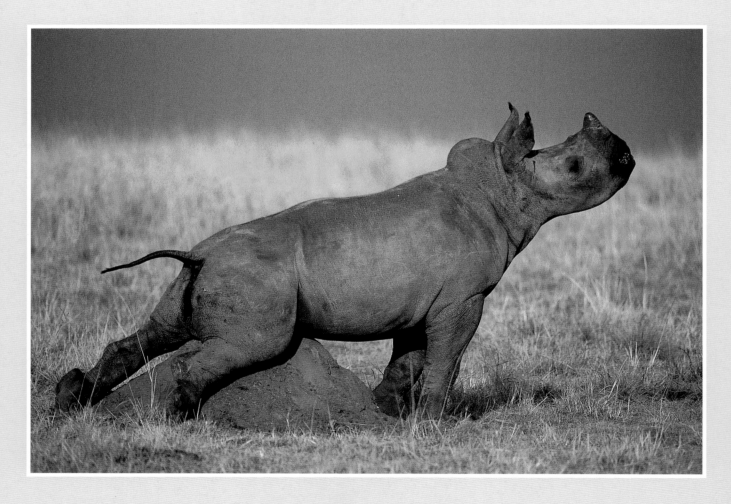

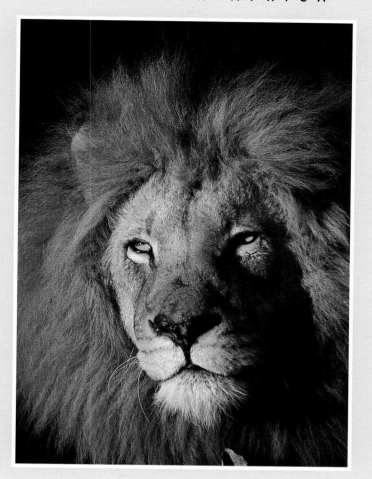

NORMA PEARMAN

Kings portrait – Krugersdorp

A window bracket on the car assisted to obtain this early lighting shot.

Pentax LX, Koboron 120-600mm, Fujichrome RDP

DR. R.J. VAN VUUREN

Croc portrait – Sabi River

Canon EOS-1, Canon 600mm, Fujichrome Provia

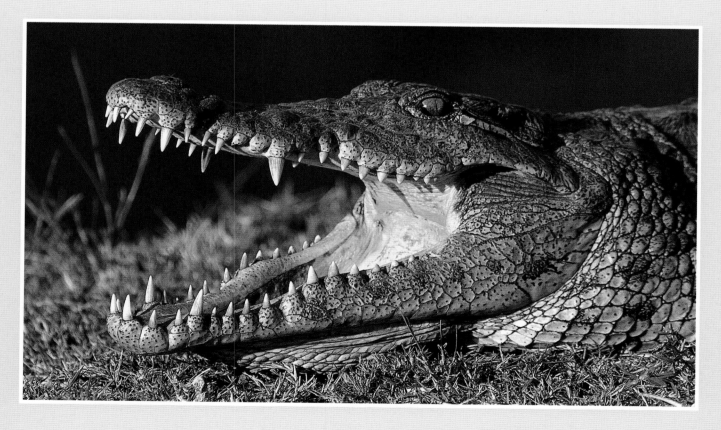

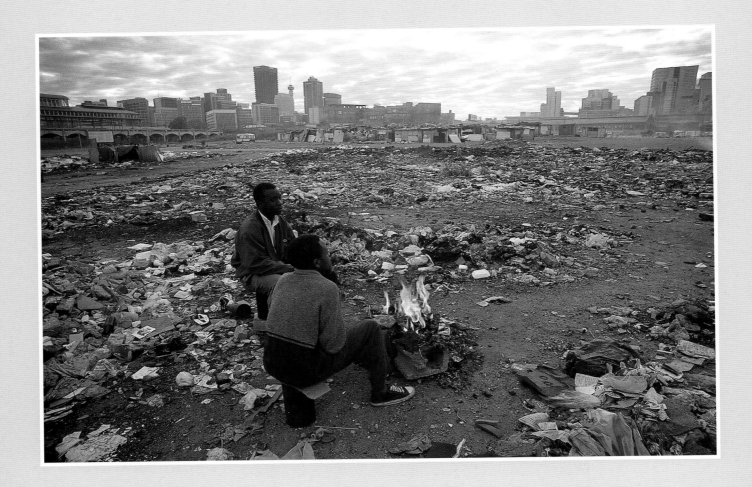

EMIL WESSELS

**Winter warm-up –
Johannesburg**

This slide was taken near
Johannesburg on a cold winter
morning in an area of land soon
to be developed.

Nikon F4, Nikkor 2.8/20mm,
Fujichrome Provia 100

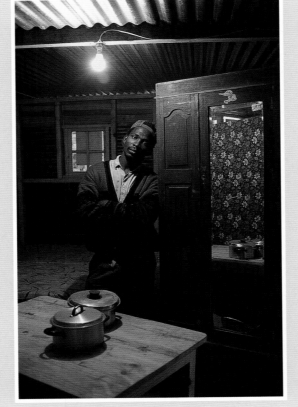

EMIL WESSELS

**A day in the life –
Amavulandlela**

Amavulandlela means the people
who open the way to the future.

Nikon F90, Nikkor 35-70mm,
Fujichrome Provia 100

HOWARD WOLFF

Proud old man

I took this very proud looking
man to my home studio
where I do most of my shots.

Canon EOS 1N, Fujichrome 100

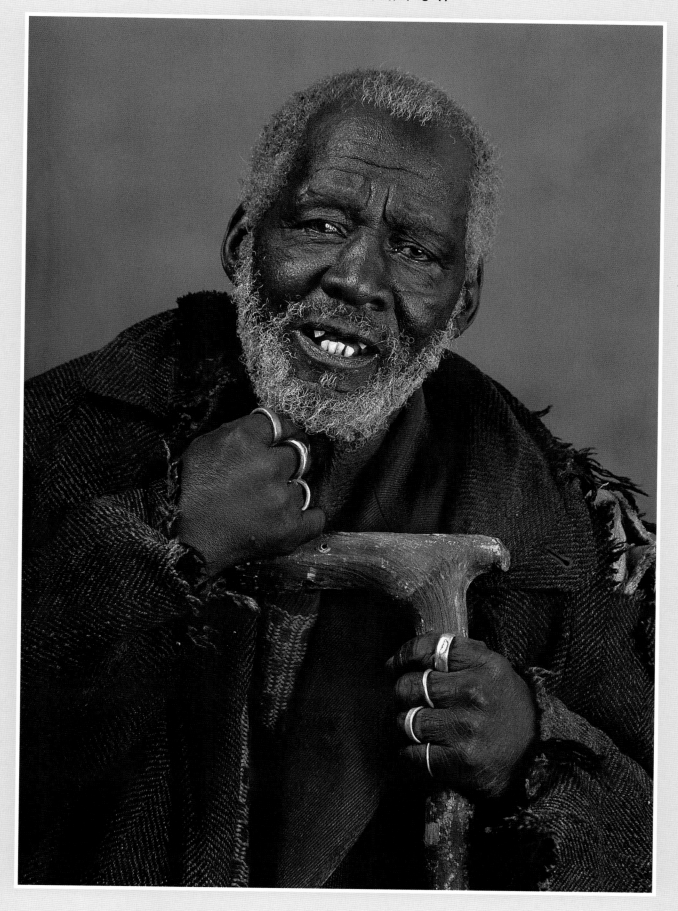

NOEL HUTTON
You won't see this at
Wimbledon – Johannesburg
Nikon F301, Fujichrome 100

JAN HAMMAN
Wave-turn – Germiston

FRANK J. REUVERS
Lone sailor – Trenneries
Canon A1, Canon 35-105mm,
Fujichrome

NOEL HUTTON

Norwood nightmare –
Johannesburg
Nikon F301, Fujichrome 100

COLIN HALL

Morning train – Germiston
Shunting Yards
Nikon EM, Tokina 35-70mm,
Fujichrome Velvia

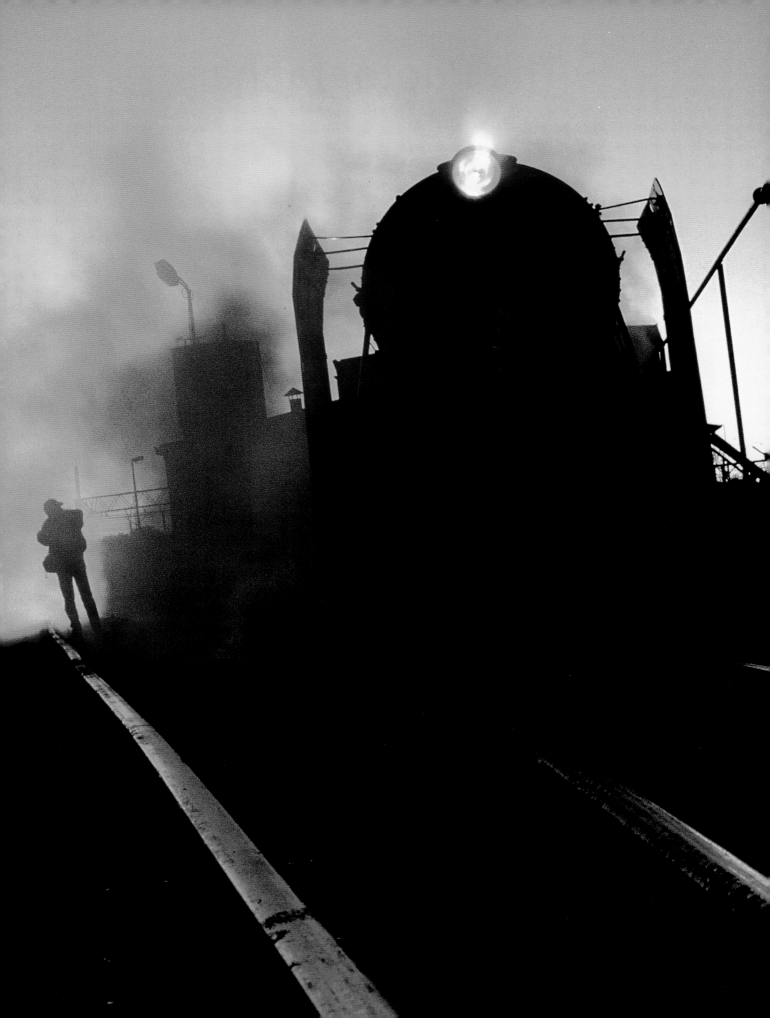

The Photographers

Noel Hutton
SOUTH AFRICA

Andrea Barelli
ITALY

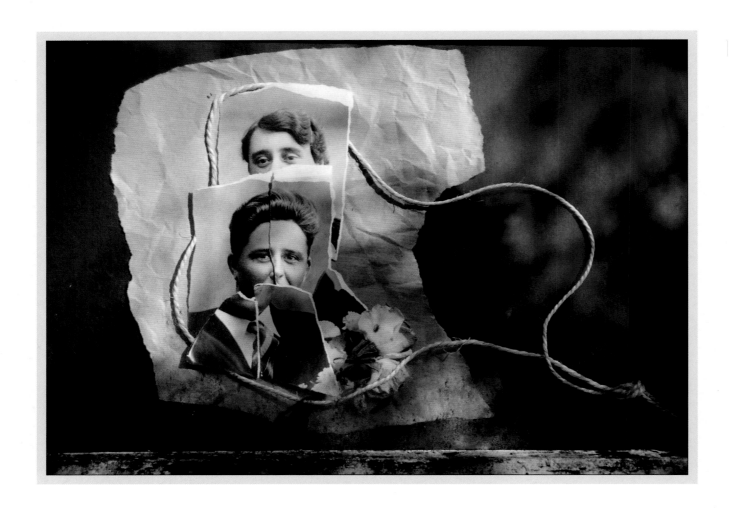

Tonny Thijssen-Stoop
NETHERLANDS

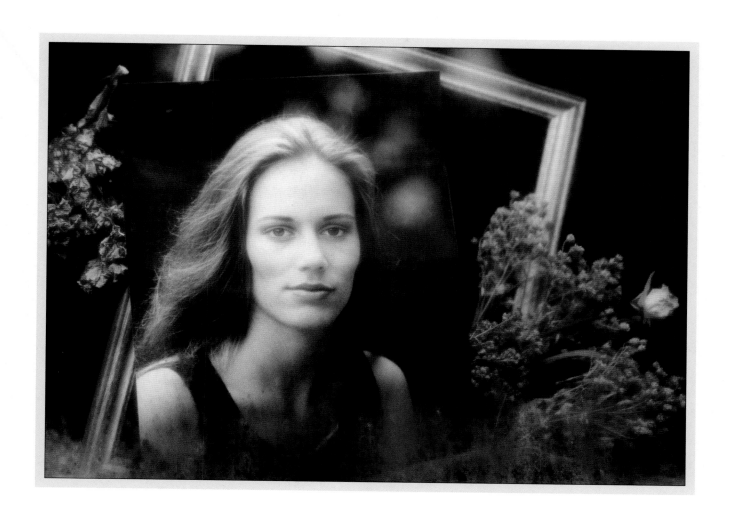

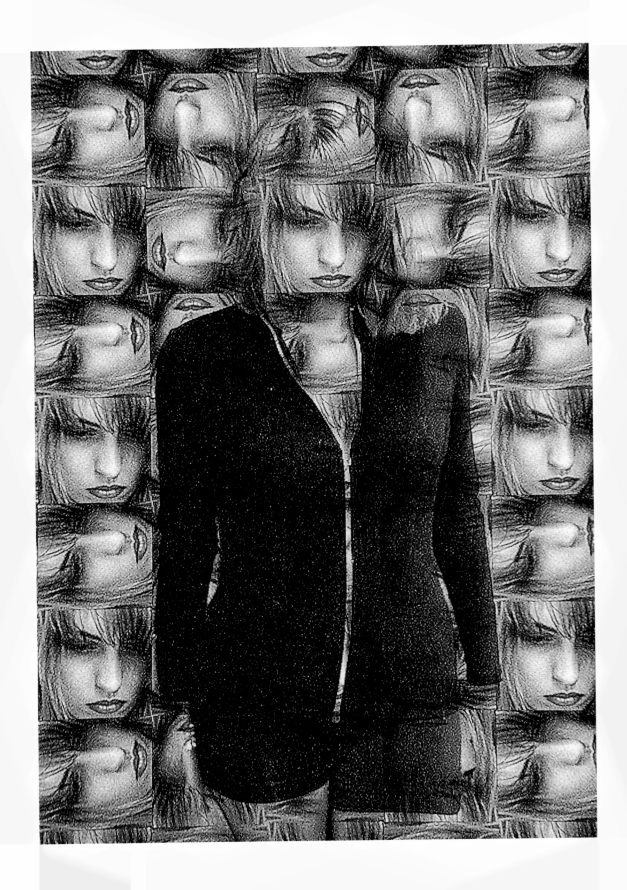

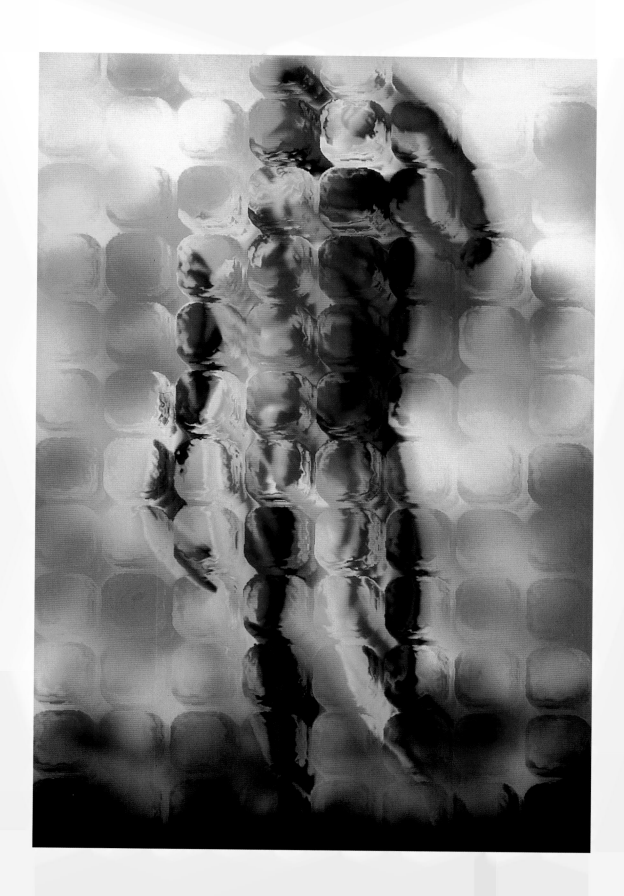

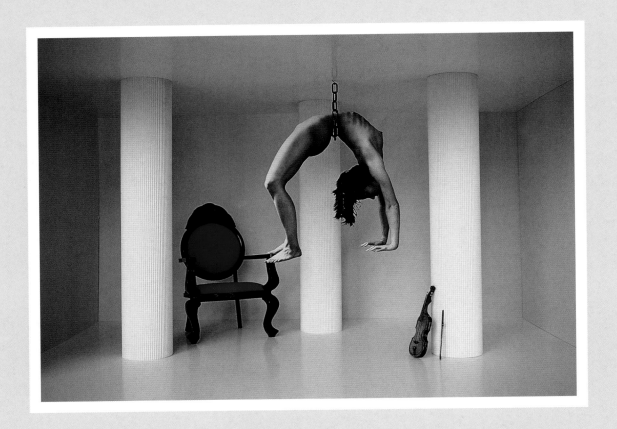

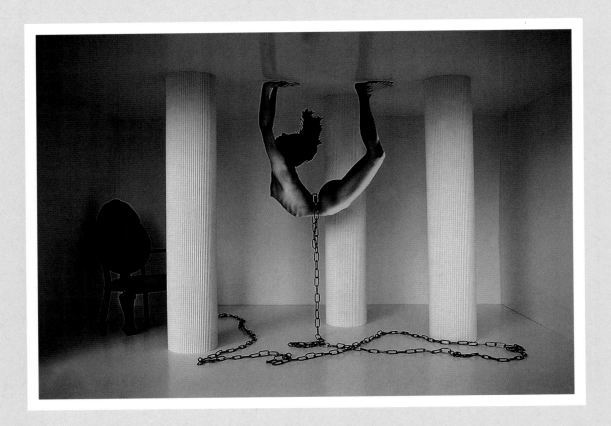

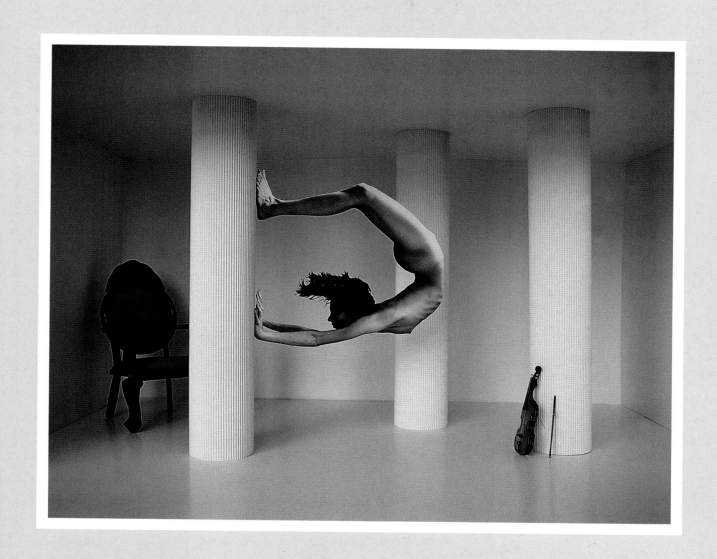

Edmund Steigerwald
GERMANY

Guy Bos
BELGIUM

Virgilio Ferrari
ITALY

Waranun Chutchawantipakorn
THAILAND

Chirasak Tolertmongkol
THAILAND

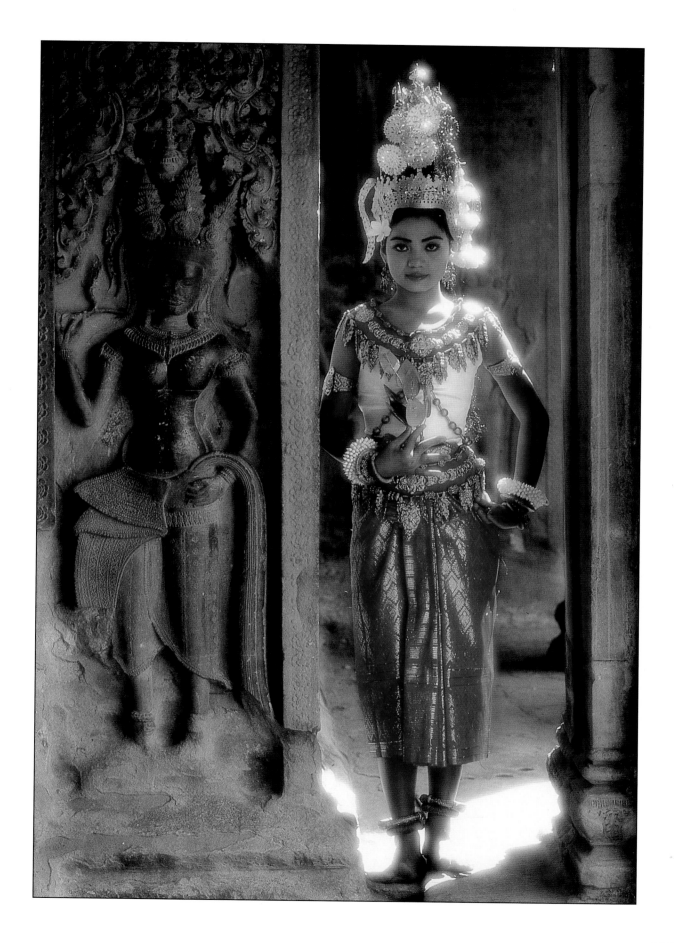

Carlo Calloni
ITALY

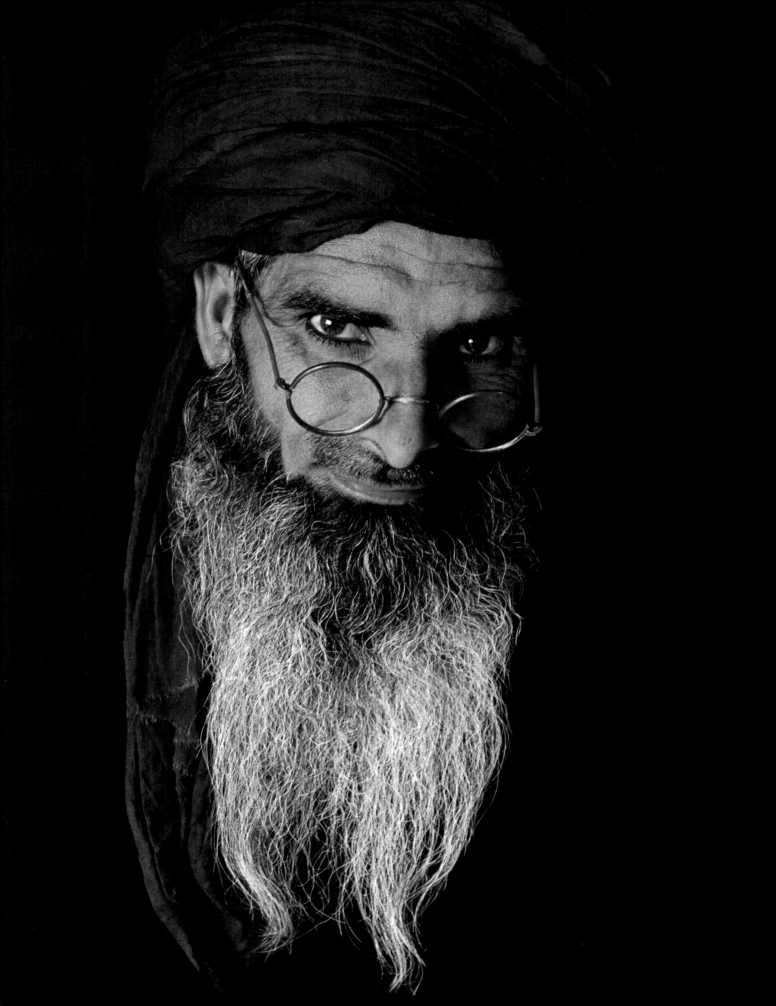

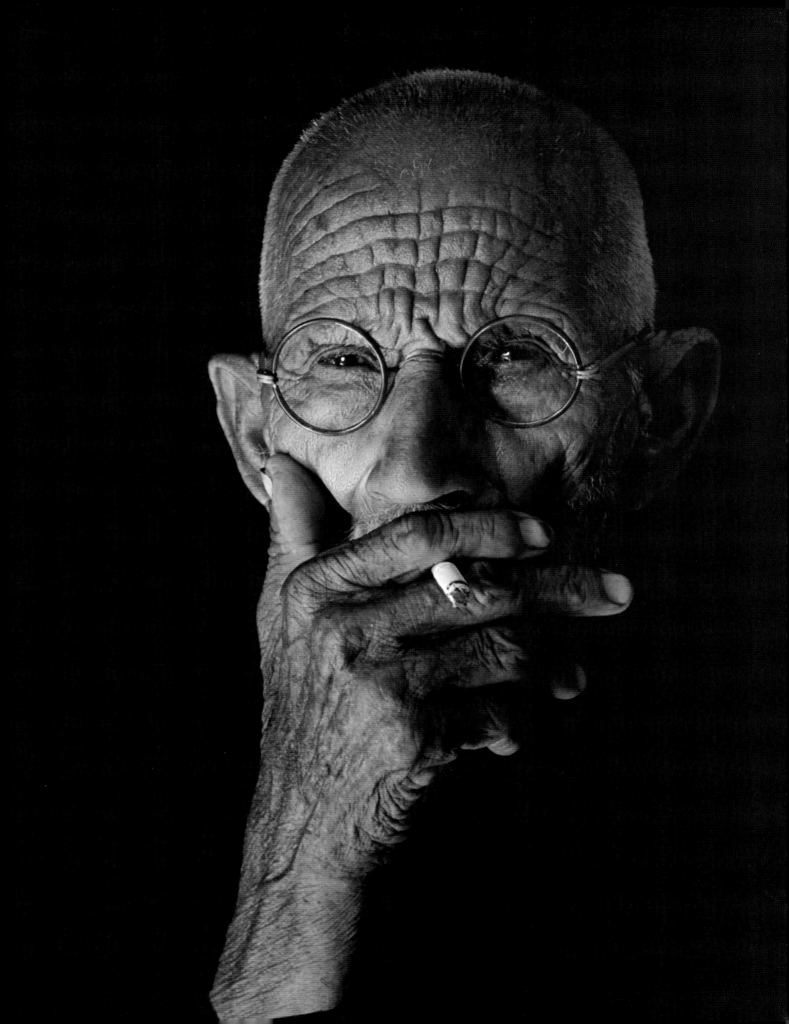

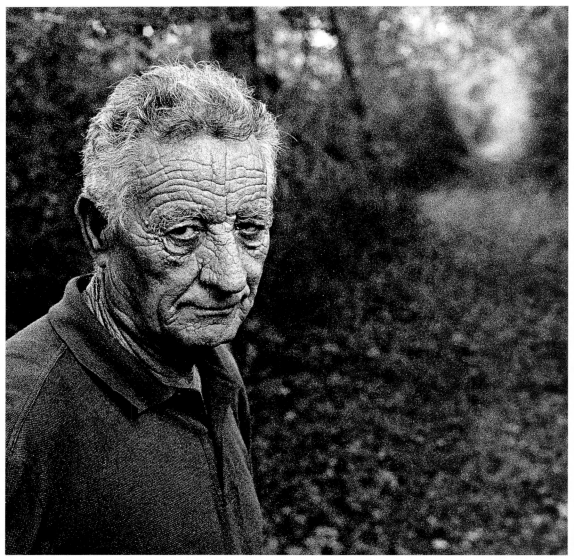

Jose Arias
SPAIN

Carlo Avataneo
ITALY

Carlos A. Milanesi
ARGENTINA

123

Colin Peter Harrison
UNITED KINGDOM

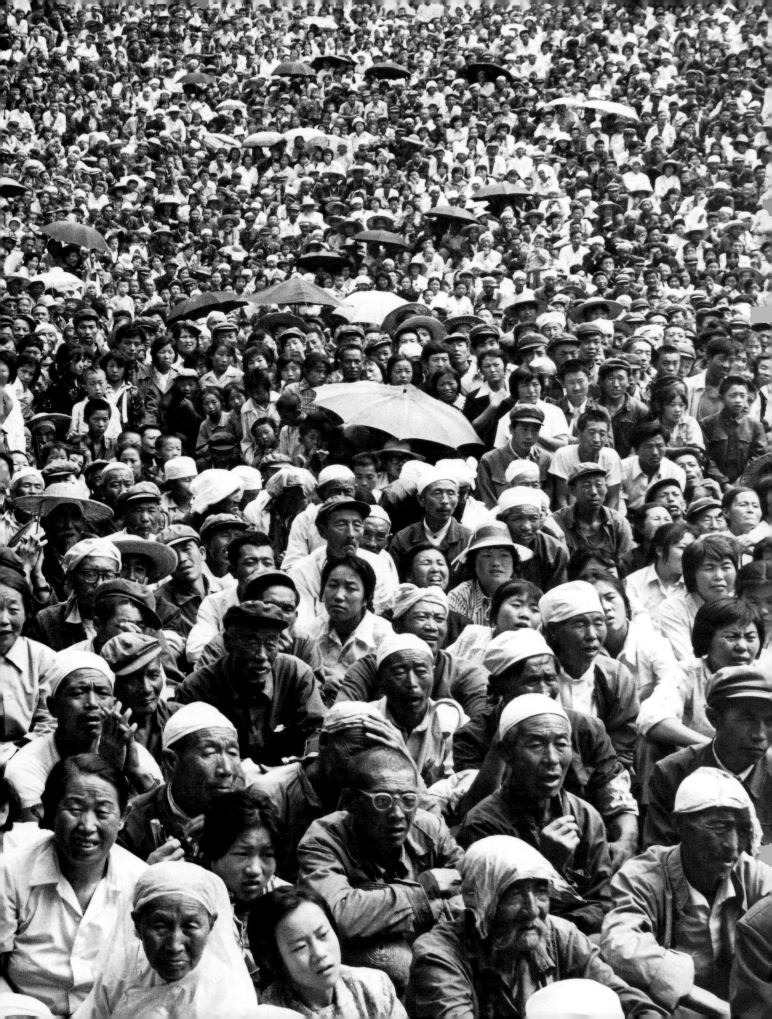

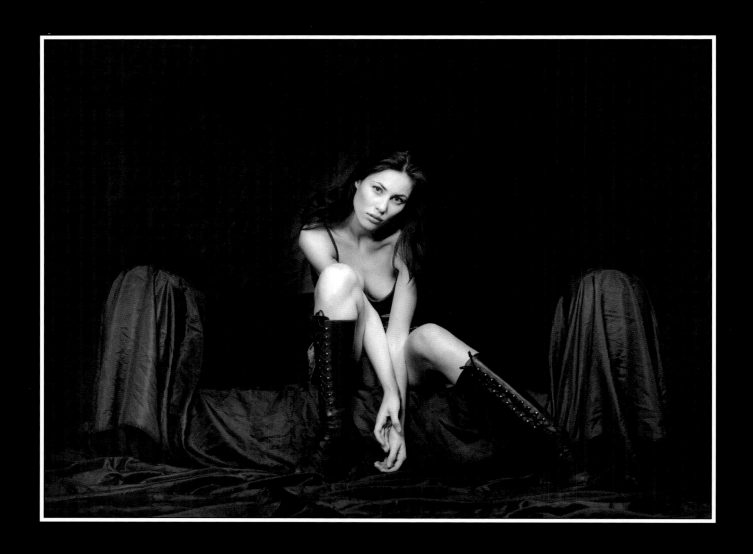

Leon Heylen
BELGIUM

PREVIOUS PAGE
Chen Bao Sheng
CHINA

Ludwig Polesny
AUSTRIA

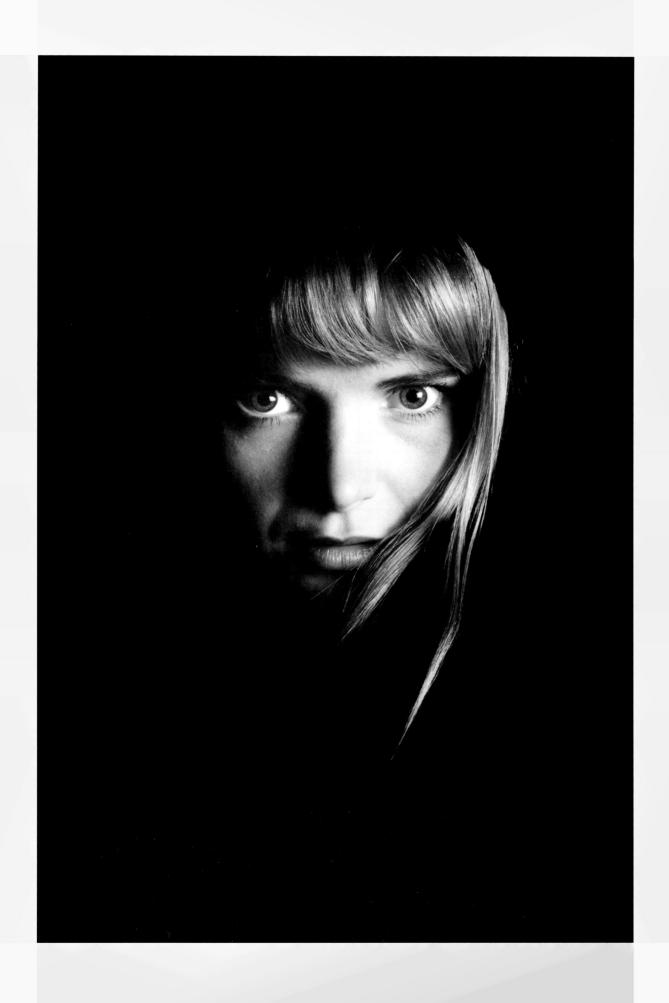

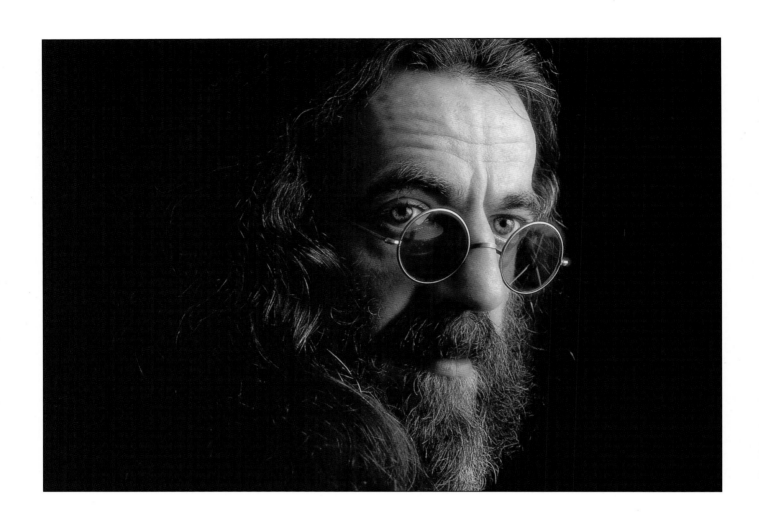

Herbert Pöttinger
AUSTRIA

Vanni Calanca
ITALY

David Fletcher
AUSTRALIA

Daniel Boiteau
FRANCE

Jan Bek
SWEDEN

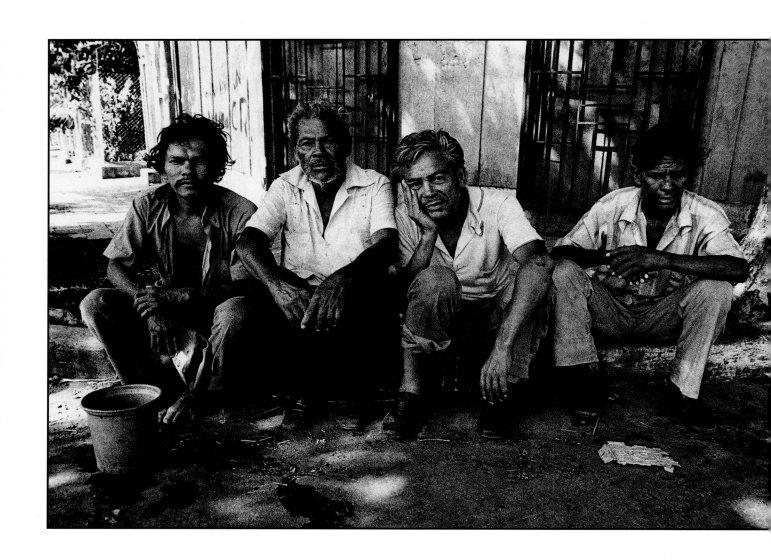

Michele Mengoli
ITALY

136

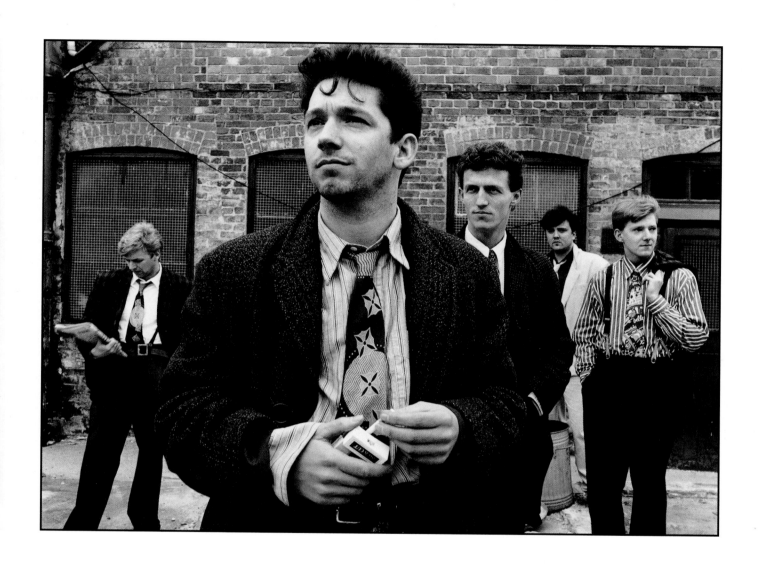

Frank Bailey
ENGLAND

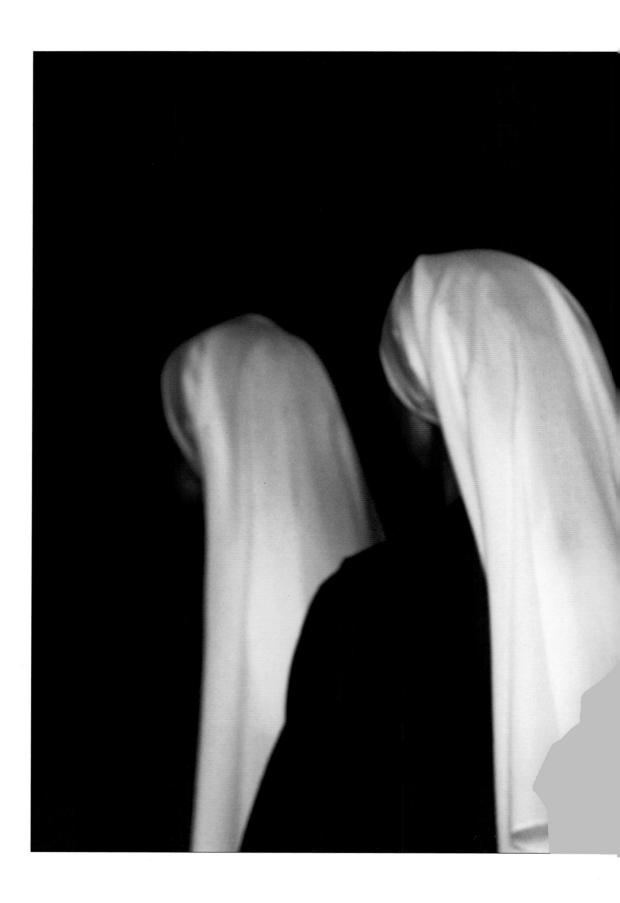

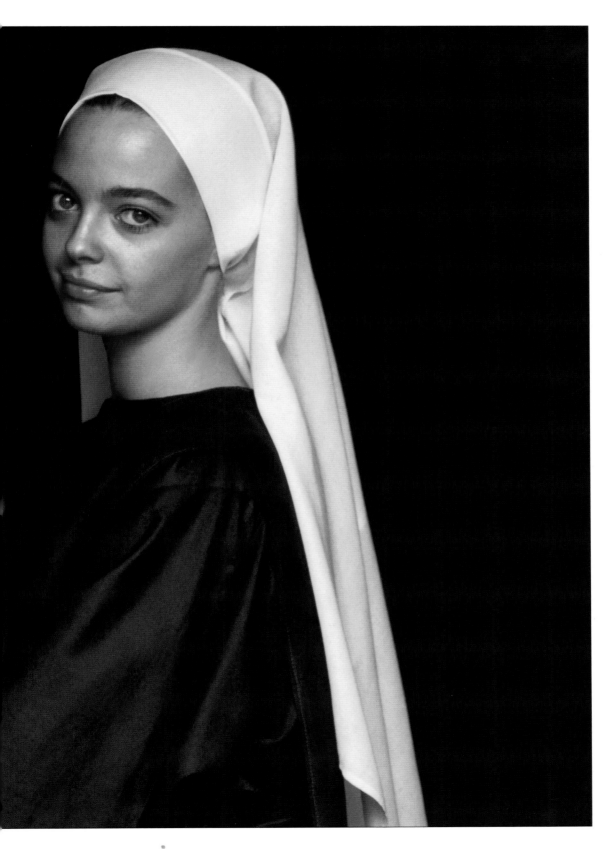

Carlo Avataneo
ITALY

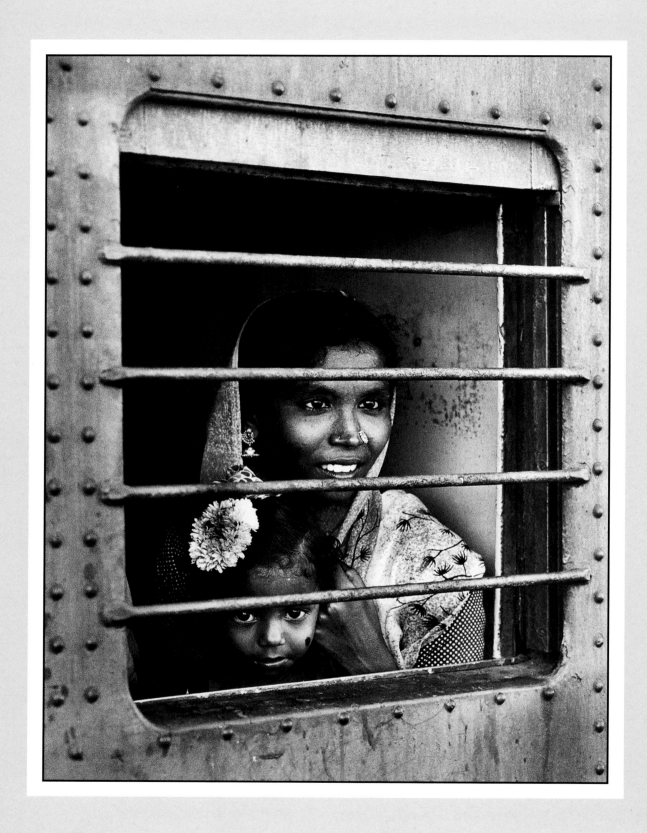

Alain Doret
FRANCE

140

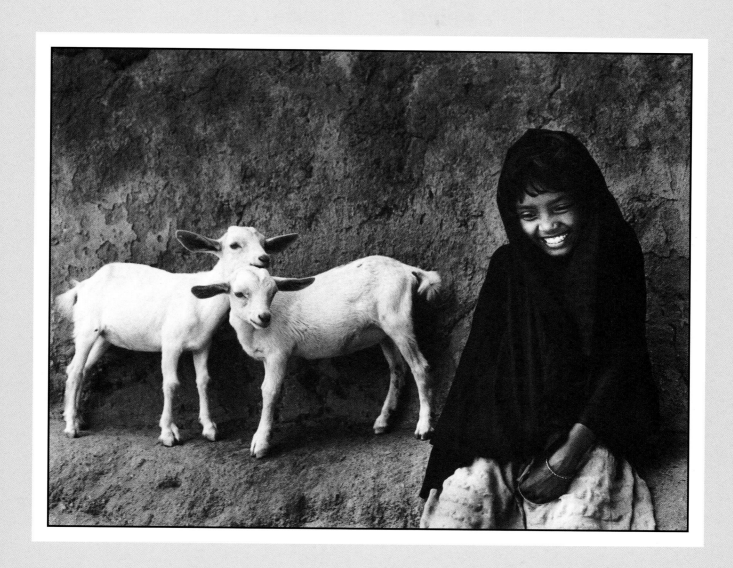

Kasi Nath Basu
INDIA

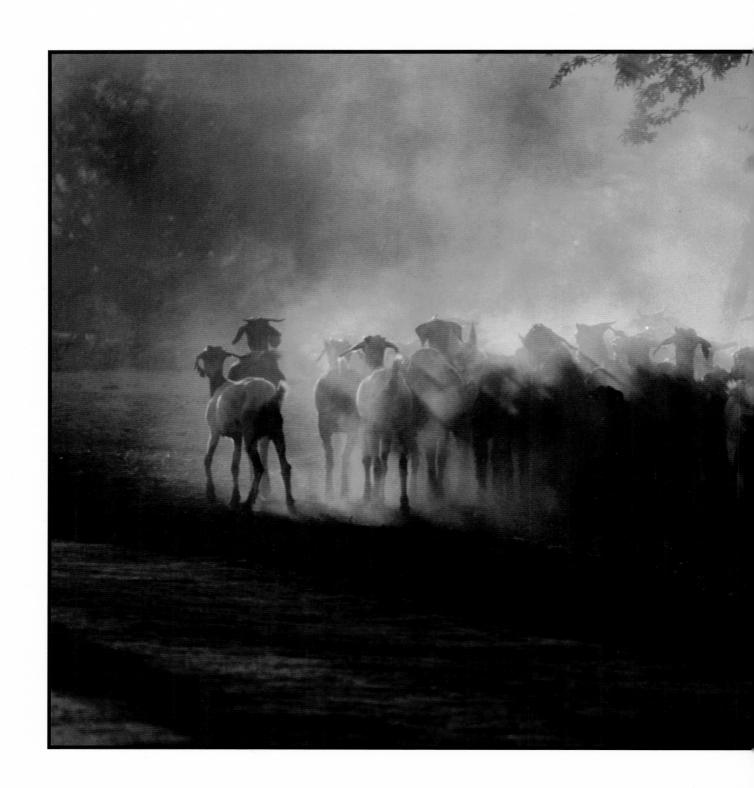

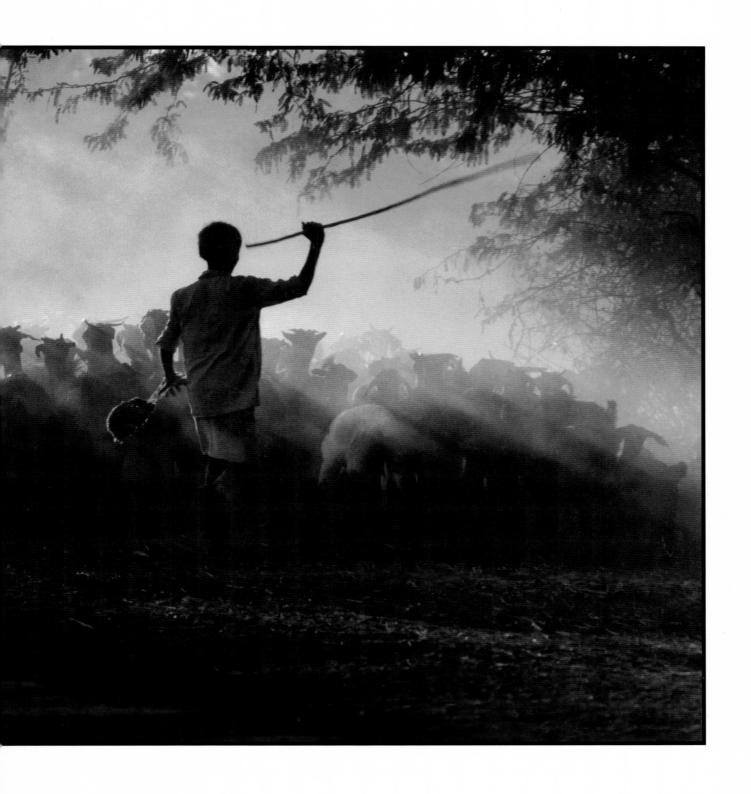

C. R. Sathyanarayana

INDIA

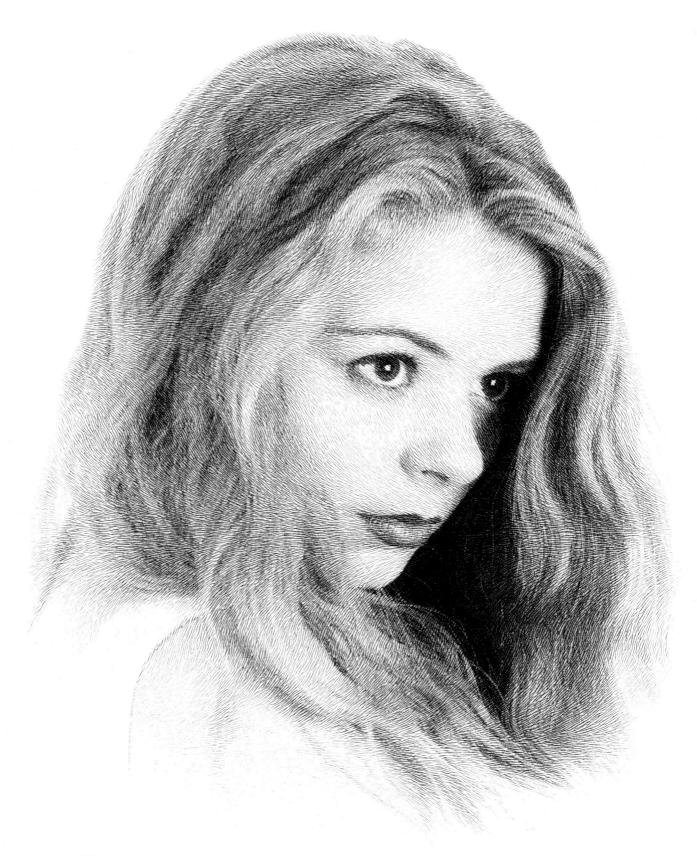

Helmut Ming
AUSTRIA

144

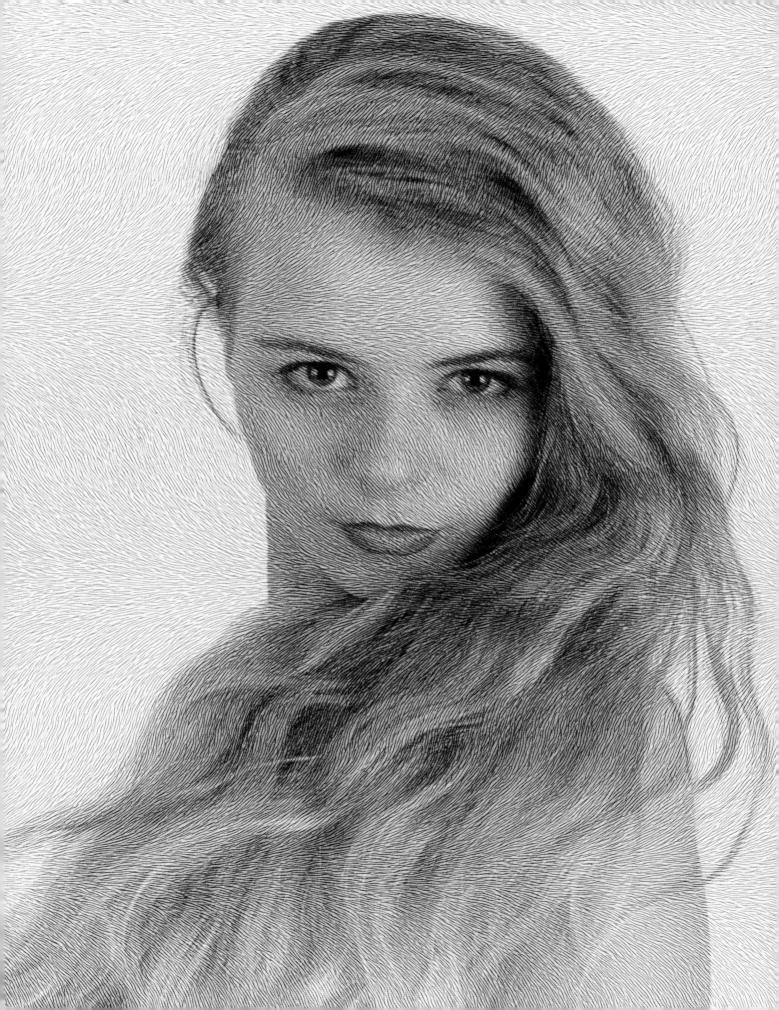

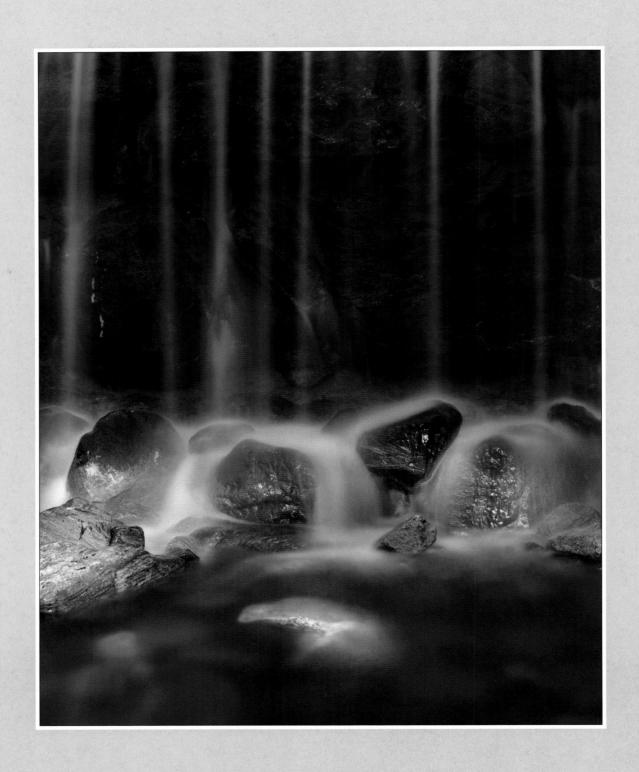

Karl Amstutz
SWITZERLAND

John Hooton
IRELAND

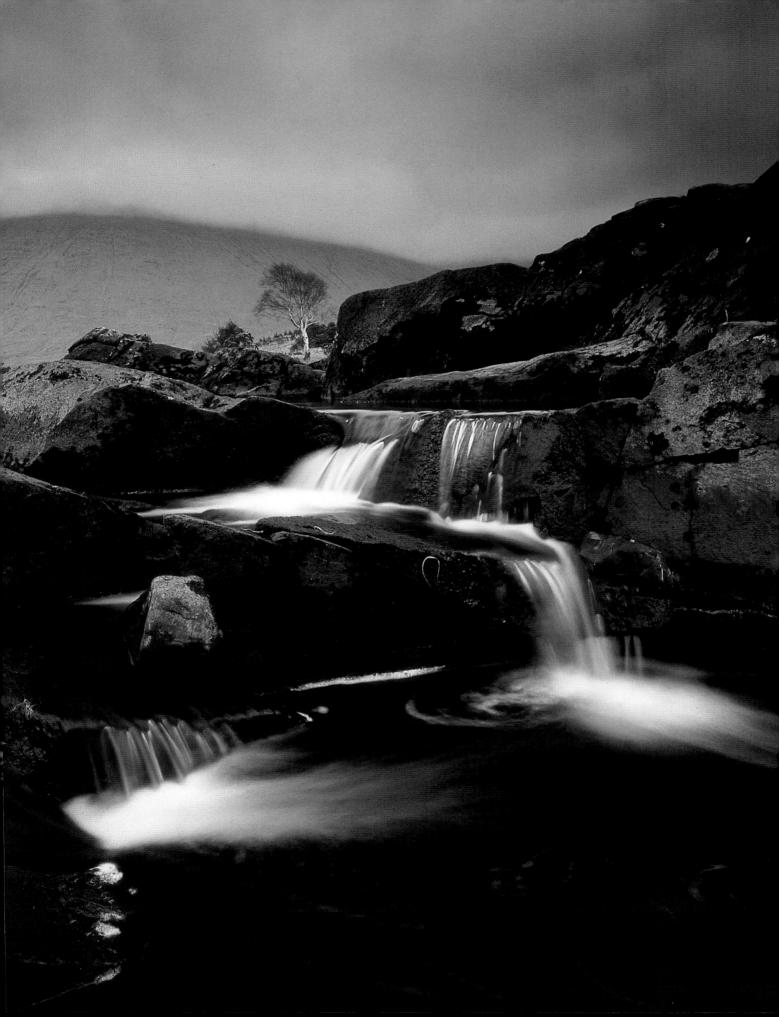

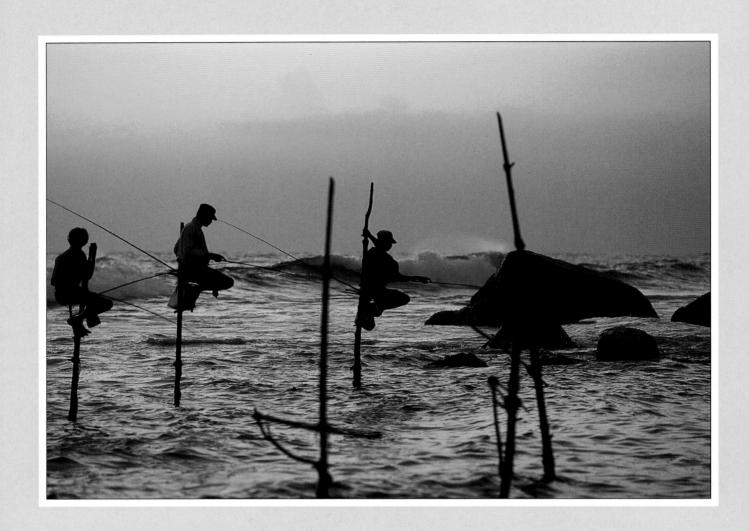

Wolfgang Wilde
GERMANY

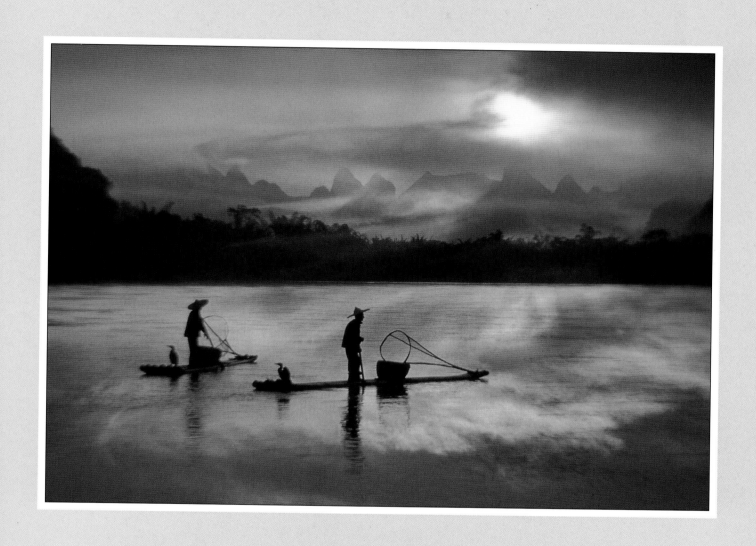

Pun Lun
CHINA

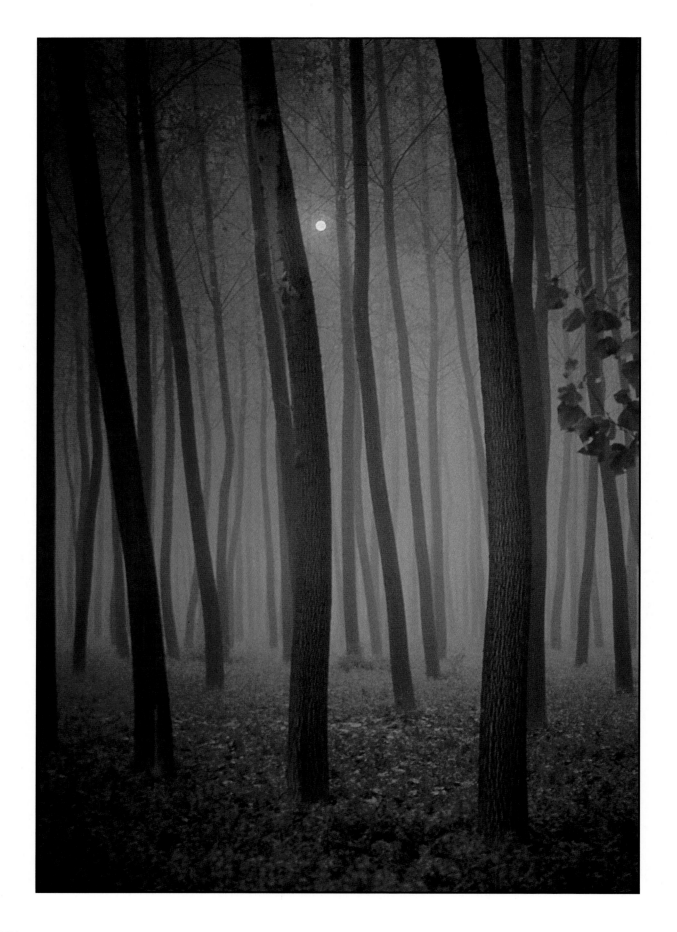

Lorenzo Masi
ITALY

Landi Battista
ITALY

Stan Murawski
UNITED STATES

Peter J. Clark
UNITED KINGDOM

153

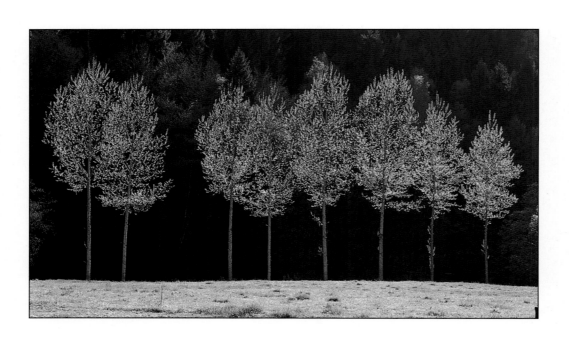

Marcel Hoogendyk
NETHERLANDS

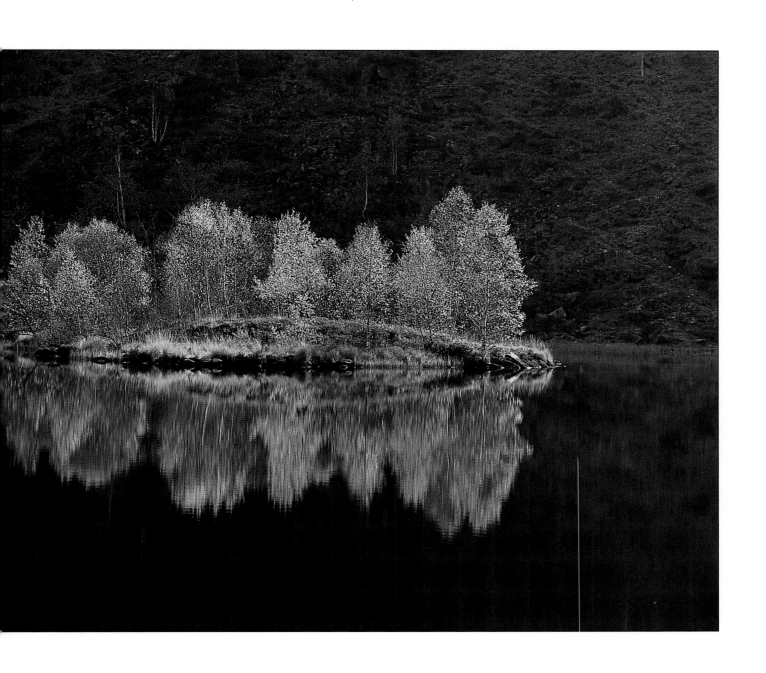

Andre Sangès
FRANCE

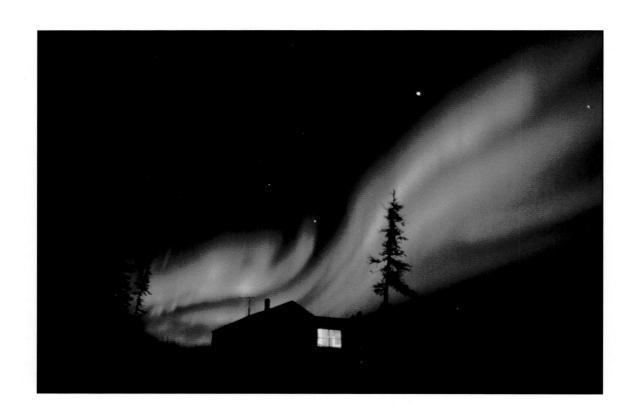

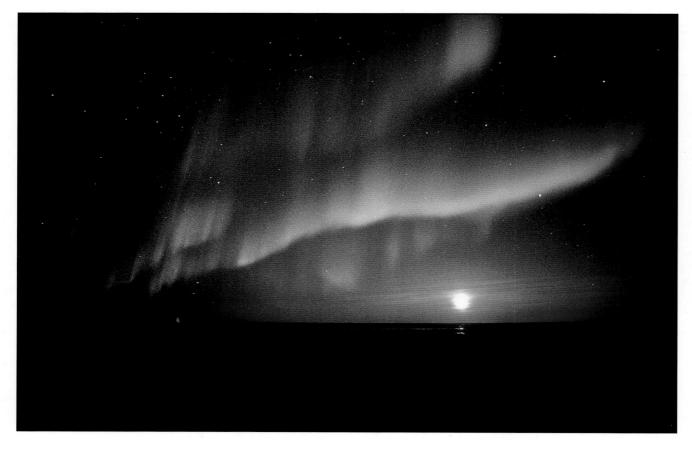

Norbert Rosing
GERMANY

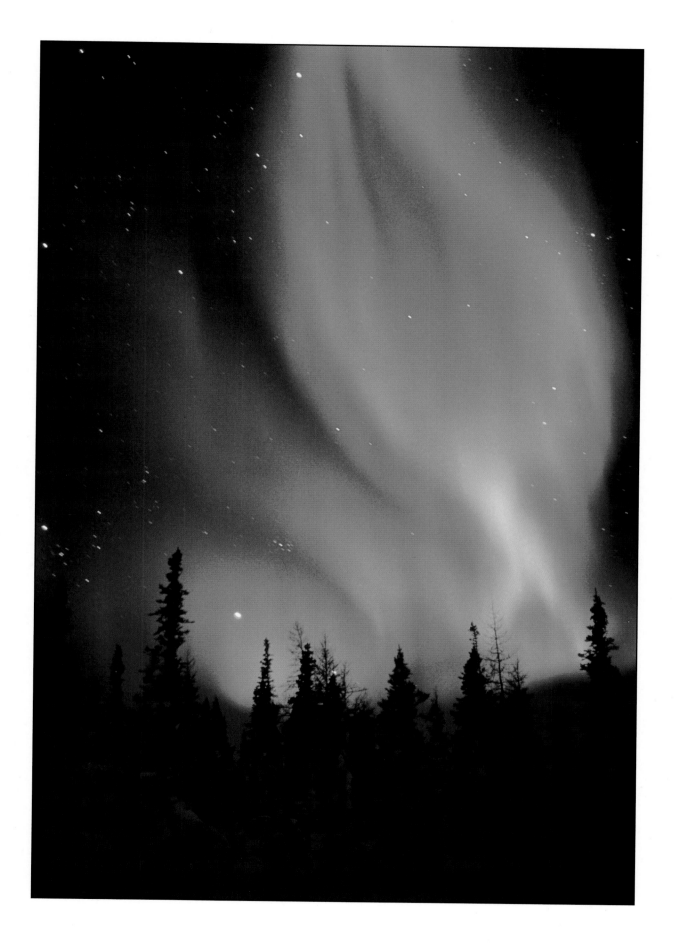

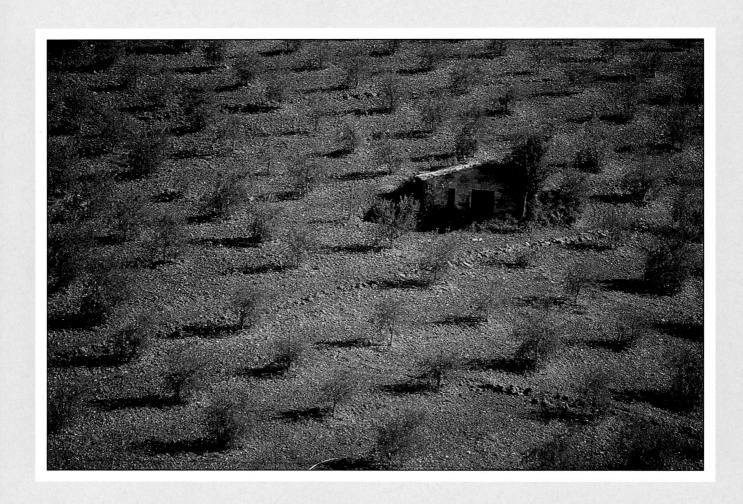

Peter Rees
UNITED KINGDOM

PREVIOUS PAGE
Alberto Goiorani
ITALY

Gerhard Flixeder
AUSTRIA

K.D. Skalski
POLAND

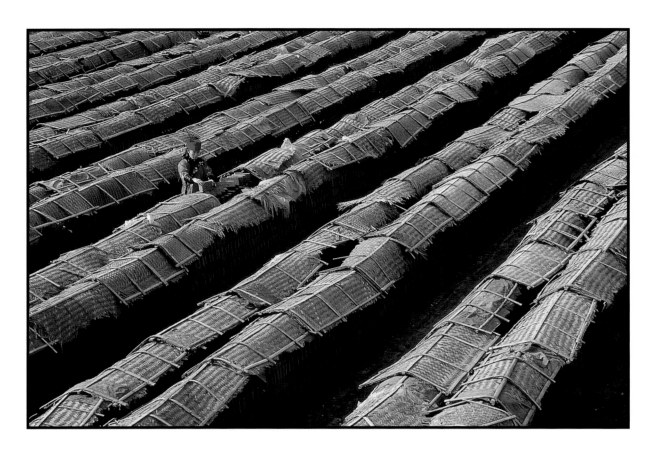

Lam Chung-Yin
HONG KONG

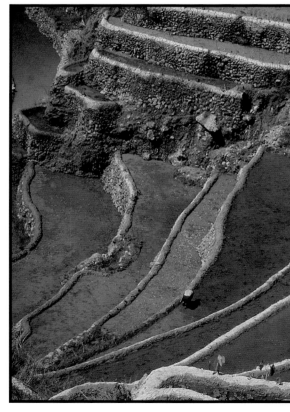

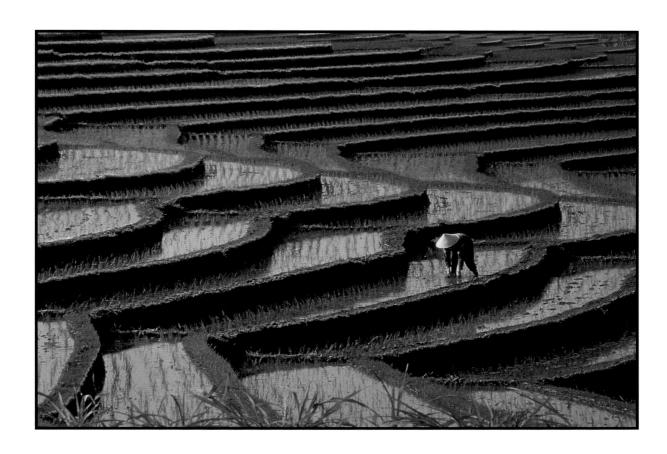

Tay Puay Koon
SINGAPORE

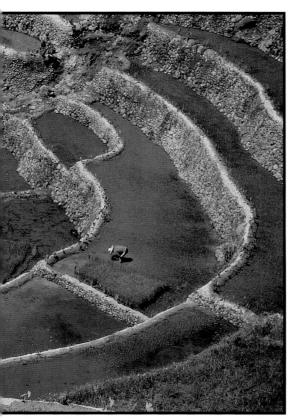

Chua Isagani
PHILIPPINES

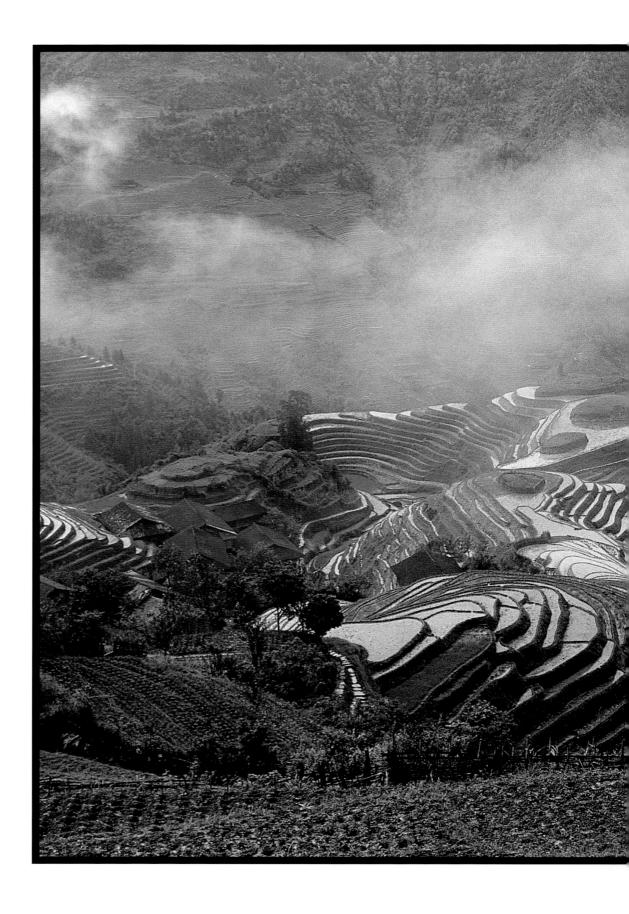

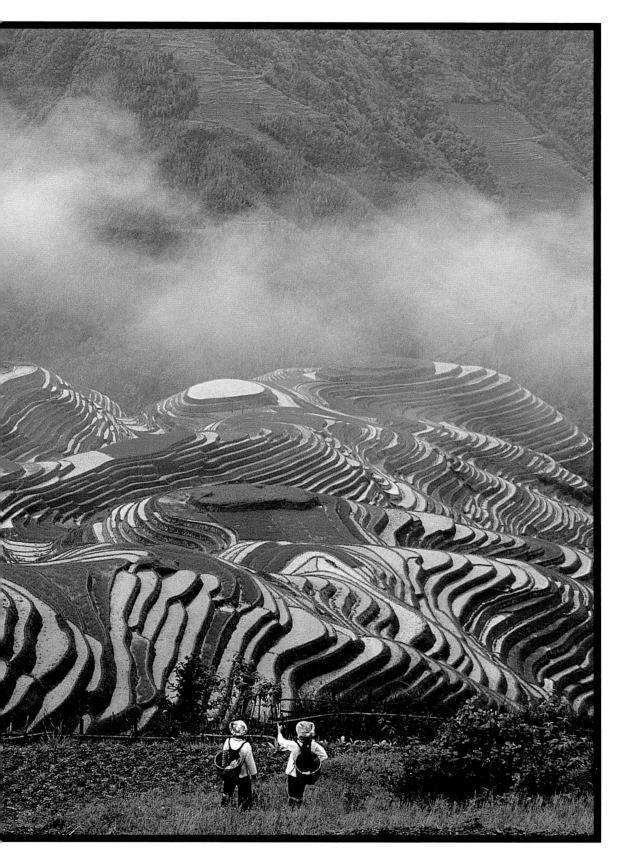

Wong Beow Leng
SINGAPORE

Günter Buesching
GERMANY

Klaus Schidniogrotzki
GERMANY

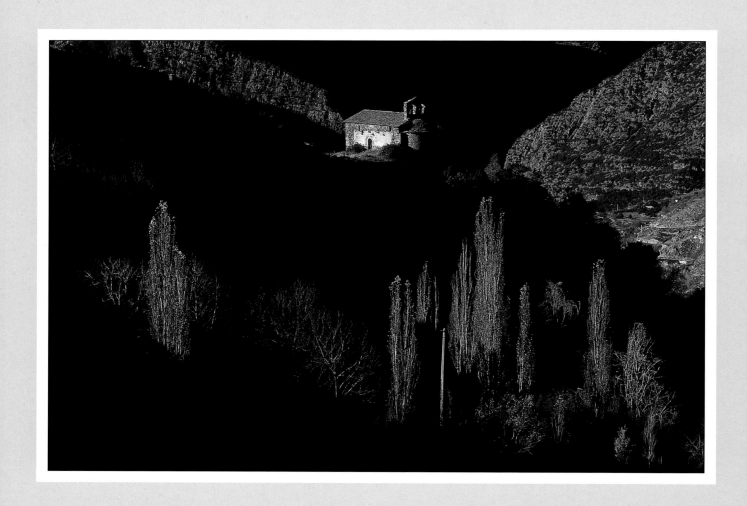

Gilles Bordes-Pages
FRANCE

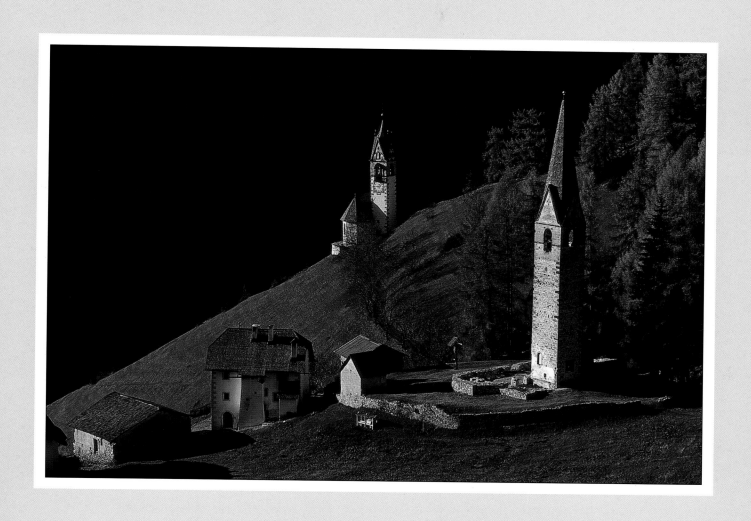

Gerd Purrucker
GERMANY

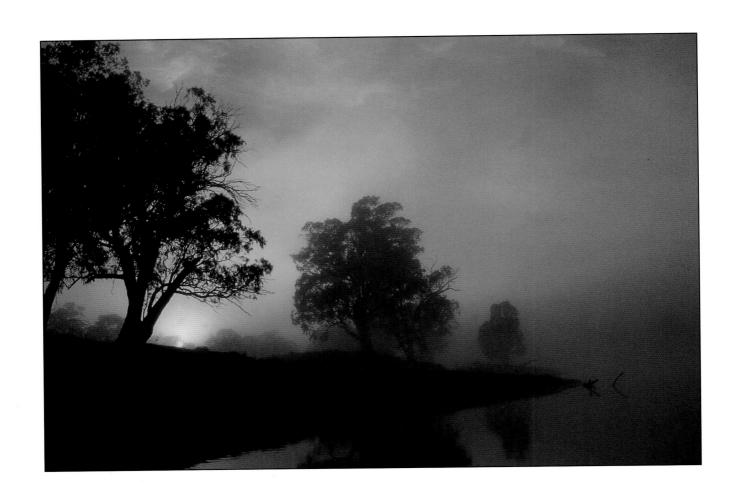

Barbara E. Miller
AUSTRALIA

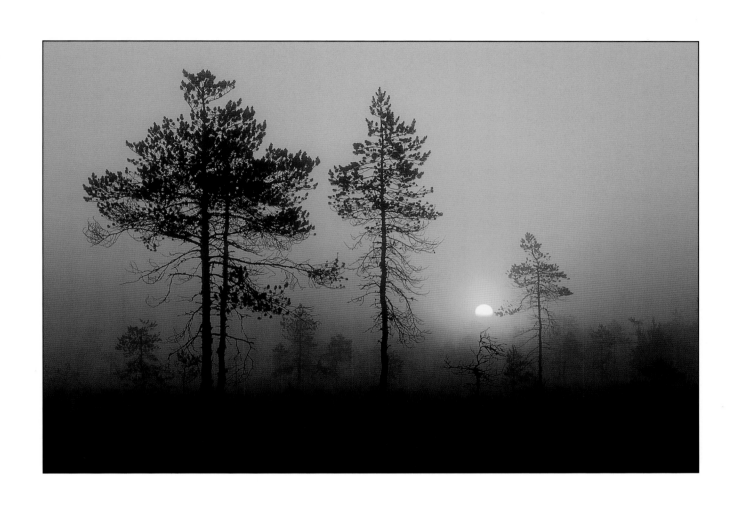

Timo J. Väre
FINLAND

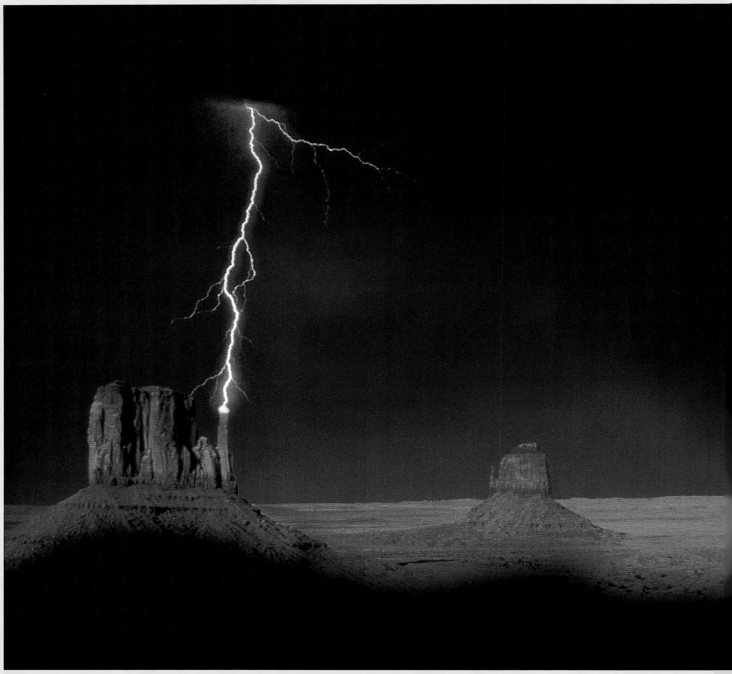

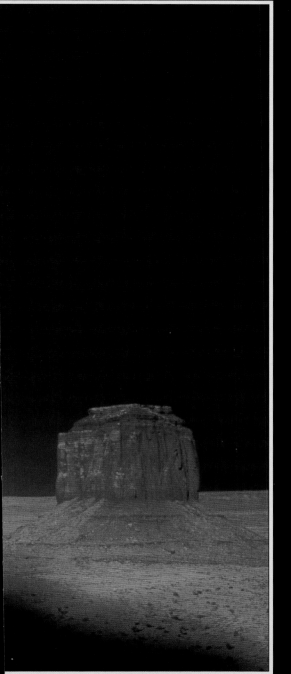
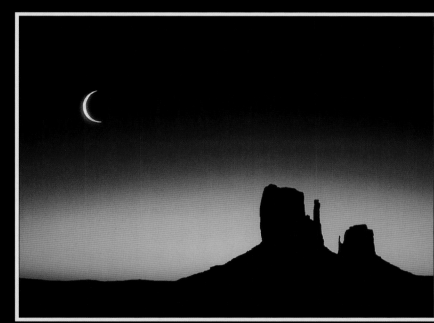

Michael Weber
GERMANY

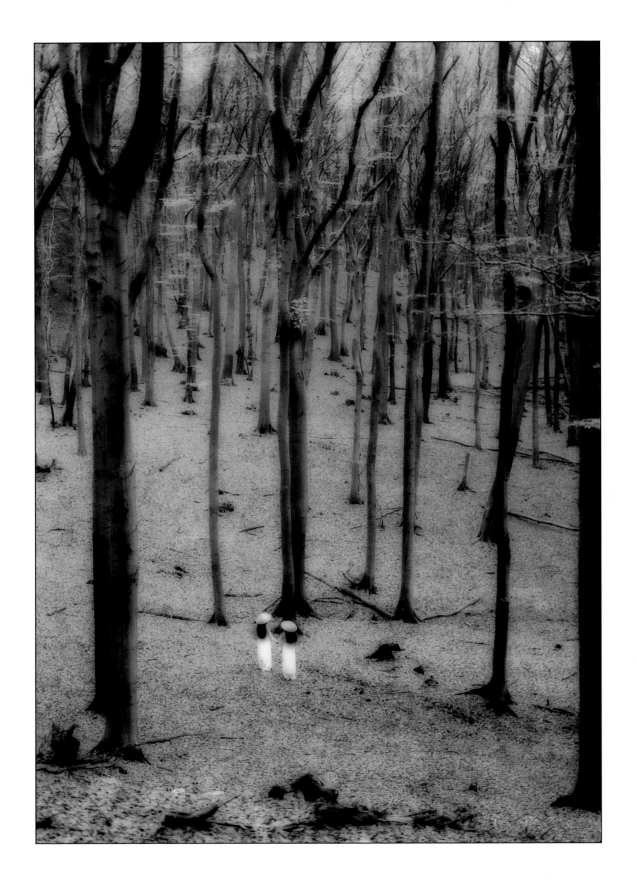

Nguyen Manh Ngoc
GERMANY

Lin Dung-Leung
HONG KONG

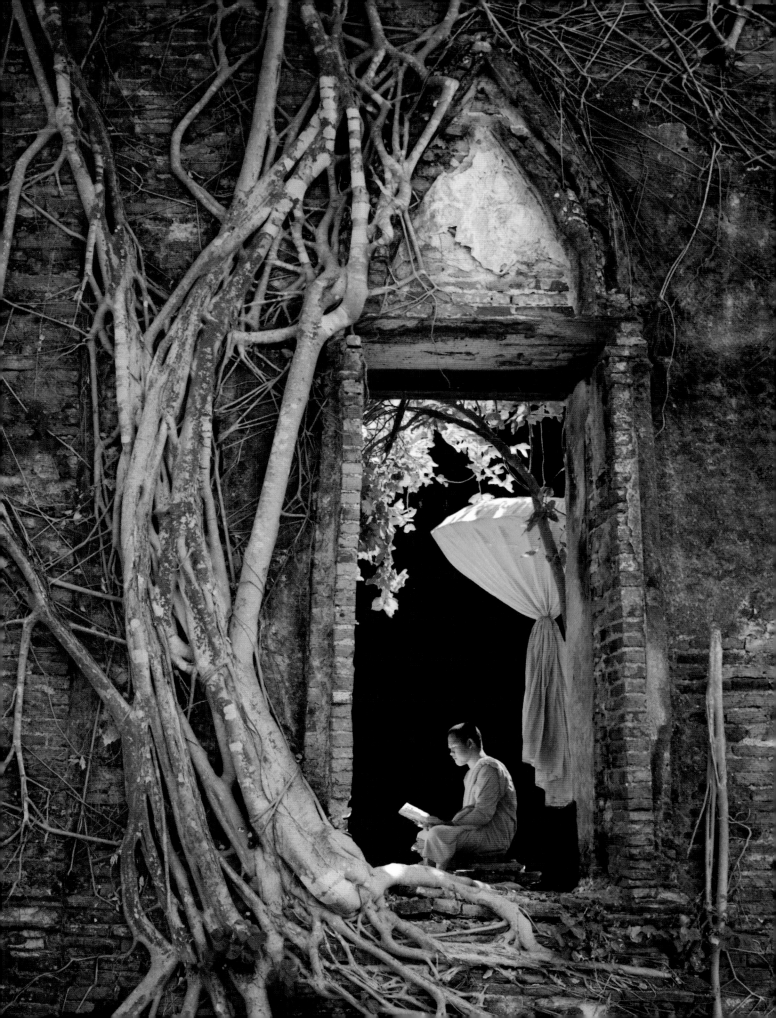

Serge Dissoubray
FRANCE

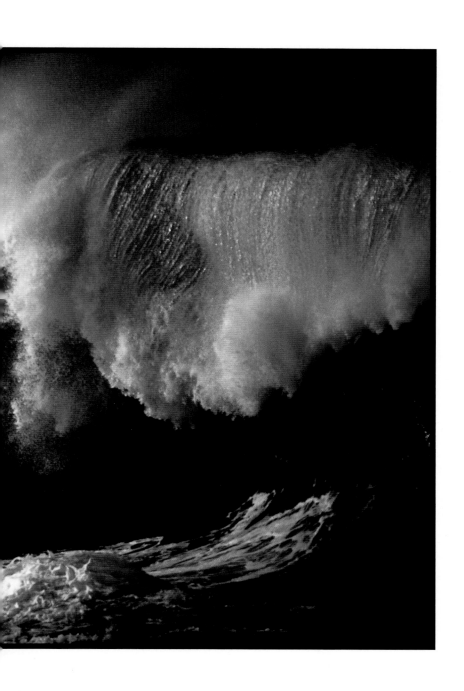

Klaus Schidniogrotzki
GERMANY

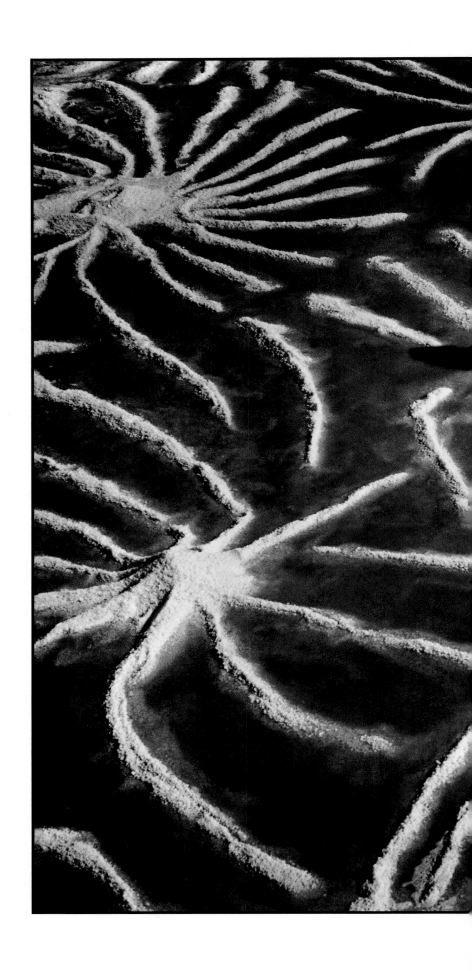

Trân Vinh Nghiã
VIETNAM

182

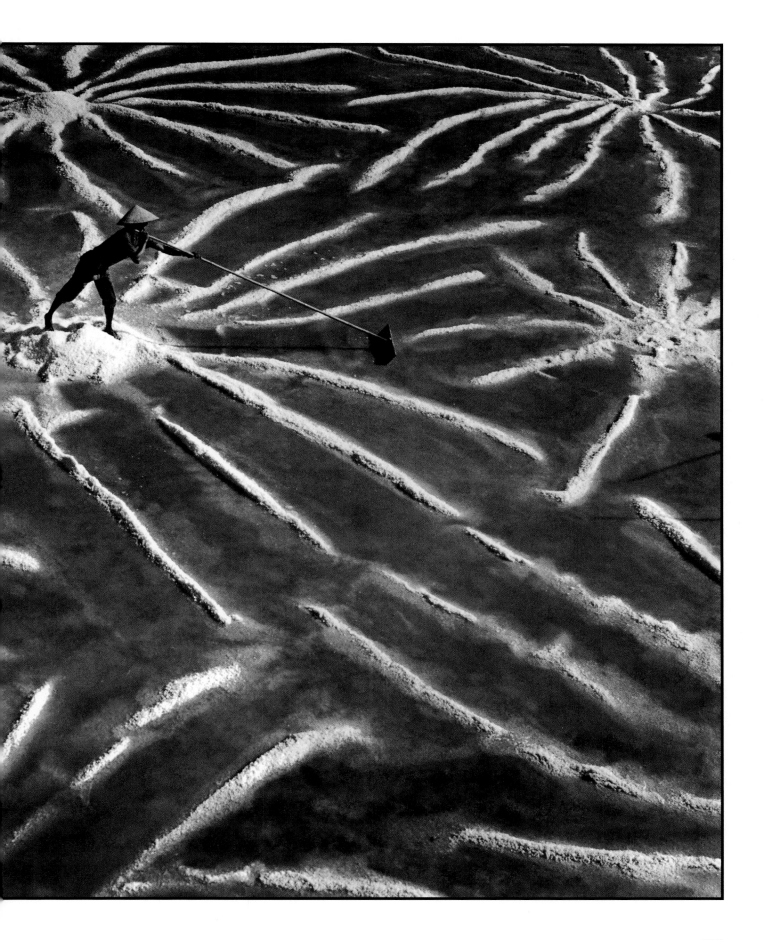

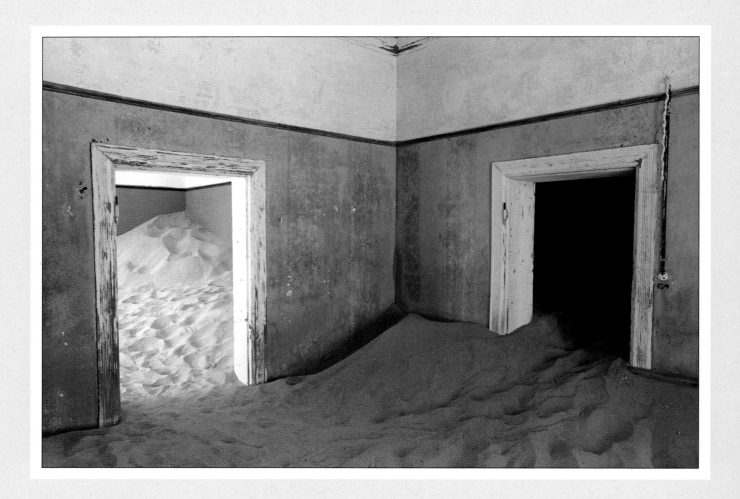

Jörg Arenz
GERMANY

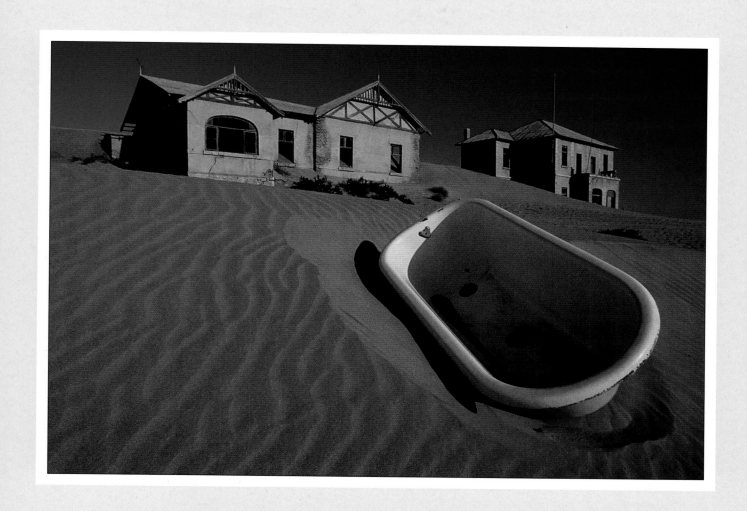

Les Gilliland
AUSTRALIA

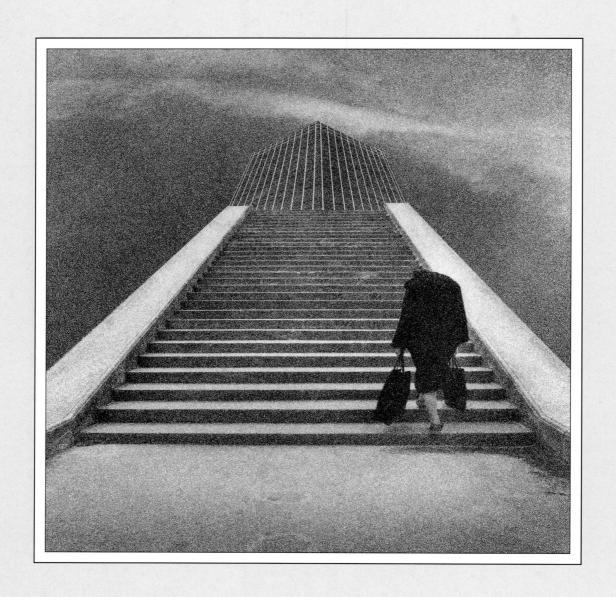

Hans van der Pol
NETHERLANDS

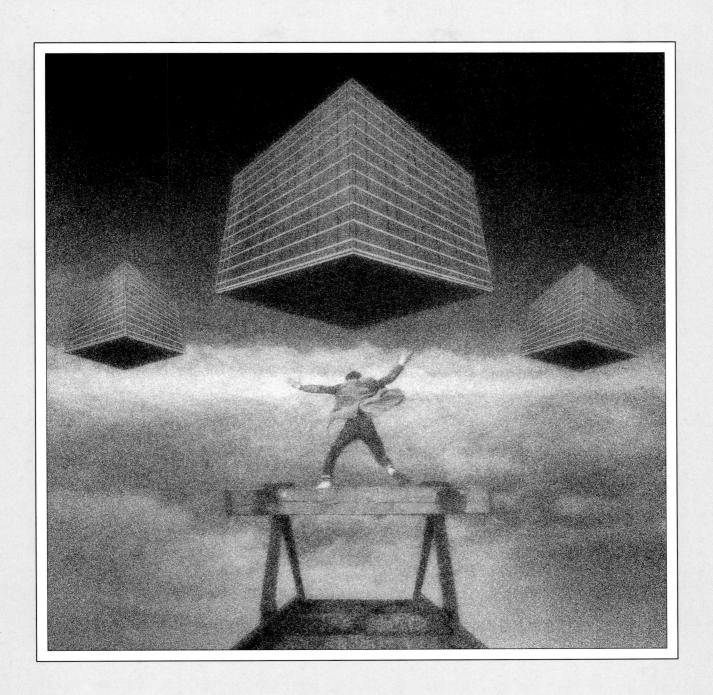

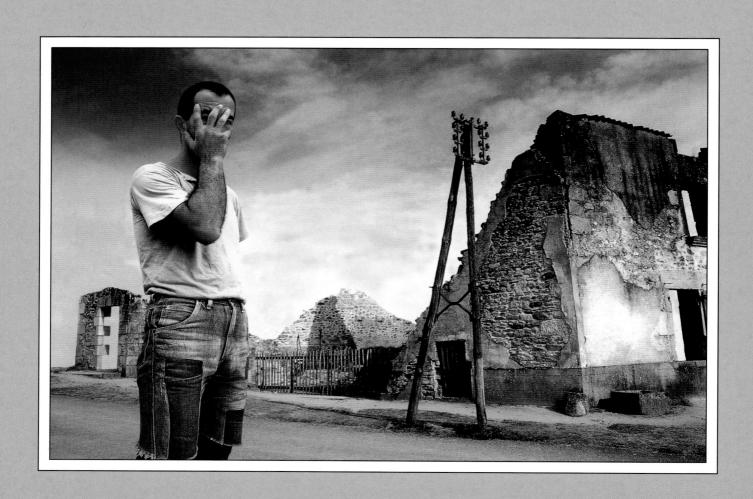

Andrea Budai
ITALY

Bob Elliott
UNITED KINGDOM

John F. Gray
UNITED KINGDOM

Guy Stoops
BELGIUM

Frank Seifert
GERMANY

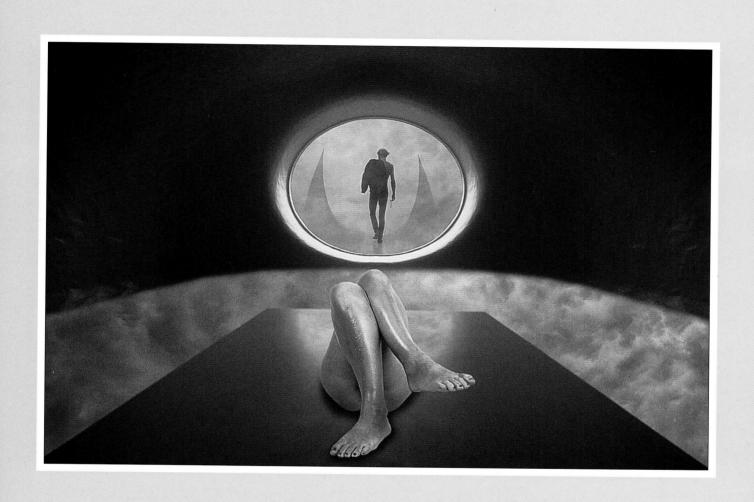

Manfred Kriegelstein
GERMANY

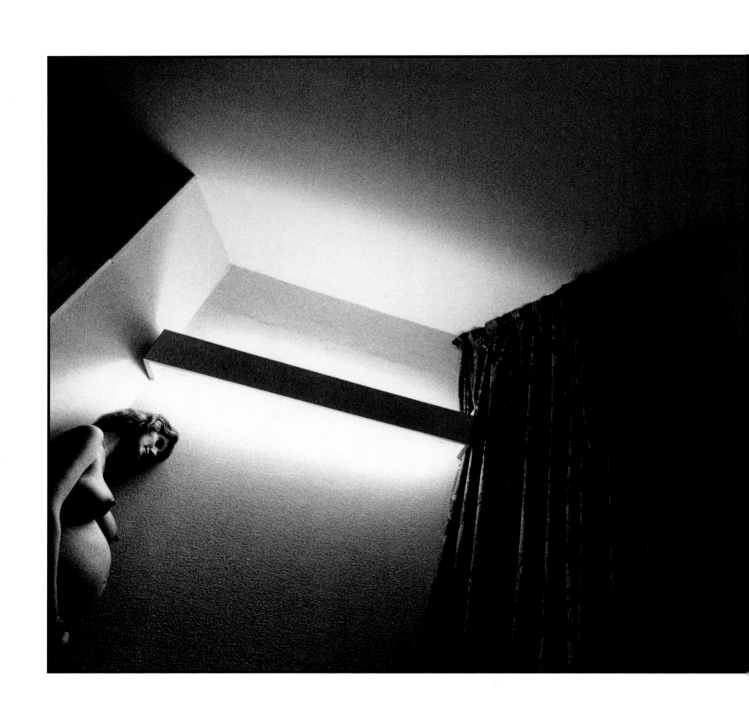

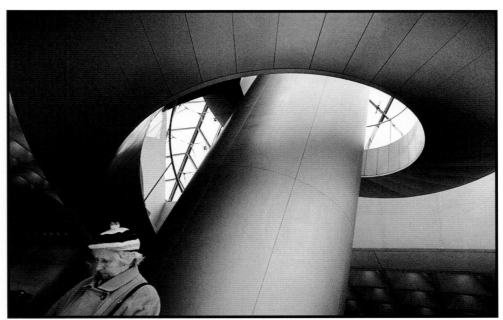

Marcel van Balken
NETHERLANDS

199

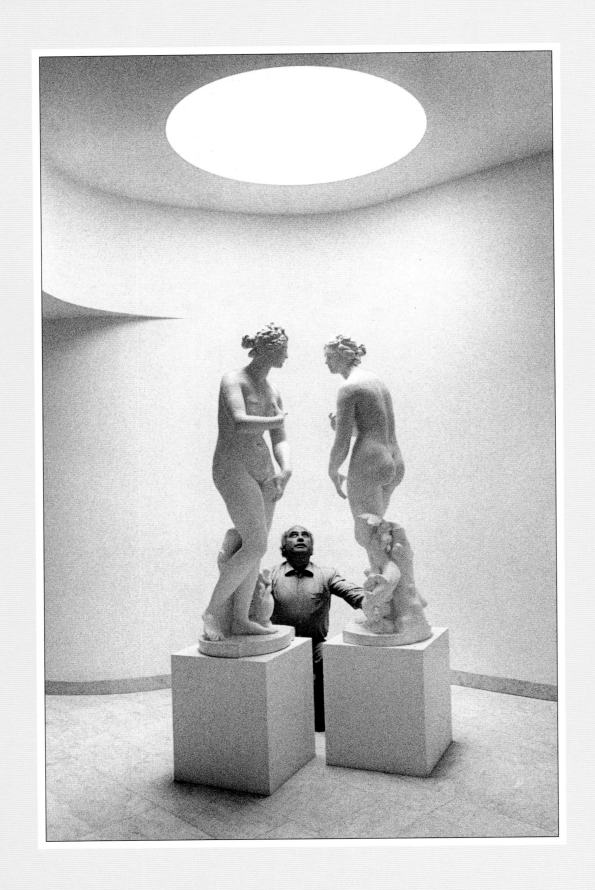

Robrecht Verwerft

BELGIUM

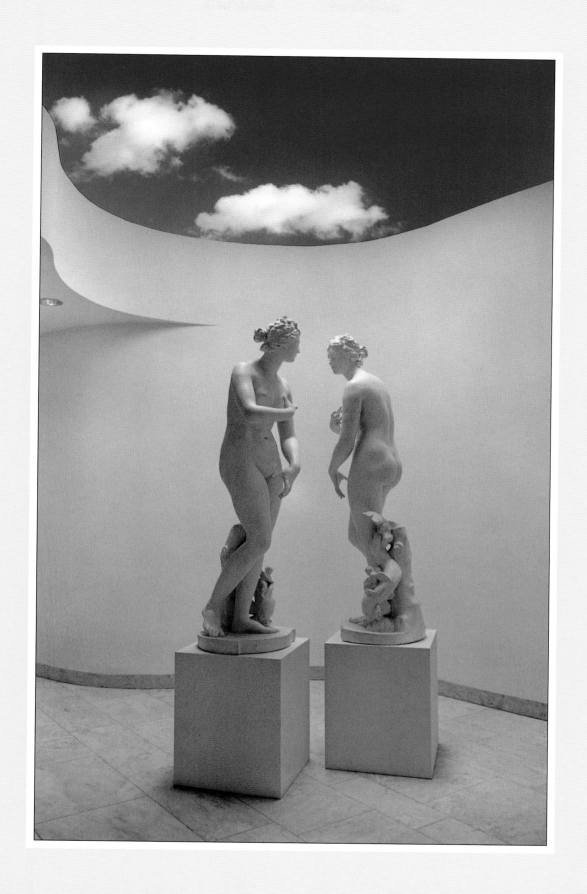

Eddy Wellens
BELGIUM

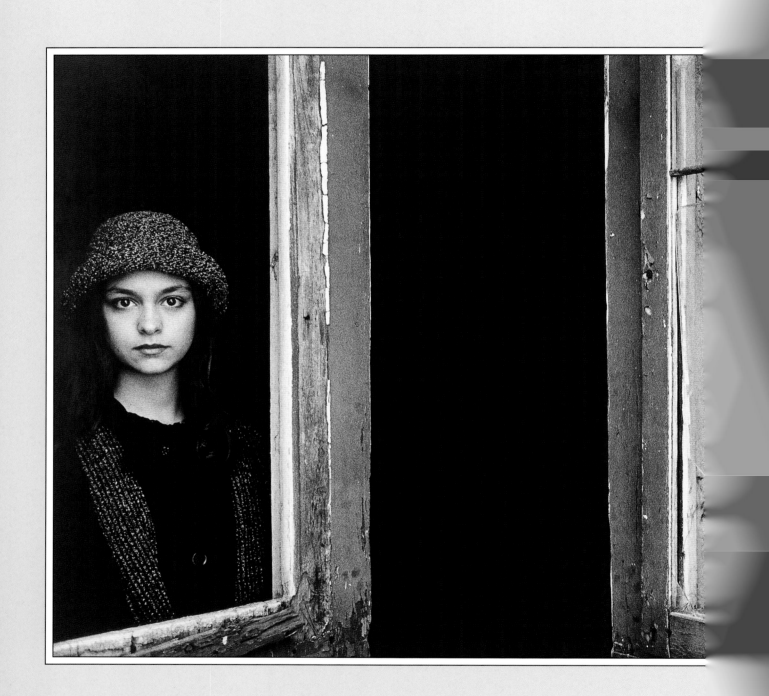

Franco Ferro
ITALY

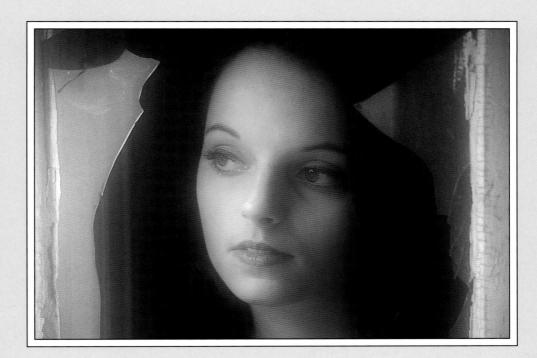

Rudi Eckhardt
GERMANY

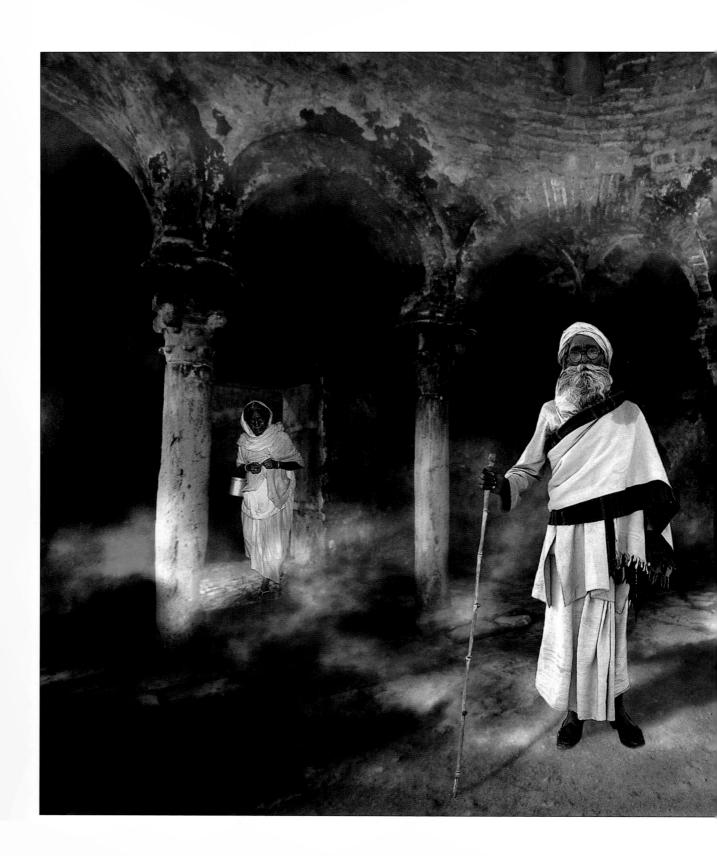

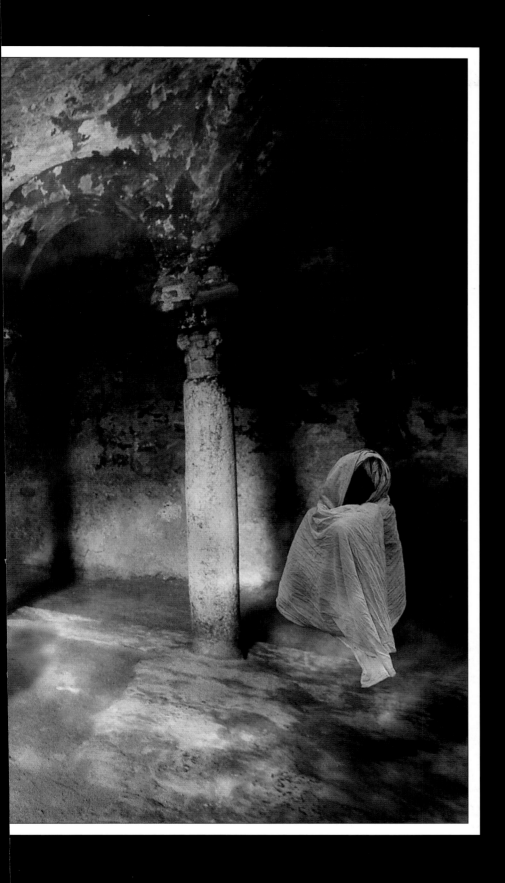

Manfred Kriegelstein
GERMANY

Marco Carli
ITALY

Klaus Rössner

GERMANY

Helmut Resch
AUSTRIA

Fernand Albert
FRANCE

Pascal Conche
FRANCE

Bernd Lindstaedt
GERMANY

Klaus Kemesies
GERMANY

Daniel Kyndt
BELGIUM

Bernd Lindstaedt
GERMANY

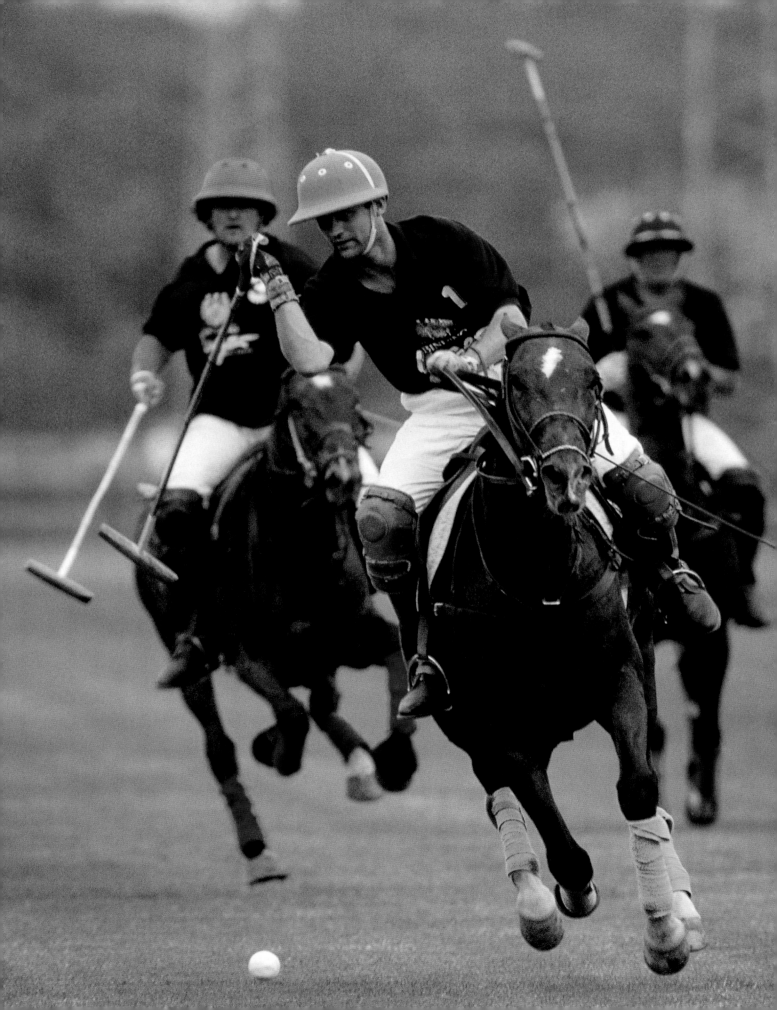

Liz Scott
UNITED KINGDOM

Nopphadol Viwatkamolwat
THAILAND

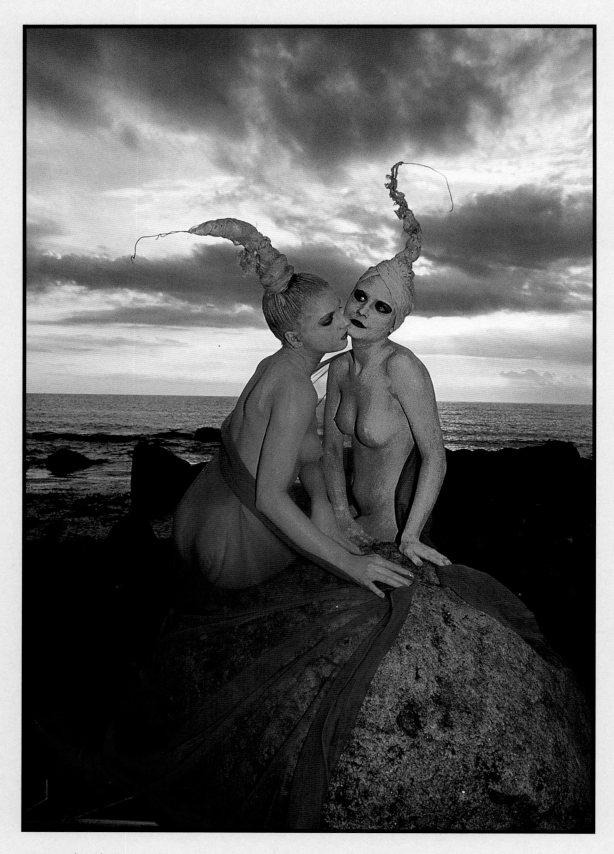

Toni Klocker
AUSTRIA

Kevin Adlard
UNITED KINGDOM

Gerd Purrucker
GERMANY

Augusto Biagioni
ITALY

Ruth Langjahr
UNITED STATES

Karl-Heinz Hansen
GERMANY

Karl Reitner
AUSTRIA

Manfred Zweimüller
AUSTRIA

Marie Antoinette Renaud
FRANCE

Alfonso Sudentas
UNITED STATES

Gerald Appel
UNITED STATES

Thomas Hennion
UNITED STATES

Carlo Cagarelli
ITALY

Thomas Schlereth
GERMANY

Robert Wong
UNITED STATES

Leslie Benedek

AUSTRALIA

August Binder
AUSTRIA

TECHNICAL
DATA

99
Photographer Noel Hutton (South Africa)
Camera Nikon F 301
Lens Nikkor Micro 200mm
Film Fuji 100
Subject/Location Johannesburgh

100, 101
Photographer Andrea Barelli (Italy)
Camera Nikon FM 2
Lens Nikkor 55mm
Subject/Location Perutz/Italy

102, 103
Photographer Tonny Thijssen-Stoop (Netherlands)
Camera Nikon F 4
Lens Sigma 2.8/90mm Macro
Film Fuji 400 SuperG
Subject/Location Made/Netherlands

104
Photographer Günter Meindl (Austria)
Camera Nikon F 4
Lens Nikkor 1.8/85mm
Film Fujicolor 800
Subject/Location Steyr/Austria

105
Photographer Ben Goossens (Belgium)

106
Photographer Edmund Steigerwald (Germany)
Camera Canon EOS 600
Lens Canon 1.8/50mm
Film Agfa Scala 200
Subject/Location Hannover/Germany

107
Photographer Edmund Steigerwald (Germany)
Camera Canon EOS 5
Lens Canon 3.5-5.6/28-80mm
Film Kodak Elite 100
Subject/Location Hannover/Germany

108, 109
Photographer Guy Bos (Belgium)
Camera Nikon FE
Lens Nikkor 50mm
Film Fujicolor SuperG 100
Subject/Location Flemalle/Belgium

110/111
Photographer Virgilio Ferrari (Italy)
Camera Mamiya RB67
Lens Mamiya Sekor 1:3.8/90mm
Film Kodak ProGOLD 160
Subject/Location Italy

112
Photographer Waranun Chutchawantipakorn (Thailand)
Camera Leica R 6
Lens R 2.8/60mm
Film Fuji Velvia 50
Subject/Location Wat Sri Chum Sukoh/Thailand

113
Photographer Chirasak Tolertmongkol (Thailand)
Camera Canon EOS 1
Lens F2.8/80mm
Film Fuji Velvia 50
Subject/Location Angkor Wat/Cambodia

114, 115
Photographer Carlo Calloni (Italy)

116, 117
Photographer Sayyed Nayyer Reza (Pakistan)
Camera Nikon F 4
Lens Nikkor 60mm Micro
Film Fuji Reala
Subject/Location Lahore/Pakistan

118
Photographer Marco Carli (Italy)

119
Photographer Virgilio Bardossi (Italy)

120, 121
Photographer Jose Arias (Spain)
Camera Hasselblad 503 CX
Lens Makro Planar 120mm
Film Ilford FP4 Plus
Subject/Location Mijas/Spain

122
Photographer Carlo Avataneo (Italy)

123
Photographer Carlos A. Milanesi (Argentina)

124/125
Photographer Colin Peter Harrison (UK)
Camera Canon T90
Lens 24mm
Film Original images on Kodachrome 64
Subject/Location London/UK

126/127
Photographer Chen Bao Sheng (China)
Camera Nikon FM 2
Subject/Location Yulin Shaan Xi/China

128
Photographer Leon Heylen (Belgium)
Camera Rolleiflex
Lens Tessar 75mm
Film Kodak TRI-X
Subject/Location Beringen/Belgium

129
Photographer Ludwig Polesny (Austria)
Camera Canon A 1
Lens Canon 35-70mm
Film Kodak Technical Pan
Subject/Location Linz/Austria

130
Photographer Herbert Pöttinger (Austria)
Camera Minolta
Lens Rokkor 85mm
Film Fuji
Subject/Location Grieskirchen/Austria

131
Photographer Vanni Calanca (Italy)

132, 133
Photographer David Fletcher (Australia)
Camera Nikon F 4
Lens Nikkor 85mm
Film Ilford HP 5
Subject/Location Horsham/Australia

	134
Photographer	Daniel Boiteau (France)

	135
Photographer	Jan Bek (Sweden)

	136
Photographer	Michele Mengoli (Italy)
Camera	Nikon F 3
Lens	Nikkor 24mm
Film	Kodak TRI-X
Subject/Location	Managua/Nicaragua

	137
Photographer	Frank Bailey (United Kingdom)
Camera	Hasselblad 500 C
Lens	Distagon 50mm
Film	Ilford FP 4
Subject/Location	Weymouth/Dorset/England

	138/139
Photographer	Carlo Avataneo (Italy)

	140
Photographer	Alain Doret (France)

	141
Photographer	Kasi Nath Basu (India)

	142/143
Photographer	C. R. Sathyanarayana (India)

	144
Photographer	Helmut Ming (Austria)
Camera	Nikon F 90 X
Lens	Sigma 70-210mm
Film	Fuji SuperG 100
Subject/Location	Traun/Austria

	145
Photographer	Helmut Ming (Austria)
Camera	Nikon F 90 X
Lens	Sigma 70-210mm
Film	Ilford Delta 100
Subject/Location	Traun/Austria

	146
Photographer	Karl Amstutz (Switzerland)
Camera	Mamyia RZ 67
Lens	Mamyia Sekor 110mm
Film	Kodak Ektachrome 100
Subject/Location	Montafon/Austria

	147
Photographer	John Hooton (Ireland)
Camera	Canon T 90
Lens	Canon 17mm
Film	Fuji Velvia 50
Subject/Location	Mayo/Ireland

	148
Photographer	Wolfgang Wilde (Germany)

	149
Photographer	Pun Lun (China)
Camera	Nikon FM 2
Lens	Nikkor 24mm
Film	Kodak Ektachrome 100
Subject/Location	Guang Xi/China

	150
Photographer	Landi Battista (Italy)

	151
Photographer	Lorenzo Masi (Italy)
Camera	Nikon F 401 S
Lens	Nikkor 35-70mm
Film	Fuji Velvia
Subject/Location	Padula di Fucecchio/Italy

	152
Photographer	Stan Murawski (United States)
Camera	Minolta X 700
Lens	Rokkor 2.8/28mm
Film	Kodachrome 64
Subject/Location	Yosemite/United States

	153
Photographer	Peter J. Clark (United Kingdom)
Camera	Canon EOS 1
Lens	Canon 28-80mm
Film	Kodachrome 64
Subject/Location	Yosemite/United States

	154
Photographer	Gianfranco Volonte (Italy)
Camera	Contax ST
Lens	Planar 1.4/50mm
Film	Kodak Ektrachrome
Subject/Location	Val Girola/Italy

	154
Photographer	Marcel Hoogendyk (Netherlands)
Camera	Nikon F 90
Lens	Nikkor 2.8/80-200mm
Film	Fujichrome Velvia
Subject/Location	La Gleize/Belgium

	155
Photographer	Andre Sangès (France)
Camera	Nikon F 801
Lens	Nikkor 70-210mm
Film	Fuji Velvia
Subject/Location	Etang de Lers/Ariege/France

	156, 157
Photographer	Norbert Rosing (Germany)
Subject/Location	Northern Lights/Arctic Circle

	158/159
Photographer	Alberto Goiorani (Italy)
Camera	Nikon F 3
Lens	Nikkor 2.8/105mm
Film	Kodachrome 25
Subject/Location	Maremma/Grosseto/Italy

	160
Photographer	Peter Rees (United Kingdom)
Camera	Minolta 7000i Dynax
Lens	Rokkor 70-210mm
Film	Fuji Velvia
Subject/Location	Montalcino/Italy

	161
Photographer	Gerhard Flixeder (Austria)
Camera	Nikon 801s
Lens	Nikkor 2.8/80-200mm
Film	Fuji Velvia
Subject/Location	Bali/Indonesia

	162, 163
Photographer	K.D. Skalski (Poland)

	164
Photographer	Lam Chung-Yin (Hong Kong)

	165
Photographer	Tay Puay Koon (Singapore)
Camera	Nikon F 90
Film	Fujichrome Velvia
Subject/Location	Bali/Indonesia

	165
Photographer	Chua Isagani (Philippines)
Camera	Nikon FTN
Lens	Nikkor 4.5/80-200mm
Film	Kodak Ektachrome
Subject/Location	Philippines

	166/167
Photographer	Wong Beow Leng (Singapore)

	168
Photographer	Günter Buesching (Germany)
Camera	Minolta XG-9
Lens	Rokkor 4.5/80-200mm
Film	Fujichrome 100
Subject/Location	Durbach/Germany

	169
Photographer	Klaus Schidniogrotzki (Germany)
Camera	Minolta Dynax 700si
Lens	Rokkor 28-105mm
Film	Fuji Velvia
Subject/Location	Cochem/Mosel/Germany

	170
Photographer	Gilles Bordes-Pages (France)
Camera	Nikon F 801
Lens	Nikkor 2.8/80-200mm
Film	Fuji Sensia
Subject/Location	Pyrenees/France

	171
Photographer	Gerd Purrucker (Germany)
Camera	Minolta X 700
Lens	Rokkor 70-210mm
Film	Fujichrome Velvia
Subject/Location	La Valle/Italy

	172
Photographer	Barbara E. Miller (Australia)
Camera	Olympus OM4
Lens	Olympus 50mm
Film	Fujichrome Sensia 100
Subject/Location	River Murray/Australia

	173
Photographer	Tim J. Väre (Finland)
Camera	Canon A1
Lens	Canon 35mm
Film	Fujichrome Velvia
Subject/Location	Valkmusa/Finland

	174
Photographer	Michael Weber (Germany)
Camera	Canon F-1N
Lens	Canon 3.5/20-35mm
Film	Fujichrome Velvia
Subject/Location	Monument Valley/United States

	175
Photographer	Michael Weber (Germany)
Camera	Canon F-1N
Lens	Canon 3.5-4.5/35-70mm
Film	Kodachrome 64
Subject/Location	Monument Valley/United States

	176
Photographer	Nguyen Manh Ngoc (Germany)
Camera	Canon F-1N
Lens	Canon 35mm
Film	Kodak Gold
Subject/Location	Vietnam

	177
Photographer	Lin Dung-Leung (Hong Kong)
Camera	Hasselblad 500C/M
Lens	Planar 80mm
Film	Kodak
Subject/Location	Bangkok/Thailand

	178/179
Photographer	Serge Dissoubray (France)

	180/181
Photographer	Klaus Schidniogrotzki (Germany)
Camera	Minolta Dynax 700si
Lens	Rokkor 300mm
Film	Fuji Velvia
Subject/Location	Lanzarote/Canary Islands

	182/183
Photographer	Trân Vinh Nghiã (Vietnam)
Camera	Nikon FE2
Lens	Sigma 28-80mm
Film	Agfa 100
Subject/Location	Phanthiet/Vietnam

	184
Photographer	Jörg Arenz (Germany)
Camera	Minolta X700
Lens	Rokkor 2.8/24mm
Film	Agfa Optima 200
Subject/Location	Lüderitz/Namibia

	185
Photographer	Les Gilliland (Australia)
Camera	Nikon F 4
Lens	Nikkor 2.8/24mm
Film	Fuji 100
Subject/Location	Kolmanskop/Namibia

	186, 187
Photographer	Hans van der Pol (Netherlands)

	188, 189
Photographer	Andrea Budai (Italy)

	190, 191
Photographer	Bob Elliott (United Kingdom)

	192
Photographer	John F. Gray (United Kingdom)
Camera	Canon EOS 5
Lens	Canon 28-105mm
Film	Fujichrome Sensia 100
Subject/Location	Gloucestershire/England

	193
Photographer	John F. Gray (United Kingdom)
Camera	Canon T90
Lens	Sigma 2.8/90mm
Film	Fujichrome 100
Subject/Location	Gloucestershire/England

	194, 195
Photographer	Guy Stoops (Belgium)
Camera	Nikon F-801S
Lens	Nikkor 1.8/50mm
Film	Kodak T Max 400
Subject/Location	Antwerpen/Belgium

	196
Photographer	Frank Seifert (Germany)
Camera	Nikon F 3
Lens	Nikkor 20mm
Film	Fuji Velvia
Subject/Location	Germany

	197
Photographer	Manfred Kriegelstein (Germany)
Camera	Leica
Lens	Leica
Film	Kodak
Subject/Location	Berlin/Germany

	198, 199
Photographer	Marcel van Balken (Netherlands)

	200
Photographer	Robrecht Verwerft (Belgium)
Camera	Nikon F 3
Lens	Nikkor 24mm
Film	Kodak TRI-X
Subject/Location	Mönchengladbach/Germany

	201
Photographer	Eddy Wellens (Belgium)

	202
Photographer	Franco Ferro (Italy)
Camera	Leica R 8
Lens	Elmarit 90mm
Film	Delta Pro 400
Subject/Location	Italy

	203
Photographer	Rudi Eckhardt (Germany)
Camera	Canon EOS 100
Lens	Canon 35-135mm
Film	Fuji Sensia 100
Subject/Location	Herborn/Germany

	204/205
Photographer	Manfred Kriegelstein (Germany)
Camera	Leica
Lens	Leica
Film	Kodak
Subject/Location	India

	206, 207
Photographer	Marco Carli (Italy)

	208
Photographer	Klaus Rössner (Germany)
Camera	Nikon F 501
Lens	Sigma 24-50mm
Film	Fuji Velvia
Subject/Location	Frankenwald/Germany

	209
Photographer	Helmut Resch (Austria)
Camera	Leica R 5
Lens	Leica 2.8/60mm
Film	Kodachrome 64
Subject/Location	Zeiselmauer/Austria

	210/211
Photographer	Fernand Albert (France)

	212
Photographer	Pascal Conche (France)
Camera	Nikon F 90
Lens	Nikkor 24mm
Film	Fujichrome Velvia
Subject/Location	Haute Savoie/France)

	213
Photographer	Pascal Conche (France)
Camera	Nikon F 90
Lens	Nikkor 24mm
Film	Fujichrome Velvia
Subject/Location	Paris/France

	214
Photographer	Klaus Kemesies (Germany)
Camera	Canon EOS 1N
Lens	Canon 2.8/300mm
Film	Kodak Elite 100
Subject/Location	Bad Homburg/Germany

	215
Photographer	Bernd Lindstaedt (Germany)
Camera	Leica R 4
Lens	Leica 2.8/280mm
Film	Kodak Elite II
Subject/Location	Bensheim/Germany

	216
Photographer	Daniel Kyndt (Belgium)
Camera	Canon T 90
Lens	Canon 4.5/600mm
Film	Kodachrome 200
Subject/Location	Germany

	217
Photographer	Bernd Lindstaedt (Germany)
Camera	Leica R 4
Lens	Leica 2.8/280mm
Film	Kodak Elite II
Subject/Location	Frankfurt/Germany

	218
Photographer	Liz Scott (United Kingdom)
Camera	Pentax ME Super
Lens	Tokina 70-200mm
Film	Kodak T Max 3200
Subject/Location	United Kingdom

	219
Photographer	Nopphadol Viwatkamolwat (Thailand)
Camera	Nikonos V
Film	Kodak Lumiere 100 X
Subject/Location	Santa Barbara/United States

	220
Photographer	Toni Klocker (Austria)
Camera	Canon EOS 600
Lens	Canon 2.8/80-200mm
Film	Fuji Sensia 100
Subject/Location	Liepaja/Latvia

	221
Photographer	Kevin Adlard (United Kingdom)
Camera	Nikon F 4
Lens	Nikkor 28-70mm
Film	Fuji Velvia 50
Subject/Location	United Kingdom

	222
Photographer	Gerd Purrucker (Germany)
Camera	Leica R 5
Lens	Leica 70-210mm
Film	Fujichrome Velvia
Subject/Location	Fichtelgebirge/Germany

	223
Photographer	Gerd Purrucker (Germany
Camera	Minolta X 700
Lens	Rokkor 70-210mm
Film	Fujichrome Velvai
Subject/Location	Weissenstadt/Germany

	224, 225
Photographer	Augusto Biagioni (Italy)

	226
Photographer	Ruth Langjahr (United States)
Camera	Nikon N 90
Lens	Nikkor 70-210mm
Film	Fuji 100
Subject/Location	Philadelphia/United States

	227
Photographer	Karl-Heinz Hansen (Germany)
Camera	Nikon F 4
Lens	Sigma 5.6/180mm
Film	Fuji Provia 100
Subject/Location	Rendsburg/Germany

	228
Photographer	Karl Reitner (Austria)
Camera	Minolta XGM
Lens	Rokkor Macro 100mm
Film	Fuji Sensia 100
Subject/Location	Steyr/Austria

	229
Photographer	Manfred Zweimüller (Austria)
Camera	Canon T 90
Lens	Canon 3.5/50mm Macro
Film	Kodachrome 64
Subject/Location	Salzburg/Austria

	230, 231
Photographer	Marie Antoinette Renaud (France)
Camera	Canon T 90
Lens	Kiron 100mm Macro
Film	Fuji Velvia 50
Subject/Location	France

	232
Photographer	Alfonso Sudentas (United States)
Camera	Nikon
Lens	Sigma 2.8 Macro
Film	Kodak Ektachrome 100
Subject/Location	Westfield/United States

	233
Photographer	Gerald Appel (United States)
Camera	Canon EOS 1
Lens	Canon 5.6/400mm
Film	Fuji Provia 100
Subject/Location	San Diego/United States

	234
Photographer	Tom Hennion (United States)
Camera	Canon EOS-A2
Lens	Canon 3.5-4.5/28-105mm
Film	Kodak Ektachrome 100
Subject/Location	Philadelphia/United States

	235
Photographer	Carlo Cagarelli (Italy)
Camera	Nikon 601
Lens	Nikkor 24mm
Film	Fujichrome Sensia 100
Subject/Location	Cortina d'Ampezzo/Italy

	236
Photographer	Robert Wong (United States)
Camera	Canon EOS
Film	Fuji Provia
Subject/Location	Etosha Park/Namibia

	237
Photographer	Thomas Schlereth (Germany)
Camera	Nikon FM 2
Lens	Tokina 4.0-5.6/70-210mm
Film	Fujichrome Sensia 100
Subject/Location	San Diego/United States

	238/239
Photographer	August Binder (Austria)
Camera	Nikon 801 S
Lens	Nikkor 75-300mm
Film	Ilford FB4
Subject/Location	Vienna/Austria

	240
Photographer	Leslie Benedek (Australia)
Camera	Minolta 700 XI
Lens	Rokkor 100-300mm
Film	Fujichrome Sensia 100
Subject/Location	London Zoo/England